Two Paths to Equality

Two Paths to Equality

Alice Paul and Ethel M. Smith in the
ERA Debate, 1921–1929

Amy E. Butler

State University of New York Press

Cover: The photo of Alice Paul (*left*) is courtesy of the Alice Paul Centennial Foundation, Inc. and the National Museum of American History, Smithsonian Institute. The photo of Ethel M. Smith (*right*) is reproduced from the Collections of the Library of Congress.

Published by
State University of New York Press, Albany

For information, address State University of New York Press
90 State Street, Suite 700, Albany, NY 12207

Production by Dana Foote
Marketing by Anne Valentine

Library of Congress Cataloging-in-Publication Data

Butler, Amy E., 1965–
Two paths to equality : Alice Paul and Ethel M. Smith in the ERA debate, 1921–1929 / Amy E. Butler.
p. cm.
Includes bibliographical references and index.
ISBN 0-7914-5319-7 (alk. paper) — ISBN 0-7914-5320-0 (pbk. : alk. paper)
1. Women's rights — United States — History. 2. Equal rights amendments — United States — History. 3. United States — Politics and government — 1919–1933. 4. Paul, Alice, 1885–1977. 5. Smith, Ethel Marion, 1877–1951. I. Title
HQ1236.5.U6 B88 2002
323.3'4'097309042 — dc21
2002020823

10 9 8 7 6 5 4 3 2 1

This is dedicated to
my step-mother
Mary Retan
(1921–2001)

Contents

Acknowledgments

Many librarians and archivists provided essential assistance with this book. I would like to thank the Schlesinger Library staff as well as the archivists at the Library of Congress, National Archives, Swarthmore College, George Washington University, and Vassar College. State University of New York at Binghamton librarians Rachelle Moore, Diane Geraci, Cheryl McKee, and Ed Sheppard were instrumental to the completion of this work.

I also am grateful for Amelia Fry's friendship and many hours of conversation about Alice Paul. Leslie Latham generously shared endless memories about the National Woman's Party. I will remain eternally grateful to Sarah Elbert for always challenging my most basic assumptions and for being a consistent source of inspiration throughout the length of this project. In addition, I am grateful to Dara Silberstein, Amy Shapiro, Dick Dalfiume, Carole Turbin, Jean Paquette, Tim Houlihan, Kristen McDonald, Betsy Otto, Dia Black, and Emily Appal.

This book certainly could not have been completed without the mentorship of Kathryn Kish Sklar, the leading influence in my committment to women's and labor history. Her exemplary scholarship on progressive era politics laid the groundwork for this book. I am grateful for the twelve years she committed to working with me, first as an undergraduate, then graduate student. I have benefited immeasurably, both professionally and personally, from her insight.

The Elusive Search for Equal Rights in the Twentieth Century

Sex equality is elusive, and depending on context, can be vitally significant or virtually meaningless. It categorizes women according to both difference and sameness. In both cases, men set the standard. Treating women like men is not equivalent to treating men and women equally.
— Zillah Eisenstein, *The Female Body and the Law*

[P]atriarchy has always played women off against each other and manipulated differences among women for its own purposes. Nevertheless, feminists must confront and negotiate differences among women—differences of class, race, culture, age, political affiliation, and sexual practices—if they are to transform such differences into positive rather than negative forces in women's lives.
— Barbara Johnson, "The Postmodern Feminism"

This book began in the early 1990s as a biography of Alice Paul. Stories of her tenacious and intrepid leadership during the suffrage movements in England and the United States, and as the author of the Equal Rights Amendment (ERA), brought to life a charismatic woman who refused to compromise her principles as she advanced a legislative agenda to establish full political and legal equality for women. However, after examining the perspectives of women who criticized Paul and her organization, the National Woman's Party (NWP), divergent interpretations of her leadership quickly unfolded. Most notably, Ethel M. Smith, Legislative Secretary of the National Women's Trade Union League (WTUL), earned distinction in the early 1920s as a recognized leader of the opposition to the ERA, championing a widely accepted alternative to Paul's vision. Though she supported the principle of equal rights for both women and men, she also believed such legislative efforts should be tailored to women's distinct needs, especially as new and permanent members of the labor force.

Both women engaged in a heated debate over the most effective methods to achieve their legislative goals. Their differences were based on competing personal politics and class-based political philosophies. Paul believed that legislative enactment of the ERA would fully emancipate women by eradicating all political and legal discriminations based on sex. By integrating the principle that men and women were the same into the legal fabric of American law and politics, women

would then be free to compete equally with men not only in the workplace, but in all aspects of social and economic life. She particularly opposed efforts to regulate the conditions of women's labor, describing protective legislation as an unnecessary interference in women's capacity to demonstrate the full range of their professional interests and talents. Passage of the ERA, Paul believed, would benefit all of society because women could then pursue the profession of their choice, without restrictions on hours of work or rate of pay, and play an important role in the development of a prosperous economy. While her views have become more accepted in the past fifty years, at the time they undermined the hard-won legislative victories achieved by women such as Ethel Smith.

Smith questioned Paul's approach to women's equality predominantly because it benefited professional and business women at the expense of her primary constituency—wage-earning women. She believed the principle of equal rights had little meaning if it failed to recognize women's distinct experiences in the labor force. These experiences varied according to each woman's class status, family responsibilities, degree of union activity, and type of work performed. Smith understood labor laws as the most effective means to equalize women's place in the labor force. She fought vehemently for the passage of eight-hour, minimum wage, and health/hygiene laws to mitigate tenacious forms of gender-based exploitation that resulted in low wages, long hours, and limited job opportunities. She did not see such legislation as an indication that women were weaker than or inferior to men. Rather, she believed women's labor laws established the foundation of a women's labor movement that complemented the goals of male-dominated unions, while at the same time ensured that women's unique experiences as workers were integrated into the fight to establish standards in industry. Smith envisioned a society in which diverse interests, regardless of gender or class, worked collectively to build a partnership between labor, business, and government. This tripartite alliance, she believed, would not only strengthen the efficacy of individual groups, but society as a whole.

Because Paul's equal rights agenda fought to establish that women were the same as men under the law, it directly threatened the constitutionality of labor laws that recognized women's distinct experiences as workers. Her approach to women's equality contrasted starkly to the WTUL's view, and its closest allies. At a time in which Smith's approach to equal rights proved to be a unifying force among organizations such as the League of Women Voters (LWV), Women's Bureau, National Consumers' League (NCL), and American Federation of Labor (AFL), to name a few, Paul stood her ground and continued to develop a campaign first to gain passage of state equal rights bills, then to build momentum to gain passage of an ERA to the federal Constitution.

Paul's and Smith's debate over the meaning of women's equality raised a number of unresolvable issues that remain at the heart of current debates over

equal rights. These issues range from strategies to establish pay equity and eradicate workplace segregation to the creation of workplace policies that account for women's distinct experiences as workers. Most notable among these distinctions is the necessity to recognize women's responsibilities as primary caretakers, and ensuring that employers provide access to quality health care that accounts for women's unique health care needs. All of these issues converged in the debate over the ERA in the 1920s. Indeed, many of the same issues pursued by women's organizations today mirror the debate over the ERA in the early twentieth century, suggesting that the ongoing search for women's equality could benefit by reexamining the history of this issue. By considering the ERA debate in all of its complexities, especially the perspectives of women such as Smith who have been rendered invisible in historical analyses of the period, we may develop a more comprehensive assessment of the pros and cons of equal rights as a legislative strategy. In the process, we also may develop a broader understanding of how the ERA debate contributed to the evolution of legal strategies to advance civil rights and affirmative-action policies in the latter half of the twentieth century.

For thirty years, historians have portrayed the ERA debate as a feminist dichotomy pitting the radical NWP against the more conservative aims of the WTUL and its allies. This approach highlights how the NWP's forward-looking vision challenged antiquated and discriminatory definitions of womanhood. Alice Paul is heralded as an unapologetic martyr who devoted her life to overcome women's culturally ascribed roles and is, with few exceptions, recognized as the leading force in efforts to build momentum for policies that established full political and legal equality for women.[1] From the suffrage movement through the decades leading to World War II, Paul pushed to keep the national spotlight on the ERA, demanding that women be afforded the same opportunities as men.[2] But little attention has been given to why so many women dedicated themselves to preventing ratification of the ERA. Typically, ERA opponents are described as defenders of traditional domestic values and sanctity of motherhood.[3] A closer examination of Smith's career, however, also reveals a forward-looking vision for the nation. Her perspective helps unravel the components of a complex legislative strategy that attempted to circumvent the political and legal conservatism of the period, and establish government responsibility for the conditions of women's workplace participation.[4]

The NWP was not alone in its search for women's equality. A multitude of national organizations simultaneously developed and pursued multifaceted and overlapping legislative campaigns to achieve political and legal equality for women, oftentimes allying with one another to build a more powerful presence. The WTUL had for almost twenty years achieved tough legislative victories by advancing a view of equality that was anathema to Paul and her organization. This shaped the WTUL's mission to reform the conditions of women's labor through unionization and passage of protective labor legislation. By facilitating collective action

and workplace protections, they argued, working women were empowered to compete equally with working men. Because the NWP demanded that women were the same as men, passage of the ERA denied the validity of the legislative and legal strategies championed by organizations such as the WTUL. In addition to their conflict with the NWP, leaders of the opposition to the ERA fell victim to a scandalous claim that *they* were radicals who attempted to subvert the principles of democracy because they believed the state should assume an active role in regulating the conditions of the labor contract.[5]

Because the ERA debate involved freedom of contract and how to determine the appropriate degree of government intervention into the operation of business, it mirrored a larger legal debate that first took shape in the early decades of the twentieth century. A conservative legal doctrine, now known as legal formalism, dominated American jurisprudence from the post-Civil War period to the end of World War II. By chipping away at the Fourteenth Amendment, the U.S. Supreme Court sculpted social and economic policies that supported the unfettered growth of big business.[6] The Court also built alliances with the powerful monied classes that shared the desire to preserve the status quo through the perpetuation of laissez-faire individualism. As this legal principle reigned supreme, freedom of contract became the foremost of all individual rights, businesses were declared persons under the Fourteenth Amendment, and women were excluded from the Amendment's provisions.[7] Though Paul worked to remedy the latter, she also accepted the basic tenets of legal formalism, and her ERA campaign helped bolster the legitimacy and strength of this form of jurisprudence.

A group of lawyers developed an opposing view to legal formalism that was more responsive to the needs of a modern industrial society. Known as legal realism, this form of jurisprudence forged alliances among prominent constitutional experts, members of the social settlement movement, labor organizations, and social scientists. Each group shared a commitment to establish legal precedents that recognized the everyday circumstances of people's lives. Unregulated growth of American capitalism amounted to a "mechanical jurisprudence" that turned its back on the severe exploitation of unorganized labor, urban poverty and prevalence of disease, especially in large, overpopulated cities such as Chicago and New York.[8] Smith worked closely with the lawyers who assumed a leading role in shaping legal realism, most notably Roscoe Pound, Dean of Harvard Law School, and his protégé, Felix Frankfurter, ensuring that working women's interests factored into this new form of jurisprudence. These attorneys agreed with Smith's assertion that female-specific legislation, such as the Washington, D.C. minimum wage law for women, provided a foot in the door for establishing the foundation of a longer-term effort to transform legal thinking as it applied to women and the workplace, and balancing the interests of business with those of individuals.

Bringing a biographical approach to the study of legislative and legal strate-

gies used in the ERA debate creates a more diversified context of significance for what was at stake in the minds of its most outspoken leaders. Specifically focusing on Paul and Smith creates a case study to help identify the factors that have constrained efforts to achieve full political and legal equality between women and men in the twentieth century. This approach identifies major tensions between both women as a conflict over divergent class-based interests and political philosophies. Exploring their personal politics and different understandings of the role of the state also highlights their contributions to the larger legislative and legal debates of the period, including strategies to mediate between the rights of individuals and needs of the community, and the conflict between government responsibility and unregulated growth of business.

The debate over the ERA in the 1920s was a defining moment not only in the history of women's politics, but also in the evolution of legislative and legal conceptions of equal rights, workplace protections, and the move toward the welfare state. No single study has pulled all of these issues together into a comprehensive analysis and considered how women such as Paul and Smith were influenced and constrained by the discriminatory barriers imposed by the legal culture of the period.[9] Rather than explaining the ways in which participants in the ERA debate disagreed over the meaning of women's equality and negotiated their viewpoints within the established legal and political systems, most historians have relied heavily on the theoretical framework of equality versus difference. That framework accepts the ideal of formal equality without analyzing the political and legal limitations of the concept. With few exceptions, historians who use the equality versus difference approach to explain the ERA debate have established a hierarchical relation between each term in which difference is assumed to be subordinate to the principle of equality.[10] Though this approach has produced numerous important studies that have enhanced our understanding of the first ERA, it has, at the same time, concealed the exclusionary aspects of equal rights and refuted the complex legacy of early-twentieth-century social policy that recognized the differences between men and women.

Historians did not consistently challenge this methodology until the 1980s. Biographies of leading labor legislation supporters were particularly influential in creating a new context to understand the ERA debate. Such scholarship explains the interaction between individual reform interests and processes through which the personal is translated into political activism. Diane Kirkby's important study, *Alice Henry: The Power of Pen and Voice*, fills a significant historiographical gap, providing the most detailed analysis of the WTUL to date.[11] Through a biographical method, she situates Alice Henry, editor of the WTUL's monthly publication, *Life and Labor*, within a generation of professional women that directed its skills toward creating social change for the collective good. Using a biographical approach, she refutes the long-held belief that the WTUL turned to legislation only after achieving

limited success at organizing trade union women.[12] Legislative reform was central to the WTUL's mission from its founding in 1903, until 1951, when it ceased to exist as an organization. Kirkby also challenges critical interpretations of women's labor law advocates, refuting the assertion that they all sought to uphold Victorian notions of womanhood.

Studying Henry's career reveals how many women believed that women's labor laws were necessary because the economic system depended on women as a cheap, unorganized, and fluctuating labor supply. In addition, other WTUL members, and their allies, worked to advance women's "economic and political position in advanced industrialized America by establishing a system of industrial relations where the state was the third party to the labor contract."[13] This approach developed as a strategy to circumvent the conservatism of the legal system, which defined the freedom of contract as the foremost of all civil rights. Efforts to regulate the conditions of contract for both men and women were consistently deemed unconstitutional. However, the WTUL and its allies advanced a female-specific approach to regulating working conditions, finding that state and federal courts were more likely to affirm labor laws that applied only to women.

The most recent biography of Florence Kelley adds depth and dimension to Kirkby's study, identifying how proponents of women's labor laws shared a commitment "to turn the state into a positive instrument in the lives of working people."[14] By tracing Kelley's rise from a researcher and resident at Chicago's Hull House to the powerful position of General Secretary of the NCL, Kathryn Kish Sklar portrays Kelley as a woman who, like Henry, sought remedial legislation as an alternative to the late-nineteenth-century conservative judicial doctrine that "refused to recognize class as a valid basis for public policies." That strategy used sex-specific laws for the class-specific purposes of changing the jurisprudence of laissez-faire and its attendant protection of freedom of contract. By challenging legal conservatism, according to Sklar, Kelley worked to enhance women's economic status in the labor force and to restructure the relationship between the state, employers and employees.[15]

This book builds on current biographical analyses of the period by examining both sides of the ERA debate with a focus on its two leading figures. Using the biographical method to analyze the search for equality in the twentieth century shifts the debate's focus away from equality versus difference. Instead, a larger perspective is created that situates these women at the center of battles that have shaped American labor relations and that helped expand legal interpretations of civil rights in the mid-to-late twentieth century. While Paul's vision was widely rejected in the early twentieth century, forty years later, the next generation of women activists cast her as a role model for the women's movement because of her uncompromising commitment to the ERA. While it is true that Paul has significantly impacted the history of American women, the contributions of the

women who advanced the majority view of equal rights during the first half of the twentieth century have been overlooked. A biographical comparison of Paul and Smith helps create a more complete picture of the events as they unfolded. The following chapter outline is shaped by three primary issues—the impact of Paul's and Smith's different class backgrounds on their definition of equal rights, how their personal politics influenced their choice of organizational affiliations and constituencies, and the factors that shaped their political philosophies as they interpreted the role of the state.[16]

Chapters 1 and 2

Paul and Smith underwent a process of self-identification in reaction to the discrimination they experienced early in their lives. Chapters 1 and 2 explore their respective lives prior to the 1920s, addressing the factors that shaped their intense and subjective interest in equal rights. The first chapter traces Smith's transcendence from a rural, working-class background to the ranks of highly visible political activists who opposed the ERA. Though her personal papers were destroyed when she died in 1951, we know from her family history that memories of her childhood were flooded by her father's never-ending struggle to financially support his family. His strength and commitment to his wife and children motivated her to become the first woman in her family to seek gainful employment outside of the home.[17]

After accepting a civil service appointment, she moved to Washington, D.C., not only becoming financially self-sufficient, but also affirming her commitment to a strong work ethic and belief in the merit system—values she learned from her father. Though she moved fairly quickly up the ranks of the civil service, she eventually encountered severe gender discrimination that imposed a "glass ceiling" on future advancement opportunities. She refused to accept such limitations, resigned from her position, joined the ranks of the national suffrage movement, led by the National American Woman Suffrage Association (NAWSA) and then the organized labor movement. Galvanized by limited opportunities for advancement and inequitable salaries compared to her male counterparts, she fully devoted herself to advancing a legislative agenda that recognized women as permanent members of the labor force and their right to equal wages and equal compensation compared to men. She also became a leading force to establish cooperative relations among labor organizations, skilled and unskilled women workers, government agencies, and diverse reform groups.

Smith has been overshadowed not only by Alice Paul, but also by the more prominent women that worked closely with her, such as Margaret Dreier Robins, Florence Kelley, and Carrie Chapman Catt. And yet, these and other well-known

reformers of the early twentieth century relied heavily on her talents as a lobbyist, journalist, and trade unionist. She was an unassuming individual who did not lead mass demonstrations, parades, or other forms of public protests. Rather, Smith was a respected and passionate advocate who worked behind the scenes translating complex public policies, such as minimum wage laws, civil service reform, and the eight-hour day, into effective public education and advocacy strategies. Her written work gained coverage in prestigious national newspapers, including the *New York Times* and *Washington Post*, and in printed documents geared toward educating women about their rights as workers. She also frequently rose to the occasion as a capable public speaker, writing and delivering testimony before congressional committees, and addressing meetings of state and local organizations.

As an active participant in some of the most controversial legislative debates of the early twentieth century, Smith's viewpoints provide an insightful, compelling example of the diversity of women's reform interests. From NAWSA and the WTUL to the National Federation of Federal Employees Union (NFFE) and Women's Joint Congressional Committee (WJCC), Smith was moved by strong personal convictions of the need for reform in public and private employment in a way that equalized opportunities for men and women.[18] Her career demonstrates the centrality of class and economic issues in the women's labor movement and the importance of cooperative action in efforts to move a policy agenda. Unraveling the components of that agenda reveals the interconnected nature of reform efforts designed to establish government responsibility for the social and economic welfare of citizens.

The second chapter describes Paul as a woman of inherited wealth who enjoyed educational privileges that were unusual for either a man or a woman in the early twentieth century. She initially pursued a career as a social worker and teacher, professions considered acceptable for a woman of her class. She quickly disparaged social work as an inefficient mechanism for social change, because she viewed the poor as passive victims who did not actively seek to better their lives. When she learned of the militant, political, public protests organized by the Women's Social and Political Union (WSPU), Paul abandoned social work as a career and became engrossed in the effort to establish women's legal right to vote. Her commitment to woman suffrage was motivated not only by her loyalty to Emmeline Pankhurst, the WSPU's guiding force, but also by the need to expand the rights of the women of her class. To do so, she founded her own organization and worked to challenge discriminatory cultural and legal views of women for the remainder of her life.

These early experiences in Paul's life reveal the significance of class interests to her approach to equal rights. Examining the letters she wrote to her mother while in England, materials not yet used by historians, reveals a budding conservative political philosophy shaped by the belief that each individual had the capacity

to achieve his or her goals if they applied themselves. Trained in the new social sciences of the early twentieth century, she concluded that piecemeal legislation to remedy the conditions of labor and urban poverty was ineffective. Rather, she turned to political and legal strategies designed to bring about more immediate and pervasive change to women's lives. To accomplish her goals, she remained focused solely on the ERA and increasingly distinguished herself as a leader among the nation's elite women, especially upwardly mobile professional and business women.

Chapters 3 and 4

Chapters 3 and 4 situate Paul and Smith within the larger context of the early 1920s and examine how their respective organizations continued to pursue their competing equal rights agendas in the years following the suffrage movement. Between 1921 and 1923, the NWP and the WTUL experienced significant setbacks that impeded the success of their competing approaches to equal rights. Both chapters describe in parallel fashion how both organizations presented their objectives to the public and policy makers, particularly their media and lobbying strategies, as they struggled to move their legislative agendas forward. This approach also provides significant insight into how both women merged their personal politics into competing organizational affiliations, leadership styles, and political philosophies. Though Paul decided in the latter months of 1920 that the NWP would regroup under the same name and pursue first state and then federal equal rights legislation, she did not immediately go public with her agenda. Instead, she seized upon the excitement of the suffrage victory and convened a highly publicized national convention attended by representatives of leading women's organizations. At the convention's end, it became clear to participants that Paul had led them astray, producing a backlash that generated even more publicity for the NWP.

When Paul publicly announced the NWP's new objectives, the narrowness of her vision and the duplicity of her tactics alienated her followers, resulting in the dramatic decline of NWP membership from several thousand to a few hundred women. Despite this decline, Paul clung tightly to her individualistic approach to equal rights and cultivated the support of a small cadre of upwardly mobile and society women with the financial resources to keep the NWP afloat. During this period, the NWP's public image centered on dramatic pageantry that manipulated the historic and cultural symbolism of the women's rights movement for the political purposes of mobilizing women to support equal rights legislation. Paul's views, however, were not well received. To explore why, Chapter 4 compares Smith's activities during the same period, and sets the stage for understanding the larger legal issues that eventually emerged at the core of the ERA debate.

Smith was a living example of the competent and strong woman on public display through the NWP's pageantry. She rejected the bonds of domesticity and emerged as an upwardly mobile, financially dependent, uncompromising political activist who was respected not only among women's organizations, but also among prominent male leaders such as Samuel Gompers, President of the AFL, Jesse Adkins, President of the NCL, and Felix Frankfurter, one of the most noted attorneys of the period. Chapter 4 traces Smith's career into the 1920s, showing how her work with the WTUL and other reform organizations enabled her to reject the traditional gendered assumptions that shaped the lives of so many women, including those in her family. Smith's work also provided her with the resources to rise above the barriers of her working-class roots and to engage in pursuits to help other women achieve the same level of professional development and financial self-sufficiency.

As the legislative watchdog for the WTUL, Smith tracked congressional debates on the diversity of issues that affected working women's lives. She also played a key role in bringing the WTUL into a powerful collective agency of women that presented a unified front on Capitol Hill and exemplified the height of women's political influence in the 1920s. Based on her extensive participation in national legislative campaigns, Smith quickly emerged at the forefront of efforts to block the ERA. Though she agreed with Paul's assertion that women were entitled to the same opportunities as men, she believed that the ERA was too sweeping in its objectives and would have no significant impact in redefining women's role in terms of law or culture. According to Smith, any efforts to redefine women's social and economic status required piecemeal legislation that targeted specific issues, and ushered in change one strategic step at a time.

Chapter 5

As Paul and Smith assimilated their personal political agendas into their institutional affiliations, both accepted the principles of the legal system and supported legislation that incorporated their constructions of women into judicial interpretations of equal rights. The last chapter shows that as they debated the most effective construction of a stable legal subject, they accommodated their definitions of "womanly" behavior and interests according to the confines of the legal system. Paul wrote the ERA to provide legal representation for the interests of well-educated, professional women who successfully competed in the labor force for advancement.[19] Because she viewed women as the same not only to men but to one another, she isolated her organization at a time in which women's organizations were increasingly attempting to meet the diversity of interests that affected women's lives.

Conversely, Smith and her supporters were at the center of an historic shift in legal thought that moved away from more than fifty years of judicial conserva-

tism toward legal decision making based on the recognition of real-life circumstances that shaped people's lives. In the short run, Smith experienced significant setbacks throughout the 1920s, as conservative organizations, including the NWP, publicly attacked the credibility of the WTUL and its supporters. As a leading critic of women's labor laws, Paul allied with those who opposed government regulation of the labor contract. Though she recognized the ramifications of her actions, she refused to accept any obstacles that impeded her single-minded objective, passage of the ERA. For the time being, Smith's seemingly elusive search for equality lay dormant until the Great Depression and World War II generated a national crisis that forced policy makers to seriously grapple with the issues she had so ardently championed for fifteen years. In the long run, however, female-specific labor law played a key role in setting the stage for the creation of the welfare state and litigation strategies to advance civil rights in the 1950s and 1960s.

Neither Ethel Smith nor Alice Paul accepted hegemonic constructions of womanhood in any aspect of their thinking. They both recognized that women's labor force participation rates were dramatically increasing, and that working women were permanent members of the labor force. They both viewed political and legal reforms as the best means to equalize the playing field for working men and women. Paul's and Smith's definitions of equality were premised on shared assumptions concerning the construction of citizenship rights. Both argued that women were entitled to participate in the exercise of political power and adhered to conceptions of justice based on legal definitions of equality.[20]

Though Paul and Smith shared many of the same views, their competing political philosophies and class allegiances prevented them from finding common ground regarding the best methods to provide women with the same economic opportunities as men. Bringing a biographical approach to the ERA debate identifies both women as savvy politicians who knew how to negotiate male-dominated national political circles. As they vied for influence within the conservative political and legal culture of the period, their personal politics, organizational affiliations, and understanding of the role of the state prevented them from recognizing their shared concerns and respecting their differences. Their inability to merge their perspectives into a flexible, diverse strategy played a key role in prohibiting both women from achieving their legislative and legal goals in the 1920s.

"To the Victor Belong the Spoils"

The Merits of a Combined Suffrage and Labor Agenda, 1877–1920

Ethel Smith's home state of Illinois was a microcosm of labor protest, government corruption, and social reform. As the nation moved from an agricultural to industrial economy, state and local policy makers allied with industrial interests, maintaining the dominance of decentralized government and the political philosophy of laissez-faire individualism. With support from state officials, employers smashed existing unions and thwarted attempts at unionization through yellow-dog contracts and injunctions. In response to the repeated economic downturns, political and legal conservatism, and exploitation of labor that permeated the state's urban areas, Chicago became the site of a burgeoning reform movement that attempted to mitigate the unregulated conditions of a rapidly industrializing society. Such reform efforts brought short-term victories locally, but those who shaped and led these efforts rose to prominence by forging a national model of economic and legal reform designed to increase government responsibility for social welfare. Though Smith matured within the quiet solitude of rural Sangamon County, Illinois, she would later follow in the footsteps of these early reformers and emerge as a politically savvy and tenacious lobbyist, journalist, and trade unionist whose dedication to social reform placed her at the center of important early-twentieth-century legislative battles.

Smith's commitment to social reform bore direct relation to her father's persistent financial struggle. In her family history, completed in 1948, she remembered: "[I]t was always hard times with us." Her father, Richard Smith (1852–1910), waged a constant struggle in search of employment that paid him a living wage. He moved from job to job, working as a farmer, teacher, and deputy sheriff, and he even attempted to run a livery stable business. Despite his hard work, he was "not prosperous, never a money maker, and he never could provide for us as he wished."[1] Though a dual income would have alleviated some of his financial burdens, Richard Smith, like most men of his generation, identified as the primary breadwinner for his wife and children, and he would have deemed himself a failure if the women in his family worked outside of the home.

As the eldest child raised in a modest, working-class family, Smith learned the vicissitudes of economic struggle and value of hard work from her father. Her childhood memories were shaped by visions of his strength, a refusal to sacrifice his values, and a commitment to his family. She remembered in vivid detail the many times her father drove her around the county fulfilling his duties as deputy sheriff. She wrote:

"I was small enough to perch beside him on the little seat of the two-wheeled sulky, behind our little brown mare Dolly, with the white star in her forehead. Life was very wonderful to me, exploring the world with my father, and I remember those days very well." As they rode around town, her father told her the "history of the old Sangamon River, the covered bridges and townships in the county," not only creating a sense of adventure but also instilling in her a strong personal desire to long for more than marriage and to become financially self-sufficient.[2]

Smith's eagerness to find a job rose to new proportions following her graduation from high school in 1895. Through persistent cajolery, she finally convinced her father that "it was becoming quite a common thing for girls to earn a living—that is, they became teachers or stenographers." She remembered, "At first father didn't want me to do anything—he felt it a reflection upon himself. But within a year or so I persuaded him to let me take shorthand lessons." Over the next two to three years, she worked several stenography jobs and used the experience to refine her organizational and management skills so that she could market herself for better-paying jobs. Never content with secretarial wages or responsibilities, Smith pursued a more rewarding, better-paying position in the civil service, embarking on an adventure that she had never imagined would be possible.[3]

Smith's civil service career began when she traveled to Chicago to take the examination that would qualify her as a stenographer in the Census Office. After passing the exam, she remembered: "I . . . was sworn in as a stenographer in the Office of the Chief of the Division of Manufactures in the 12th United States Census at $600 a year." She maintained this job for only ten months, however, because the Census Office was not yet a permanent institution.[4] After she passed the civil service examination for stenographer and typist positions in 1901, the Civil Service Commission "transferred [her] to the Bureau of Fisheries as a clerk at $720 a year" and assigned her to stenographic duty in the Office of the Chief of the Division of Scientific Inquiry.[5] Within a few months, she was promoted to the position of private secretary to the chief.[6] At this point she had moved up to $1,000 a year, which was to say the least, better than the $500 Springfield offered then. Smith's salary placed her within the ranks of the highest-paid women in the civil service.[7]

Her tenure as a federal employee coincided with highly discriminatory employment practices, inconsistent wage standards, and advancement opportunities that oftentimes depended more on political connections than on the quality of work performed. The passage of the gag rule in 1902 designated department heads with primary responsibility to determine hours of work and wage levels for their employees. In addition, department heads could determine the sex of eligible candidates, contributing to the exclusion of women from some branches of the civil service and preventing their advancement into higher-paying positions. Despite the persistence of gender discrimination, civil service employment created new professional opportunities for women at the turn of the twentieth century, including working-class

women such as Smith, providing them with the financial means to achieve white-collar status.[8] Smith's stenographic skills, combined with her youthful optimism and determination to succeed, helped her initially escape the discriminatory pay inequalities and occupational segregation that shaped the workplace experiences of so many women and men employed in government service. Her position in the U.S. Fish Commission was originally designated as a man's job. Fortunately, the Director of the Division of Scientific Enquiry rejected the first two rounds of male applicants and instead decided to hire a woman as his personal secretary. The Civil Service Commission then forwarded the names of three women to the chief and, indeed, Smith received the job. Smith's supervisor afforded her, to a great extent, the opportunity to explore her interests and to develop her abilities.[9]

As Smith worked her way through the civil service ranks, the women with whom she would later collaborate forged a reform movement that first took shape in Chicago's Hull House, a social settlement founded in 1889 by Jane Addams and Ellen Gates Starr. Located in one of Chicago's poorest neighborhoods, the middle-class women who resided at Hull House worked directly with the urban poor, studied the conditions of wage labor, and developed legislative and legal remedies to alleviate the most severe forms of exploitation. Based on empirical research and direct interaction among the neighborhood's impoverished, these women built the foundation of a reform movement dedicated to remedying unhealthful working conditions, long hours of work, and low wages. At a time in which women were largely excluded from public policy debates and the philosophy of laissez-faire individualism reigned supreme, achieving these goals necessitated acceptance into the male-dominated political and legal circles of the period. This required a pragmatic strategy that did not overtly reject their culturally ascribed roles as women, while at the same time constrained the unregulated growth of industrial capitalism and circumvented the hegemony of conservative political and legal thought.[10]

The women who launched this reform movement called for the creation of workplace standards that included healthful working conditions, a fair wage, and the eight-hour day. Their vision of the state as an arbiter of social justice, however, starkly contrasted with the long-held tradition of the nonregulatory state. As they pursued state-level legislation that regulated the working conditions of men and women, they were stymied by a legal tradition that defined freedom of contract as the foremost of all individual rights. Because state and federal courts consistently interpreted class-based legislation as an infringement on the constitutional right to contract, these women quickly determined the need for a new strategy to advance their reform agenda. From the 1890s into the early twentieth century, they developed a network of activists that slowly built national momentum for labor reform designed to balance the rights of workers with the economic interests of their employers. To accomplish their goals, gender became a surrogate for class legislation to build the legitimacy of government regulation of the labor contract.[11]

By creating and advancing a female-specific strategy, these women emerged as an effective lobby group that wielded substantial power. Through their efforts, they began the process of redefining the role of the state, creating government agencies such as the Children's Bureau in 1912, the Women-in-Industry Service during World War I, and later the Women's Bureau, a battle in which Ethel Smith emerged as a leading figure. In effect, these women not only advanced strategies to reform private employment but also to overcome the exclusionary aspects of civil service employment, while at the same time creating a new arm of the state to ensure that women's interests were represented in the political process.[12]

As the movement for women's labor laws emerged on the national scene, Smith underwent a period of profound personal growth and fulfillment. For three summers between 1901 to 1903, she assisted the director of Scientific Enquiry as he fulfilled his responsibilities as the director of the Commission's laboratory in Woods Hole, Massachusetts. Here, for the first time, she was exposed to academic thought and investigation. During these summers, Smith worked as her supervisor's secretary and as the librarian for residence research workers. As a librarian, she interacted directly with the laboratory's researchers, remembering that the experience was "as good as a course in biology." She wrote:

> Those three summers were a new era for me. Here was New England with its history and traditions . . . here was the sea, with its vast distances, its mysteries and its ships—all utterly new to me. Nor had I known anything of college life. Woods Hole . . . was (and is) a center of marine biological research. It drew professors and students from many universities for summer courses . . . and for independent research. There was a delightful social life, as well as the learned one, and a whole new aspect of the world for me.[13]

Government service offered multiple new experiences for Smith, unknown to her parents. Woods Hole exposed her to the academic world of research and afforded her the opportunity to develop the research, analytical, and publishing skills that were crucial not only to further her advancement in the civil service but to build her self-confidence and diversity of interests. By 1904, her duties moved beyond administrative when the chief asked her to assist the editor of the Commission's publications. During the next four years, she combined the responsibilities of both positions, learning about writing and editing "chiefly . . . scientific (biological) and commercial bulletins."[14] She was promoted to the editor's position when he retired in 1906, and she held this position for eight years.

To become better qualified to fulfill her new responsibilities, Smith registered for courses at George Washington University during the 1906–07 and 1908–09 academic years. During this time, she attended evening classes in composition, literature, and criticism.[15] Frequently, federal employees used their salaries to pay

for professional training in such areas, for example, as law or medicine.[16] Smith did not, however, feel compelled to seek a professional degree. She had already become the first woman in her family to work outside of the home, and clearly she felt gratified by the opportunities afforded her as a civil servant. To Smith, college training would enhance her performance as the Commission's new editor. It would create an opportunity—much like her Woods Hole experience—to expand her analytical and organizational capacities. At this point in her life, she had every reason to believe that there were no limits to her professional growth. She embodied the values of the merit system, embracing the belief that a job well done would be recognized by her superiors. These beliefs, learned from her father's example, comprised the core of her most cherished values. Commitment to her work created a sense of dignity and distinction, of credibility and self-worth. She refused to compromise these principles, regardless of the circumstances.

After two years of experience, the completion of college courses, and continued dedication to her work, Smith's frustration grew because her salary level had not reached her male predecessor's. Initially she eagerly accepted the position without an increase in pay. As time passed, she explained:

> I had an increase in pay eventually to $1,200 and finally to $1,600, which was the maximum that I have ever received in Government service, although I was doing the work of this man, and not only his work but much of my own inherited from my previous assignment. He, of course, was underpaid for his work at $1,800, but I never received as much as he received.[17]

After supporting her advancement in the civil service for so many years the commissioner capped Smith's yearly salary at $1,600. Though he had the authority to determine personnel policies, department heads were constrained by antiquated wage scales that were fixed by a congressional act passed at the end of the Civil War. As the civil service expanded, new bureaus and departments were established, and pay for employees was fixed by new laws and regulations that did not account for wage levels in other branches. In addition, wage scales also were based on the gendered assumptions that men were the primary wage earners, and that women entered the labor force only until marriage.[18] Therefore, the concept of pay equity for men and women performing the same types of work had not yet been identified as a viable issue in the development of new federal employment practices.

In 1912, when Smith once again was passed over for a promotion, she confronted the commissioner with the argument that she was entitled to the same rate of pay as her male predecessor. When pressed about the issue, he blatantly told her that he had no intention of promoting her any further, and that she was "getting as much as any *woman* could expect." Instead, he decided to promote "poor old Jackson," even though "he's no earthly good to us." Despite his poor qualifications, the

commissioner explained he was more deserving than Smith, because he had a wife and child to support.[19] The commissioner's attitude infuriated Smith, not only because he ignored her qualifications but also because he assumed that only men had the capacity and responsibility to become primary breadwinners for their families. The fact that she and her sister Florence shared an apartment in northwest Washington, D.C., maintained their own expenses, and assumed primary caretaking responsibility for their mother from 1910 to her death in 1925 only added insult to injury.[20]

She was, without doubt, proud of her capacity to achieve financial independence, without sacrificing her personal values. Frustrated by the obstacles that prohibited her from advancement in the civil service, she took the initial steps to become active in efforts to redress widespread inequalities affecting women. In 1912, she began volunteering in the suffrage movement in the evenings. Two years later, she resigned her commission and devoted her attention to social and economic issues impacting women's rights and labor reform.[21] In 1914, she accepted a paid position as secretary for the Congressional Committee of the National American Woman Suffrage Association (NAWSA). Founded in 1890, NAWSA emerged in the early twentieth century as the mainstream woman suffrage organization. Under the leadership of Anna Howard Shaw, followed by Carrie Chapman Catt, NAWSA worked within the existing political system, and patiently attempted to establish bipartisan support for its agenda. Its members pursued a pragmatic agenda that focused on three primary approaches: (1) building the support of President Woodrow Wilson and Congress through lobbying and deputations; (2) working through state affiliations to mobilize public support for local suffrage referenda; and (3) generating public education and media to increase the visibility of NAWSA and the Nineteenth Amendment.

Smith joined the Congressional Committee following a heated period of dispute among members of the organization's more militant sect, led by Alice Paul, the chair of its Congressional Committee. NAWSA's policy of persuasion alienated Paul and her supporters, who preferred to directly challenge mainstream politics. She split from NAWSA in 1914 to launch her own organization that evolved into the National Woman's Party. Paul's break from NAWSA created significant turmoil within the organization, but at the same time created it significant opportunity for Ethel Smith. As the committee's new chair, Ruth McCormick selected Smith as secretary. In this capacity, she was responsible for more than administrative duties. She worked as a state organizer for the committee, tracking congressional votes on suffrage and reporting on state organizational activities.[22]

Though she had never engaged in local organizing, the analytical and editorial experience gained during her civil service career served her well as she explored and diversified her professional talents. As one of her many responsibilities, Smith

carefully studied and documented the activities of Alice Paul and her organization. During her travels, Smith learned that Paul had "called upon suffragists everywhere to resign from the National" and portrayed the organization as weak and ineffective compared to the NWP. When NAWSA's leadership confronted Paul regarding "her avowed intention of smashing the National," Smith was shocked by Paul's evasive attitude and did not understand why she would so brazenly attempt to undermine NAWSA's authority.[23] She concluded that Paul was more intent on pursuing her personal interests than engaging in a cooperative movement to bring the suffrage movement to a successful conclusion.[24]

In her family history, Smith did not emphasize this aspect of her participation in the suffrage movement. Though she had clearly developed a critical interpretation of Paul's leadership and tactics, she did not at this point feel compelled to devote all of her energy to combating the fallacies generated by NWP propaganda. Instead, she began to develop a broader understanding of the significance of woman suffrage to advancing the rights of women. She wrote, what "seemed to me most worthwhile was to work for the betterment of the conditions of human life, and closest to me of all were the problems of women who work for their living."[25] American entry into World War I in April 1917 created new opportunities for Smith to fully develop and articulate her beliefs.

In accordance with its pragmatic approach to politics, NAWSA pledged support for American intervention in the war, viewing the situation as an opportunity to bring new recruits into the suffrage movement. As women eagerly entered the workplace to replace the men who had gone to war, NAWSA's members assumed leadership roles within war-time agencies and emphasized the need to protect women who were new to the labor force from unnecessary exploitation. Smith emerged as a prominent figure in NAWSA during this time, based largely on her profound commitment to link woman suffrage with efforts to protect existing labor standards and to prevent the exploitation of working women. Beginning in April, Smith worked simultaneously as Director of NAWSA's Industrial Committee and Publicity Bureau.[26] Under her leadership, the Industrial Committee safeguarded industrial standards during the war. She explained that the "sudden rush of thousands of women workers into new fields" created the "danger of a breakdown of the standards protecting both women and men in industry." She organized "a systematic propaganda campaign against excessive overtime and underpay in industries where women are employed," that not only targeted working women and suffrage activists but also state policy makers and business interests.[27]

In her "Letter to Wage-Earning Suffragists," Smith warned her readers that employers were using the wartime emergency to ignore labor laws that protected the wages of men to increase their profits. She urged wage-earning women to use this opportunity to defend and protect current wage standards and to demand the application of those standards to their wages. She proclaimed that women who

were eager to do their patriotic duty by assuming the jobs worked by military men should not undervalue their own skills and "should not do men's work for less than men's pay." She believed that wage-earning women should not only look at themselves as women but rather as competent individuals whose skills entitled them to a fair return on the work that they did.[28]

Smith believed that women who were new to the workplace should engage in a cooperative effort to challenge those who discriminated against them.[29] Based on this belief, she attempted to rally suffragists behind efforts to protect the rights of these women through media and publicity; she argued that the need for women's labor during World War I created an opportunity for suffragists to extend their organizational experiences and interests into other areas that warranted legislative change. She urged suffragists to convey the lessons they had learned through collective action to women who were new to the labor force, emphasizing that "this is the hour when those who already understand these things can do much to help their sisters who are less experienced." According to Smith, women workers who were unorganized were "unwittingly one of the most serious dangers to the standards of industry the world over. Let us, as suffragists, make organized demand for those equal economic rights which will enable us to remove this danger to our country's welfare."[30]

She not only called upon NAWSA members at the state level to protect the rights of working women but also local government and businessmen. "Of employers we ask that they shall not lengthen the working hours of women, and that women who take the places of men in business, offices, stores, factories, or any other occupation shall be paid at the same rate as men." Smith proclaimed that the work performed, not the sex of the worker, should determine the rate of pay. "We recognize also the unfairness to men and the injury to industrial standards in general resulting from the competition of low-paid woman labor. Furthermore, the women who take men's places in the war emergency have likewise to bear men's burdens in the support of their families."[31] She emphasized her belief that equal pay for equal work raised standards of women's work and helped prevent the use of women by employers to undercut the standards already achieved by men in the labor movement.

As Smith articulated the link between the interests of suffragists and women workers, she lost sight of the proposed Nineteenth Amendment. NAWSA President Carrie Chapman Catt told Smith:

> I think a very great deal of the press work and perhaps all of it that has gone out concerning different phases of women's work has been helpful, but I question very gravely the advantage of giving the impression that the National Association is "putting its fingers in every possible pie" in Washington when nothing goes out about the Federal Amendment.

Catt respected Smith's research and journalistic capabilities, commenting on how "excellently written" her articles were. She told Smith that "publicity, as you know, is not my strong point." However, Catt felt compelled to ask her to "put more attention on press work for the Federal Amendment and less on the other at the present."[32] Smith, of course, complied with Catt's request, but at the same time she stepped up her activism in the labor movement.

Smith's increasing participation in the labor movement marked a pivotal moment in her life, creating the opportunity for her to combine her field organizing, lobbying, and media talents with her personal politics. Though she remained devoted to the suffrage movement, she chose to join forces with labor unions and organizations that promoted collective action to educate and unite working men and women. Most importantly, these groups created and advanced legislative strategies to establish modern standards governing the workplace and state regulation of issues that specifically impacted working women. She supported labor legislation that protected working men, but for Smith, women were in greater need of such protections because they were new to the labor force, not fully integrated into the mainstream labor movement, and more susceptible to discrimination. From this point on, she devoted herself to the principle of equal compensation for equal work, irrespective of sex, not only to protect the rights of individual workers but also to benefit society as a whole.

In November 1917, she assumed an active role in NFFE, the first national union of federal employees founded in 1917 at a meeting of delegates from local federal employee unions, Samuel Gompers and representatives of the AFL. NFFE President Luther Steward never lost sight of the organization's trade union character, consistently emphasizing the common interests among civil service employees with all wage earners and the power of collective action to provide mutual support for their common goals. The organization engaged in a wide variety of activities to establish modern standards of wages and working conditions in the civil service. From petitioning Congress and building widespread public support for proposed reforms to creating effective working relations among government officials and employees, NFFE was free to pursue legislative reform, provided that its members never engaged in or supported strikes against the government.[33]

Reclassification legislation dominated NFFE's legislative agenda, because the "Federal civil service is run on antiquated, unscientific lines."[34] Government employment expanded haphazardly, lacking standards in the establishment of wage levels, hours, promotion opportunities, and benefits. New grades and positions with new salary levels were created at each session of Congress. New bureaus and even new departments were set up, and pay for their employees was fixed by new laws or regulations that took little account of the standards in other branches.[35] NFFE believed that reclassification legislation would create a more efficient civil service system that would benefit both employees and the federal

government.[36] Through its Legislative Committee, the organization pursued a re-
form agenda designed to "advance the social and economic welfare and education
of Federal employees" and to "perfect systems that will make for greater efficiency"
in the civil service.[37] It is not surprising that NFFE appealed to Smith. She was
among the members selected to the Legislative Committee, a responsibility that
afforded her the opportunity to actively participate in lobbying efforts to pass re-
classification of civil service legislation in Congress. She assisted committee mem-
bers in the organization and implementation of NFFE's legislative program,
sought cooperation and support from other reform groups, and helped keep sys-
tematic records of congressional opinions regarding civil service reform.[38]

Participation as a member of NFFE's Legislative Committee provided
Smith with the opportunity to speak publicly about the importance of collective
action and the need to protect the interests of women employed in the federal ser-
vice and establish wage standards that were equitable for all civil service employees.
Based on her fourteen years of experience, Smith proclaimed, "[T]here is a most
startling and I think most shameful discrimination against women. I say shameful
because it is our Government that is doing it." She believed the government had
the responsibility to ensure fair employment standards for both men and women,
but instead "pays women less than it pays men for the same work, merely for the
reason that they are women, and it frankly says so. And after women have been ap-
pointed, they are denied advancement and choice of position, frankly for the rea-
son that they are women, and that men, by reason of being men, should have the
preference."[39] Under such circumstances, women needed the protections afforded
by reclassification legislation "because there is in the Government Service so much
that is unequal." Though the proposed reclassification bill would benefit men who
experienced workplace discrimination, Smith emphasized that the "problems of
the women who work are more acute than the problems of the men. The women
are massed in the lower grades of pay. There are about 30,000 in the Government
service in Washington and you will find that their average salary is $200 less a year
than the average salary of the men."[40]

Smith framed her arguments within a context of tremendous hostility re-
garding the implementation of civil service reform. "When the Civil Service was
established the Federal employee was hedged about with restrictions designed to
prevent him from engaging in "pernicious political activity."[41] Two presidential
"gag orders" proclaimed that civil service employees were "forbidden . . . to solicit
an increase of pay or to influence . . . in their own interest any other legislation
whatever . . . before Congress . . . on penalty of dismissal from the Government
service."[42] The integration of men and women into the civil service bred even more
tension. Working women challenged the "male breadwinner ethic" and middle-
class standards of propriety. To discourage women from seeking employment as
government workers, supervisors offered inequitable salaries, denied women the

same examination opportunities, and restricted their advancement opportunities to certain classifications.[43] Smith's emphasis on women's rights only added complexity to an already tense situation.

Despite innumerable obstacles hindering federal civil service reform, NFFE's membership increased by more than 300 percent between 1917 and 1919, and more than 200,000 federal employees received salary increases.[44] Among its greatest achievements was the establishment of the Congressional Joint Commission on Reclassification of Salaries, "created by Congress in 1919 to determine what reclassification and readjustment of compensation should be made so as to provide uniform and equitable pay to Federal employees."[45] Once established, the commission at once selected an expert group of men in the field of personnel to aid in its investigation. Smith believed that the commission should provide special consideration to women's experiences as federal employees. Though she felt confident "in the fair-mindedness and fair purpose of the Commission," she asked Edward Keating, the commission's secretary, to appoint "*a woman expert for consultation on all matters of policy and method,* not only affecting women in the Government service" but also "in the same way as it consults with other experts who are men."[46] Smith requested that after the commission "assembled the facts upon which it will base its reclassification, a special study be made of those facts as recorded for the women employees." She believed that only the representatives of women workers could accurately evaluate the conditions of women's work. Though Keating was sympathetic to Smith's viewpoint, he did not convince the commission to include women experts in its membership.[47]

Smith continued to publicly push for the inclusion of women in decisions to reform civil service employment. She argued that long and bitter experience had taught women that men do not understand their problems as members of the labor force, and "with all due respect to the fairest of men, and with the utmost confidence in their good intentions and sincerity, we know that woman's interests are not safe in their hands alone." She believed that an effective and comprehensive program of reform would be impossible if women were not provided with equal representation in all policy making and executive agencies.[48]

Smith attempted to raise awareness of the extent to which women were excluded from civil service appointments. Statistics then showed that women were excluded from 60 percent of civil service examinations because they were women.[49] She proclaimed: "[T]his is outrageously unjust, undemocratic, stupid and unnecessary." As a firm believer in the merit system, Smith argued that if women did not qualify for the job in question, the civil service examination would reveal that fact, and their names would not reach the register. "If they can fill the job, and the examination reveals that fact, they are entitled to certification with eligible men, and should be appointed or *rejected according to their fitness as shown by examination.*"[50] Smith did not argue that women should receive special protection. She believed that

equal competition would provide women the opportunity to demonstrate their abilities as workers. She argued that federal employees, both men and women, did not seek "special privilege" or to be "put . . . in a class apart from the general public." Instead, she wrote: "Give us a square deal and keep your favors."[51]

Smith pondered how men consistently justified the exclusion of women from entrance to many examinations and from better-paying jobs. She contended:

> Very largely, I think, the discrimination of women is involuntary, and represents merely men's instinct and habit of mind. The world was made for *man*, you see, and it was upon second thought that women entered it. Not even yet do most men freely concede our right to economic freedom—our right to work in fair competition with men. The normal order, as they see it, is for women to be limited in opportunity, limited as to field, limited as to pay. The big things, the creative jobs, and the best paid jobs, by divine right belong to men and are outside women's sphere.

Smith complained that it never occurred to the bureau chiefs in Washington "that some women might be equally capable or more so, that she might be equally in need of a job, since it takes just as much to support women's families as it takes for men's families."[52] She also emphasized that efforts to strengthen the merit system and ensure standards in the federal civil service would fail unless men accepted the fact that women were permanent members of the labor force, that they were capable of financially supporting themselves, and regularly contributed to the economic well-being of their families.

Smith's outspoken commitment to "equal rights, equal opportunity, [and] equal compensation" for working women impressed Margaret Dreier Robins, President of the WTUL, so much that she offered her two part-time paid jobs as Executive Secretary for its Washington Committee and as Resident Secretary for its National Legislative Committee. Smith accepted both positions and easily combined her newfound responsibilities with those as a member of NFFE's Legislative Committee. With the WTUL, Smith found work she "could do with zest, and . . . found many of the most vital associations and cherished friendships" of her life.[53]

Founded in 1903 by William English Walling and Mary Kenney O'Sullivan, the WTUL worked closely with the social settlement movement, especially in Chicago and New York, to unionize working women, promote labor legislation, and educate working women about their rights as workers. The WTUL also became an affiliate of the AFL. According to its constitution, drafted by prominent social settlement activists, the objectives of the WTUL included serving the "interests of wage-earning women, to acquaint the public more fully with the unhealthful and sometimes shocking conditions under which women often were employed . . . to assist women in organizing for the purpose of securing better working conditions, and

also to obtain improvements by means of legislation."[54] At first, the organization lacked effective national leadership. Robins, without question, filled that void. She initially worked closely with the middle-class settlement workers who founded the organization but ultimately focused on promoting wage-earning women, who quickly dominated the WTUL's ranks, to positions of leadership.[55]

In addition, she worked to build the confidence of wage-earning women, and was not afraid to associate the WTUL with militant labor protests. Most notably, during the Shirtwaist Strike in 1909, the affluent members of the WTUL walked the picket line, endured threats from the crowds and police, and were arrested. Their elite social status, in addition to their financial resources, brought media attention to the strike and provided the resources to keep the demonstration moving. The WTUL provided bail money for arrested strikers and created an information bureau that generated sympathetic media and public support. As the WTUL matured, Robins led the move toward a broader organizational platform. This included developing leadership among women workers to achieve equal pay for equal work and the eight-hour day and securing representation of women on industrial tribunals and public commissions. Most significantly, the WTUL adopted the strategy of pursuing female-specific legislation to achieve its objectives of equal pay for equal work, irrespective of sex.[56]

At its 1909 convention, the Legislative Committee issued a report summarizing the need for legislation. The report stated: "We believe that the organized women, who have the power because of their organization to contract collectively for their labor, are bound to secure protection for their weaker sisters and brothers and to demand that the state secure for all conditions that will safeguard the health of the workers and the welfare of future generations." The committee outlined a legislative program designed to protect wage-earning women, "because the mass of them are young, between 16 and 21 years, inexperienced, unskilled, without the . . . power to bargain on equal terms with their employers, for, while the employer has the power to wait, these girls are helpless because of the struggle for a mere existence." This legislative program contained a series of measures "to safeguard the health of female employees," such as the eight-hour day, elimination of night work, protected machinery, an increased number of women factory inspectors, and a legal minimum wage in sweated trades. By 1920, the WTUL had 600,000 affiliated members organized in twenty local branches and had substantially diversified its agenda.[57]

When Smith joined the WTUL two years prior, she played a key role in promoting organizational growth and diversifying the WTUL's legislative agenda. Through its Committee on Legislation, chaired by Agnes Nestor, Smith assumed primary responsibility for operating the WTUL's newly formed Legislative Department in Washington, D.C. The Washington Committee, as it was called, became the WTUL's "instrument for furthering beneficial legislation in Congress, and to

becoming a center of nation-wide propaganda on behalf of wage earners."[58] As a member of the WTUL's national Legislative Committee, Smith earned a reputation as the organization's legislative watchdog and as an effective lobbyist for minimum-wage laws, the creation of a Women's Bureau in the Department of Labor, and the eight-hour day. At the same time, her responsibilities as Washington Committee secretary provided her with the opportunity to forge a well-defined publicity agenda for the WTUL. Her primary responsibility included educating working women in Washington, D.C. specifically about the power of unionization.[59]

Smith immediately built the case for the creation of a national publicity service to build support for the WTUL's reform agenda. At a 1921 Executive Committee meeting, she argued, "[E]veryone of us knows that organizations that get before the public most often in a creditable way are the organizations that grow." She continued:

> [W]e know that nobody, not even our own members fully understand our story unless they hear it in every possible way; we know that the general public, which is the audience we must reach, is slower still to understand. . . .Whether they admit it or not, people *do* believe what they read in the newspapers. Therefore the newspapers are the *most* important medium of communication for us, and money spent for an efficient League press service is money well spent. Such a service would supplement every other department of the League's work.[60]

Smith's arguments were well received, as was the national publicity campaign she orchestrated. Because of her talents, the WTUL reached more than 1,000 newspapers, keeping the WTUL's activities before the public and reaching individuals who they may not have reached through on-the-ground organizing. Through the media service, Smith received coverage in such prestigious national newspapers as the *Washington Post* and *New York Times*. In addition to reaching a national audience, she also tailored her written work to capture the attention of the WTUL's primary constituency through its publication, *Life and Labor Bulletin,* and NFFE's newspaper, *The Federal Employee.*

In the period 1918–1920, Smith produced articles that demonstrated her commitment to the establishment of pay equity in government and private employment. During this two-year period, she strongly and consistently supported labor protests and legislation designed to establish a legal minimum wage. Corresponding with her concern for the establishment of a living wage, Smith also called for "a woman's movement within the . . . labor movement" as a "necessary and inevitable" outcome of the "general movement for political democracy."[61] In May 1918, she published a series of articles that described the strike conducted by eighty nonunion women cigar makers in Washington, D.C. from March to May 1918. The WTUL's

Washington Committee, including Smith, assumed an active role in mediating the dispute between the women workers and their employer, Henry Offterdinger, the owner of the largest cigar factory in Washington, D.C. According to Smith, Offterdinger refused to increase the pay of his women workers because "of the increased cost of his materials." She criticized him for being impervious to the needs of his workers, accused him of operating a "parasitic business, subsidized by the families of his employees," and claimed that his business had "no moral right to exist."[62] Smith believed that employers were responsible for providing a living wage for their employees and equal pay for men and women. With the help of the WTUL, the women cigar makers' demands were met.

Smith described the women cigar makers' strike in Washington, D.C. as a successful example of cooperative action. With the help of the WTUL's Washington Committee, the women strikers were introduced to Joseph Dehan, a representative of the Cigar Makers International Union, and Samuel Gompers, "who took steps at once to organize and secure proper affiliation for the plucky but thus far isolated group of strikers."[63] She also argued that the cigar makers' strike was a situation of "interest and concern to our membership, since it involves three basic principles—collective bargaining, minimum wage, and equal pay for equal work, regardless of sex." Smith wrote that Rebecca Perry, the leader of the women strikers, along with officers of the WTUL, investigated the wage differentials between men and women employed in Offterdinger's factory. The outcome of such inquiries revealed that women cigar makers were paid by the week, while the men were paid by the piece. According to Smith, the support of the WTUL and the Cigar Makers International Union enabled the women strikers to play a key role in the struggle to establish equal pay among the sexes in the workplace.[64] In May, Offterdinger conceded and fulfilled the strikers' demands for "better wages, equal pay for equal work, improvements in sanitation and the right to organize." Smith proclaimed that the victory was "of great significance to women workers in the District of Columbia, where the prevailing wages for women were notoriously low."[65] Overall, she believed that the strikers "learned what organization means" and the importance of a "solid front," not only for better wages, but for "self-government in the workshop."[66]

In June 1918, Smith's focus shifted from wage-earning women in private employment to women in government service, turning first to writing articles that exposed the inequitable working conditions endured by the women in the Bureau of Engraving and Printing.[67] The bureau employed more than 4,000 women, the largest number of women in any branch of the civil service. Their responsibilities included making federal paper currency, liberty bonds, and postage stamps.[68] Through her written work, Smith emphasized how poorly paid these women were compared to their male counterparts. She wrote, the "record of the Bureau of Engraving and Printing, so far as its women employees are concerned, has been one

of notorious overwork and underpay." These women earned, on average, less than fifty dollars a year and had not received an increase for salary in fifteen years.[69] In one of her articles, Smith cited Agnes Nestor, chair of the WTUL's Legislative Committee:

> Men who wipe machines in the Bureau of Engraving and Printing get better pay than the women who operate those machines. Men who carry the product of the machines from one place to another in the building receive more than the women who work those machines. Messengers, ink carriers, waste paper sorters, stablemen, drivers, who are men, receive better wages than do the women who help to make, examine, and are responsible for the perfection and integrity of the count on American paper money, stamps and Liberty bonds.[70]

As the "largest employer in the District and the largest employer in the world," Smith argued, the government held the responsibility to ensure that men and women received equal compensation for equal work.[71] To achieve that goal, however, Smith recognized that women needed to unite to demand to be recognized as competent participants in the labor force. The battles waged by the Bureau women led to one of the early collaborations between the WTUL and NFFE.

Though the Bureau women were organized in Federal Employee Union 12776 of the AFL, they turned to the WTUL for assistance in waging a protest to demand higher wages. Representing the WTUL, Smith "joined hands in the fight" to demand pay equity for the women in the Bureau of Engraving and Printing, helping them organize a publicity campaign to "bring the Bureau women's case before the public and the Treasury Department (of which they [were] a part.)"[72] In addition, Agnes Nestor asked the Secretary of the Treasury to recommend to Congress an increase in salary for the women in the Bureau of Engraving and Printing. Specifically, she requested "a minimum of $75 monthly." The Treasury Department, with the approval of President Woodrow Wilson, agreed. However, Swagar Sherley, chair of the Appropriations Committee in the House of Representatives, refused to uphold the Treasury Department's request.[73]

Smith followed congressional debates over the appropriation in both the House and Senate Appropriation Committees. She wrote that under the leadership of Representative Sherley, the House voted to cut the Treasury Department's original suggested appropriation from $669,000 to $200,000. She reported triumphantly that the Senate Appropriations Committee voted to restore the original suggested amount of $669,000. In the end, according to Smith, the "conferees compromised, as not infrequently happens, and the bill as passed carried but $330,000 for the increase, or about half the original figures." Nonetheless, she argued, the "fact that any increase at all was secured counts . . . as an important victory for the

allied forces" in behalf of the women employed in the Bureau of Engraving and Printing. She believed that the struggle "demonstrated once more the necessity and the possibilities of organized effort."[74]

Smith's support and coverage of the cigar makers and Bureau of Engraving and Printing strikes helped build her reputation as a well-known advocate of minimum wage legislation.[75] In 1918, the Central Labor Union of Washington, D.C. selected her to serve as the unpaid labor representative on the local Minimum Wage Board created by the Keating-Trammell minimum wage law.[76] Congress enacted this law to protect the women and minors of the District from conditions detrimental to their health and morals resulting from wages that were inadequate to maintain decent standards of living. The 1918 law authorized the board to "represent as far as practicable, the employing class, the employed class, and the general public." The three members of the board had the legal authority to convene a conference to examine the conditions of labor within a particular industry if they believed the women employed in that industry were underpaid. According to the provisions of the law, "[T]his conference shall be composed of not more than three representatives of employers in such occupation, an equal number of representatives of the employees in such occupation, of not more than three disinterested persons representing the public, and of one or more members of the board.[77] Board members could legally "summon witnesses and examine the books of employers" and ultimately determine whether or not "a substantial number of women workers [were] receiving wages inadequate to supply them with the necessary cost of living."[78]

Smith assumed an active role on the Minimum Wage Board as the representative of workers' interests. She served with Jesse Adkins, President of the NCL, who represented the public interest, and Joseph Berberich, President of the Merchants' and Manufacturers' Association and representative for employers' rights. Between 1918 and 1919, the board heavily relied on the labor of its secretaries, Clara M. Beyer and Elizabeth Brandeis.[79] Though it is difficult to determine the relationship between these two women and board members, Adkins explained that Beyer and Brandeis were the people who really did the work. "They go out and look over the payrolls in the store and if they find that the proprietor is violating the law they call his attention to it, and so far they have been able to persuade him to correct the mistake; usually it has been a mistake." When necessary, Beyer and Brandeis convened the board to address existing pay inequities in industries that employed women throughout the District.[80]

As a member of the Minimum Wage Board, Smith worked to uphold the provisions of the "highest minimum wage for women thus far achieved through legislation."[81] Following a conference for the mercantile industry, the board ruled that "it will be illegal for any merchant in the District of Columbia to pay less than $16.50 per week to any woman in his employ who has had seven months' experience." Moreover, the board's decision applied "to all the women workers in the establishment—

not only the saleswomen, but office workers, telephone operators, milliners, tailoresses, janitresses, and all others."[82]

The District of Columbia minimum wage law helped unite the women's and labor movement in a way that Smith had envisaged. AFL leaders, for example, supported the law as an effective way to increase women's wages and to stimulate union organization. Frank Morrison, Secretary of the AFL, argued, "It has brought a wage increase of approximately 38 percent to more than 10,000 working women, most of whom were formerly far below the bread line, and it has stimulated organization," leading to two new local AFL affiliates.[83] In addition, Smith's defense of the minimum wage law brought her into an alliance with a mode of legal thought that challenged the dominance of laissez-faire individualism. By arguing that women were entitled to special legislation, the minimum wage law created one of several legal precedents that convinced policy makers of the need to regulate the terms of the labor contract. Because the substance of this legislation countered long-held traditions of legal thought, conservative forces quickly challenged its constitutionality.

As the legality of the minimum wage law worked its way to the Supreme Court, Smith continued to worked tirelessly in support of legislation and organizational efforts to establish equal rights and opportunities between men and women workers in the labor force. She devoted tremendous time, energy, and her own money to ensure the continued operation of the Washington branch. The WTUL struggled financially between 1918 and 1920. Nonetheless, Smith agreed to continue working for the committee without a guarantee that she would receive a monthly salary. In June 1919, Smith "asked two banks for a loan on [her] liberty bonds, and [could] not get it."[84] She warned Robins that they "will simply have to close up the office if the National cannot send us what it owes for the period since January."[85]

From 1919 to 1920, Smith and other committee members used their salaries and personal savings to support the WTUL's work in Washington. By June 1919, conditions had become so precarious that Smith wrote to Robins to say: "I am sorry to bother you with things like this, but I think you ought to know how serious is our financial situation."[86] In August, Smith told Robins that because she had used her personal resources to fund the committee's work, she had "practically no money at all," and her "July salary ha[d] not yet come."[87] She explained that other members of the Washington Committee had "all advanced money to meet emergencies, and still there are outstanding bills for printing and rent." Smith further explained:

> With the check you sent us the other day I paid one month's rent, the telephone and telegraph bills, and one bill for office supplies, which had held over so long we could have had to lose the telephone and the telegraph account if

we hadn't, and collectors were making our lives so miserable about the others we couldn't afford, for the League's sake, to the let the thing run on.[88]

She also wrote a letter to Emma Steghagen, the WTUL's Treasurer, to say that her "personal account is now down to nothing—I can't even pay my own house rent tomorrow, nor meet my share of our household expenses. What with paying out of my own pocket a salary to Miss Quay [the committee's secretary]. . . .I am completely 'broke.'" Smith proclaimed, "I can't really go on dodging collectors and working without supplies," and she told Steghagen that "we will simply have to close up the office if the National cannot send what it owes for the period since January.[89]

Smith told Robins: "As you know, I have always utilized the League's press service to assist any of our affiliated unions who furnished material or wanted the service." NFFE "had a more extensive service than any others, partly because they furnished their own machinery for the service . . ., and partly because of the close interrelation of their Legislative program and the League's." When NFFE decided to set up its own publicity service, Smith was its first selection to lead it.[90]

In December 1920, NFFE's Executive Council offered Smith the paid director's position of its newly formed Publicity Bureau, believing that her demonstrated writing and analytical ability would keep civil service concerns before the public and encourage new memberships. As the bureau's director, Smith actively corresponded with publicity committees in all of the 215 NFFE unions, facilitating the organization of local campaigns in support of reclassification and other legislation.[91] Smith asked for the WTUL's consent before she accepted NFFE's offer. She explained to Robins that NFFE had decided by convention resolution and council vote to establish its own publicity service on a larger scale and selected Smith as the person to direct the service. "As I did not want to give up my work for the League, however, they asked me to consider a part-time arrangement."[92] The Executive Committee consented and applied the unused portion of her salary to add a full-time assistant to the Washington Committee's staff. Smith was pleased that she would be freed "from the harassing office details and mechanical work which have been so burdensome" and "can put that time to creative purpose for the League."[93]

Smith also assisted in the publication of that organization's newspaper, *The Federal Employee.* NFFE established the bureau in December 1920 "to meet both the needs of its larger membership" and to increase appreciation for the "importance of keeping the public informed of the purposes of organized employees and needs of the civil service. As the bureau's director, Smith conducted an "active correspondence with publicity committees in all of the 215 local unions composing the National Federation of Federal Employees."[94] She also submitted her written work to Washington newspapers and to correspondents for other media sources throughout the country. Smith received high acclaim for her publicity work. NFFE members printed an article to acknowledge her contributions to the orga-

nization, complimented her as an unassuming character, and emphasized her invaluable service to *The Federal Employee.* "She is both the conductor and motorman of the new publicity bureau at National Headquarters. Most folks don't know news when they see it. Those who do rarely know how to get it printed. Ethel Smith can do both."[95]

In late 1920, however, she halted her work for over one month to recover from severe exhaustion. In November, she wrote that she was getting over "this exasperating siege of mine." She was not very good at relaxing, because if she was not working, she did not know what to do with her time. In a letter to Margaret Dreier Robins, Smith explained:

> [T]he only sensation I've been conscious of for months has been conflict. It was in every phase of my work, of course, and it stayed with me every waking moment, translating itself into all my other relationships and giving me no peace, for there was always myself to fight and the despair of ever conquering that most formidable enemy.

Smith's reform work consumed her to the point that she no longer maintained a private life. She became so obsessed with her legislative, journalistic, and organizational responsibilities that she collapsed. Even as she recovered from severe exhaustion, she lamented that she could not "get [her] mind and eyes to dwell upon the beautiful and the happy things," and she continued to ruminate over all of "the struggle and the hardship."[96]

From mid-November through December, Smith attempted to direct her energy to regaining her strength. In a long letter to Margaret Dreier Robins, she wrote: "It's quite a horrid feeling when one realizes, as I have done these past weeks, that one has forgotten how to play, has lost the power of relaxation, and is unable to put oneself in key with the pleasure and with beautiful things." She told Robins, "[T]here are two types of reading matter I could make my mind take hold of, namely books and articles relating to my work, which were bad for me, and stories of adventure which carried me along without any mental effort. I've become completely fascinated by the moral code of the six shooter and the conversation of the cowboy and feel as if I could absorb indefinite narratives of that atmosphere and simplified mode of existence."[97] In literature, the West "functions as a symbol of freedom, and the opportunity for conquest" in which the protagonist displays his "unswerving purpose" and "capacity to continue in the face of total exhaustion and overwhelming odds." The simplified language of the cowboy demonstrates his ability to control his feelings and to "maintain boundaries that divided [him] from the world." However, Smith did not possess the silent, mysterious, and impenetrable traits of the cowboy.[98] Her struggle, to a great extent, was "the personal is political," well before the second wave of twentieth-century feminism coined that

phrase. She was fully engaged in her work, and not even persistent illness would keep her from pursuing her goals.

At age forty-three, her life had moved through various stages, each one solidifying the values learned as a product of a rural, working-class family. As she adhered to the values of hard work and the merit system, Smith never forgot her personal experience with gender discrimination. Such memories galvanized her to challenge gender barriers in the workplace and to quickly develop a reputation as an outspoken field organizer, lobbyist, and journalist. In her mid-twenties, she achieved financial security, breaking with the tradition of the male breadwinner, not to mention the compulsion to marry. Smith became a leading figure within a community of women that shared her commitment to legislative reform to establish government responsibility for working conditions and to equalize women's place in social and economic life. She earned recognition among these women for her keen intelligence, quick wit, and tenacity of spirit, and she formed the relationships that sustained her both professionally and personally for the rest of her life.

As her views came to fruition, her primary opponent in the 1920s—Alice Paul—also had begun to articulate and pursue a legislative strategy to advance women's rights. Smith joined NAWSA following Paul's split from the group. Her departure created significant opportunity for Smith to refine her organizational and lobbying talents. However, Paul's break with NAWSA set the stage for her emergence within the ranks of women leaders during and after the suffrage movement. Paul was just as committed as Smith to her personal convictions, and she also refused to compromise her principles, regardless of the consequences. Her rise to power, however, followed a different route.

From Charity Organization to Militant Protest

Alice Paul's Rise to Prominence, 1885–1920

Like Ethel Smith, Alice Paul rose to prominence as a defender of women's rights in the workplace. She too believed that men and women were entitled to equal compensation and opportunity, and that discriminatory practices should be abolished. Though both women shared the same political and economic concerns, their organizational affiliations and approach to achieving their goals differed dramatically. The similarities in their personal politics could not be bridged due in part to their different class backgrounds and choice of organizational affiliations. Paul initially attempted to fit into the culturally ascribed roles for a woman of her class, however, she eventually rebelled against such strictures and launched a political career that directly challenged mainstream depictions of women as weak and dependent. Based on her wealth, intelligence, and tenacity, she had every reason to believe that she could make a difference in changing how women were perceived in politics, law, and culture. By age twenty-eight, she had secured a place in the history of American women, but that history is complex and has never been explored in its entirety.

Born in January 1885, Paul was steeped in the economic and religious stability of the Quaker enclave of Moorestown, New Jersey. As a product of the village's most upstanding and affluent family, she lived a comfortable, middle-class lifestyle that for the time being remained far removed from the vicissitudes of urban strife. Her father, William Mickle Paul (1850–1902), owned several successful businesses and worked as President of the Burlington County Trust Company and Vice President of the Moorestown National Bank.[1] Looking back on her childhood, Paul had very little to say about her father, who by all accounts was stern and detached from his family. He died of pneumonia on April 26, 1902, leaving his wife, Tacie Parry Paul (1859–1930), and their four children a sizable inheritance.[2] In contrast to her father's demeanor, Paul's mother was a kind and gentle woman remembered for her independent personality and keen intelligence. She also was a product of a very political family who instilled in Tacie an active social conscience, a quality no doubt she passed on to her daughter.

As a descendant of her mother's distinguished name, it was predetermined that Paul would continue the family tradition and attend Swarthmore, a Quaker college that her grandfather, William Parry (1817–1888), had co-founded with Lucretia Mott.[3] At Swarthmore, she established close relations with her classmates, engaging in risky escapades such as making fudge in her dorm room with a gaslight and sneaking away from campus after curfew to explore the town. Such antics

must have been all the more exciting for Paul, in light of her strict upbringing. Raised in the Hicksite Quaker sect, she adhered to the traditional doctrine of the inner light, striving to set a good example for others according to her own conscience. She was taught to live a simple life and to build an unshakable commitment to hard work and her community. Her father upheld these principles to their highest standards, forbidding music in the house and other forms of unnecessary frivolity. Though Swarthmore was governed by an abundance of rules, college life provided the opportunity for Paul to revel in singing and dancing, practicing football cheers, laughing, and exploring the mysteries of dating.[4] She enjoyed her two years at Swarthmore to the fullest, with the exception of emotionally coming to terms with losing her father, a process that was no doubt traumatic whether she was close to him or not.

Paul profited from the finest education available in the early twentieth century, for a man or a woman. In 1905, after completing her B.A. at Swarthmore, she engaged in educational pursuits that exposed her to the most prominent intellectuals in the developing fields of sociology and social work. First she decided to accept the College Settlement Association Scholarship and attend the New York School of Philanthropy. Founded in 1898, the School of Philanthropy, now the Columbia School of Social Work, helped bolster social work to the level of a professional science, and it became the first American educational institution to provide the systematic training of social workers. During her year-long tenure at the School of Philanthropy, she was exposed to two methods of assisting the urban poor, charity organization and social settlement work.[5] The Charity Organization Society (COS) and social settlement movement began in nineteenth-century England. Under the leadership of affluent men and women, both movements spread throughout the United States around the turn of the century. COS workers, through direct interaction with the poor, focused on changing individual behavior as the most efficient means to help alleviate the brutalities of economic struggle.[6] As model citizens, these workers believed that they could serve as role models to the poor and encourage them to assimilate American cultural values and learn how to be productive and thrifty. Those in the social settlement movement shared the class perspective of COS workers but also emphasized that individual behavior could not be considered separately from the collective good. Workers at prominent settlement houses such as Henry Street in New York and Hull House in Chicago engineered social and economic studies of neighborhood conditions, built alliances with the labor movement, and advanced social policies to mitigate the economic exploitation of the urban poor.[7]

At the School of Philanthropy, Paul took courses designed to prepare students to become expert visitors for charity organization societies. While her classes emphasized the COS perspective, her training also included fieldwork responsibilities as a resident at the New York College Settlement. In this capacity, she inter-

acted for the first time with predominantly Eastern European Jewish immigrant populations, working as an investigator and helping to organize the settlement's clubs and classes. During the summer of 1906, as Paul entered this new environment, she was exposed to so many different cultures that she proclaimed, "[O]ne feels as though in a foreign city."[8] At age twenty-one, such unforeseen religious and ethnic diversity must have shaken her confidence that she could make a difference in the lives of the neighborhood people. She supported the settlement's mission of providing a "home in the neighborhood of working people in which educated women might live in order to furnish a common meeting ground of all classes for their mutual benefit and education."[9] She also saw value in the settlement's efforts to provide the neighborhood people with manual training and dressmaking skills to enhance their employment possibilities, to encourage them to adopt the values of hard work, and to seek financial self-sufficiency.[10]

She did not believe, however, that the settlement's workers could overcome environmental problems such as the high emigration rate and cultural barriers endemic to the neighborhood. The demographic shift within the early-twentieth-century Jewish population created entirely new circumstances with which Paul grappled. The East European Jews, unlike the more assimilated German Jews, were largely displaced agricultural people who retained their religious orthodoxy and Yiddish culture. Eastern European immigrants who crowded into the industrial Northeast oftentimes rejected settlement house and COS workers' attempts to assimilate them, relying on familial and religious customs as a source of strength and identity.[11]

Though she did not believe that the settlement workers on Rivington Street successfully altered the mores of the neighborhood people, Paul argued that the middle-class residents benefited greatly from the settlement house experience. She explained that direct interaction with the poor gave middle-class residents "a knowledge of conditions which enables them to work more efficiently in the constructive movement for the betterment of this part of the city." Settlement house work, she believed, was of greatest value because it gave the residents a new sympathy that compelled them "to work more earnestly . . . and effectively, for the social welfare."[12] She retained this belief through most of her graduate school training. She remained fully focused on the COS approach to social work, and she never mentioned an interest in social policy research or reform.

With the youthful zest of a twenty-one-year-old, and persistence that became the mainstay of her character, Paul tested her School of Philanthropy training during the summer of 1906 as an investigator for the New York COS. To assure her mother that she would maintain the proprieties of her class as she explored this new environment, Paul claimed that it was "supposed to be the finest Charity Organization Society in the country," at the forefront of the movement to mitigate urban poverty. She "was delighted to have gotten the position so easily,"

because it enabled her to fulfill her mission of working effectively in the community. She also enjoyed receiving a monthly salary of forty-five dollars to help pay for her living expenses.[13]

By the fall of 1906, with her social work degree in hand, Paul traveled abroad to study social work in England. Following the acceptance of a scholarship to the Quaker Woodbrooke Settlement for Religious and Social Study, she became one of twenty-five U.S. citizens to claim the distinction of attending this institution prior to 1910.[14] As a Woodbrooker, Paul received training in social work that resembled the New York School of Philanthropy's curriculum, attending classes and working in a local settlement house two or three times a week. As in the United States, the combination of academic and fieldwork helped create a unique reputation for Woodbrooke. To further enhance its status, the institute coordinated program offerings with the University of Birmingham, allowing students to take courses at the university for the purpose of earning a social work degree. This joint venture played an important role in the establishment of social work as a respectable profession in England.[15]

Paul excelled in her courses at Woodbrooke, demonstrating outstanding academic capabilities. James St. John Heath, a lecturer in political economy and sociology at Woodbrooke, considered Paul "one of the best students with whom I have come in contact, whether in my work here, or as an Oxford University Extension Lecturer." He wrote: "She struck me as being a person of great mental acuteness, and I was surprised by the way in which she was able to master the more difficult parts of the Theory of Political Economy." He continued:

> She has a very wide range of reading, real enthusiasm over her work, and great powers of application in any subject in which she is interested. But what struck me most of all was her gift for learning about institutions and customs in the neighbourhood. Though she was not here for a very long time, she had acquired, almost entirely on her own initiative a surprising amount of knowledge of social conditions in Birmingham.

Though Heath admired Paul for her intellectual capacity and devotion to her studies, he "never quite took to the idea of [her] going to do practical work except perhaps for a short time." Her interest in social conditions, particularly during the 1907–1908 winter break from Woodbrooke, exceeded her course requirements, leading her to engage in activities that alarmed her colleagues.[16]

In late December, she boarded for ten days at the Canningtown Settlement, situated along the Thames and Lea Rivers in the dockyard district of London.[17] She explored the impoverished conditions of the surrounding neighborhoods, feeling that to fully benefit from her inquiries she should experience the daily life of an industrial worker. In early 1908, Paul applied for a wage-earning job. She told her mother:

I worked for a week in a[n] [I]ndia rubber factory which was the most interesting experience I have ever had. I dressed as a working girl—they gave me the clothes at the settlement. I took a room with one of the COS cases near Canningtown and got my own food and supported myself on my wages. I worked 6 A.M.–6 P.M. . . . I made tires for automobiles. If a girl was a good worker, she could make a little under $5 a week.[18]

She demonstrated the COS conviction that if individuals applied themselves diligently, they could find work, despite the enormous unemployment rates in London. Paul proudly told her mother that she was very lucky to have gotten the job, and that the experience was most valuable to enhancing her understanding of the day-to-day responsibilities of factory work. This was clearly an exciting time for her, creating opportunities to explore her environment with minimal restrictions and assert an independence of thought about her academic beliefs and aspirations in ways that distinguished her from her peers.

The head worker at the settlement was so impressed with Paul's dedication that she offered her a scholarship that would pay for her room and board. She turned the offer down, because her Woodbrooke fellowship provided the same amount of money. Nonetheless, to have received such an offer from what she described as one of the most prominent settlements in England bolstered her self-confident belief in the efficacy of practical work as the most effective means of understanding urban poverty.[19]

Paul continued to receive recognition for her abilities after returning to Woodbrooke in January. She caught the attention of the visiting secretary for the Dalston Branch of the London COS, who offered her a full-time job with a yearly income of $300. She complained that the salary was "wretched," but she accepted the job because "it is all they pay for the position and it is the best position one can get to see social work."[20] Paul told her mother:

I think that going to the London COS is a very good plan. I have always wanted to spend about a year in COS for it is the best way to understand social work and see all sides of it for the work is so extremely varied and I would rather spend the time in London than any other place. I do not want to come back yet for I want to see more of England first and by this plan I can support myself or nearly do so and at the same time be learning a great deal of practical work.[21]

Apparently Tacie wanted Paul to return home after finishing at Woodbrooke, and she began to complain about the mounting cost of her daughter's education. Spending too much time in England could easily be perceived by her Quaker family as excessive, and perhaps for this reason Tacie required her daughter to earn an

income. Whatever the case, she consistently emphasized to her mother that COS work was crucial to her academic development, and to cover her living expenses.

Nonetheless, between May and October 1908, Paul grew weary from her time-consuming and exhausting responsibilities. She ran the district office from 9 A.M.–6 P.M. five days a week and worked until 2 P.M. on Saturday.[22] She explained to her mother:

> I write about 20 letters a day and visit as many homes as I possibly can, superintend all the agents and volunteers . . . keep the accounts, and every spare moment I have I spend in trying to get new volunteer workers. . . . Then I have to see the poor law officers once a week and talk over all our cases with them. . . . Then one evening a week I have an adult school of 50 to 60 women, which takes considerable time.

She described her job as "hack work" that required long hours without resulting in any significant changes in the lives of COS clients or their neighborhoods.[23] To ease her workload, she sought part-time employment that would still provide her with a sufficient income and the opportunity to attend the London School of Economics (LSE).

After enrolling at the LSE, Paul began to work part time at the Peel Institute in Clerkenwell, England. She told her mother: "It is really a rather good opportunity. I wanted to go to the University but did not see how I could get half-time work that would support me at the same time."[24] At the LSE, Paul combined fifteen hours a week of lectures in sociology and politics with her responsibilities at Peel. Within two weeks she realized that Peel took so much time that she could not study. She told her mother: "So far I haven't read anything—Peel is a dead place. I spend my time looking after babies and old women." At this point, Paul realized that she was "not at all fit for any of these things she does."[25]

The exhausting nature of her work with the London COS and the Peel Institute starkly contrasted to the exciting environment of the LSE. Founded in 1895 by Fabian socialist Sidney Webb (1859–1947), the LSE faculty were frequently at odds with members of the COS. Both sides agreed on the importance of studying social and economic conditions but diverged over methods of assisting the poor. While employed by the COS, Paul became critical of direct practical action and seemingly enjoyed the LSE's emphasis on political action over social work education. In fact, the LSE became the first institution in England to offer degrees for the political and economic study of society. By 1901, it had become a center for social science training.[26]

Not only did the LSE introduce Paul to a new academic climate, she also was quite comfortable there, surrounded by well-educated, affluent people. She told her mother that she "enjoyed the LSE more than any other institution she had

attended because there are people from all over the globe and most of them seem to be very bright and up to date. It is the most stimulating atmosphere. There is an official of the Japanese Govt. - numbers of Japanese, Chinese, Indians, some Germans, French, Egyptians, Finnish." The LSE provided Paul with an intellectually invigorating environment in which she was surrounded by influential individuals from all over the world. Such an exciting atmosphere piqued her interest in political issues and seemingly restored her belief in the capacity to engage in meaningful pursuits that would benefit society as a whole.[27]

At the end of her first term, and following the completion of her work at Peel, Paul wrote: "I should like to stay on at the School of Economics for another term but I don't want to work at the same time for it simply results in getting no studying done. . . . I've seen social work pretty thoroughly in London and don't feel that I want to spend any more time on it." After studying for two years in England, Paul told her mother: "I have had all the experience of practical social work I want and am going to do nothing now but study and take my Ph.D. and teach."[28] She asked her mother to pay for her second and third terms at the LSE, and she applied for the Joshua Lippincott scholarship from Swarthmore, believing that it would enable her to study in either Germany or Switzerland.[29]

Her mother agreed to pay for Paul's studies at the LSE, but also told her "to stop wasting [her] strength on the people of the slums." She reassured her mother: "I am not doing it for their sakes but in order to learn about conditions myself," emphasizing that she wanted to direct her sights to strictly academic pursuits.[30] Her plans, however, were dashed in June 1909, because her application arrived too late for consideration. After extensive, firsthand interaction with the poor and recognition for her accomplishment in England, Paul confidently anticipated that she would win the award. Angered and dejected, she told her mother that she would never apply to Swarthmore for a scholarship again.[31] At the same time, Paul's mother made matters worse by telling her that she was spending too much money and needed to begin her career. She agreed to leave England and planned to prepare for her Ph.D. exam at home.[32]

Though Paul booked her passage, she did not return to the United States until January 1910, six months later. Instead, she quickly overcame feelings of rejection by engaging in radical militant protests as a member of the WSPU. This six-month period marked an important transition in her life, during which she realized that British law denied elite white women commensurate rights with men of the same race and class. Because gendered legal inequalities directly challenged her conceptions of class status, Paul permanently abandoned the study of social work and redirected her sights to protecting the legal rights of elite white women.

Paul first learned about the women's suffrage movement in England as a student at the University of Birmingham. In December 1907, her canvassing of local institutional developments and political events led her to a suffrage debate in

London, hosted by the university. The debate introduced Paul to the work of the WSPU. Founded in 1903 by Emmeline Pankhurst, the WSPU consisted of mid-to-upper-class white women who petitioned the British government for the vote as a means of establishing equal rights between men and women.[33] In response to Parliament's resistance to their demands, WSPU members organized mass protests to sway both government and public opinion. When abiding by the law failed to achieve their goal, the militant suffragettes resorted to actions that defied state authority and challenged gendered conventions governing the lives of white, affluent women.[34] WSPU tactics included destroying private property, heckling ministers, and even disrupting meetings of the House of Commons to demonstrate behavior that was anathema to the culturally inscribed proprieties of respectable womanhood. Because the militant suffragettes not only directly challenged government authority but also produced a new and sensational form of women's political activism, WSPU members acquired tremendous media coverage, though not always sympathetic, and an increasing number of followers.[35]

Engrossed by the combination of direct militant challenge to cultural and political limitations of women's rights, Paul joined the WSPU in January 1908. She did not engage in any militant actions until the following year, because she "could not risk having to give up my work in case of being sent to prison."[36] Though she had made multiple references to the WSPU in her letters, Paul's interest in women's suffrage surprised her mother.[37] According to Tacie, Alice "did not seem interested in the Suffrage Movement until this past summer [1908]. Up to that time she had been talking about coming home, but the letters I have received from her recently have shown her enthusiasm in the work. Alice was particularly close to Mrs. Pankhurst . . . and I believe it was largely through her influence that she became interested in . . . suffrage."[38]

Indeed, Paul respected Pankhurst for her unwavering commitment to full political and legal equality for women and her ability to build a devoted following. Between 1908 and 1910, she served as an apprentice under Pankhurst's guidance and became so thoroughly imbued with WSPU ideology that she devoted all of her time to participating in dangerous forms of protest. Paul engaged in her first militant act with the WSPU in July 1909, when she joined a deputation that tried to present a petition to Liberal Prime Minister Herbert Asquith. Through constitutional means, members of the deputation tested the legal limits of British definitions of citizenship. When Asquith refused to meet with the women, protesters proclaimed that the government denied them the "Right of Petition" and charged the police barricades. Paul was one of over 108 women arrested.[39]

That the police not only arrested the women who protested but also brutalized them challenged Paul's class sensibilities. When recounting the protest to her mother, she emphasized that the deputation women "were mostly members or connections of the nobility." She wrote: "The most distinguished people who vol-

unteered were put on the deputation proper to Asquith in the hope that their position would induce him to see them. The rest of us were to try to force our way through the police lines into the house of commons . . . if he did not admit the first lot." Paul exclaimed that the demonstration "was a really awful scene. We were all padded as though for a foot ball [sic] match—it is no wonder that no one was killed." She was horrified to witness the police grabbing the suffragettes by the throat and brutally throwing them to the ground. She described the event as "one awful nightmare."[40]

Though Paul was not physically injured during the June raid on the House of Commons, she realized that the protesters' upper-class status did not lead members of the government to provide women with full political rights. She complained that Asquith refused to hear the demands of distinguished women, but willingly received "rough hooligans representing the unemployed and representatives on any subject however trifling as far as practical politics goes."[41] After four years of work in the social settlement and COS movements in the United States and England, Paul began to articulate a class-specific defense of elite women's rights, and she abandoned issues pertaining to unemployment and urban poverty.

The violence surrounding the June protest not only challenged Paul's conceptions of class respectability but also highlighted the prevalence of gender discrimination in British political culture. She complained that Asquith refused to see any deputation that referred to women's suffrage. She told her mother: "He told us that almost all his time is taken up receiving deputations of men and yet he will not receive from women who need it much more, for the men also have their representatives in Parliament to speak for them and women have not."[42] Paul proclaimed that Asquith's "position is incomprehensible. It seems to be a matter of pride with him never to yield anything to women."[43] The WSPU's struggle to give elite white women the same political rights as men undermined Paul's understanding of respectable citizenship. Through her participation with the COS and settlement house movements, she had attempted to instill proper values of her class and gender into the lives of her clients. She was mortified to discover that legally she was no better off than the impoverished or unemployed.

In response to the July demonstration, Paul decided to return to the United States. She told her mother: "[T]he struggle is getting very grimly and deadly earnest now. I think the best thing for me to do is to get my degree as quickly as possible."[44] She asked her mother to immediately send money for her passage home. She changed her mind, however, when the magistrate permitted the suffragettes to appeal their case to a higher court for the first time, thus gaining favorable media attention. The case, Paul explained, was a success, because the government recognized the constitutionality of the WSPU's demands.[45]

Though Paul had planned to return to the United States following the July demonstration, she engaged in a second militant protest three weeks later. She

explained: "I was arrested with 12 other suffragettes for a raid on a meeting held by the Chancellor of the Exchequer. . . . One was released but the rest were sent to Holloway prison mostly for 14 days. We rebelled because we were not put into the first division where we belonged and we all refused . . . food.[46] Holloway had served as the national women's prison since 1902. When the first suffragettes were committed there in 1906, the prison became "the focus of great public attention as the struggle for votes for women which was being fought on the street took new forms behind the imposing wall of the gaol."[47] She told her mother, "Everyone admits that we are political prisoners and all over the civilized world political prisoners are put in the 1st division. We were all put in the 1st division for about a year. Then the government tried to stamp the movement out by putting us in the 2nd division where drunkards and thieves . . . are put." She continued, "For a year and a half the suffragettes were obedient in the 2nd division and spent their time in petitioning and reasoning with the Home Secretary. . . . They saw that the only thing to do was to resist."[48]

To protest the government's refusal to treat them as political prisoners, the suffragettes refused food, thus directly challenging the authority of the state. Though hunger strikes became an effective WSPU protest against the imprisonment of suffragettes, jailed WSPU members also resorted to other forms of defiance. According to Paul, "[W]e destroyed as much property as possible. I broke every pane in my window. 40 panes they tell me." In response, prison officials locked her in solitary confinement for seven to ten days. While sequestered, Paul and the other women defied the orders of the prison guards and refused to change into her prison uniform. The prison guards, she wrote, "tore off all our clothes and left us with only prison clothes. We would not put them on and I sat there for about 2 hours with nothing on."[49] When one official finally offered her a blanket to cover herself up with, she accepted, and remained wrapped in it for five days, refusing all food. After 126 hours of fasting, she required over two weeks of bed rest and medical care. One can only imagine the fortitude and strength necessary to endure such brutal treatment. Nonetheless, she believed that her personal sacrifice demonstrated her commitment to the vote. Indeed, her willingness to hunger strike placed her at the forefront of WSPU militancy.[50]

Once she recovered from her first hunger strike, Paul stepped up her activism in the WSPU and played a central role in spreading militant action throughout Great Britain. She led her first demonstration in August 1909, organizing members to disrupt a meeting held in Norwich, England, which Winston Churchill, Asquith's Board of Trade President, was scheduled to attend. This was an opportunity that she could not refuse, however, she needed to explain to her mother why she had not made arrangements to return to the United States. She told Tacie: "The suffragettes sent two other women and myself to Norwich . . . to organize a demonstration at the cabinet ministers meeting there. It was to come off

yesterday [Monday], so I thought I would be through in time to sail on Wednesday." The event proved more challenging than Paul had anticipated, because there were no suffragettes in Norwich, "so we had to rouse the town." Paul and her compatriots held about twenty-five meetings and issued 5,000 leaflets, and they attempted to distract every meeting held by a Cabinet minister.[51] By demonstrating in this region, she directly assisted the WSPU's efforts to expand its influences outside of London, and she clearly enjoyed the challenge of convincing the townspeople to support the suffragette movement.

Paul excitedly described to her mother how the Norwich protest was not only a success but also an unprecedented event in that region. She wrote: "The Secretary of the Labor Party told me that there had never been such a crowd seen in Norwich." She continued:

> The roar and tumult from the crowd was so great that it quite distracted the attention of Churchill's audience and one liberal who was very angry at the meeting being spoiled said to me the next day, "There was such hell outside that I could scarcely hear a word that the speaker said." This was just what we wanted. I thought the demonstration of June 29 in London was effective but it was mild compared to this.[52]

She believed that the crowd's overwhelming support provided the strongest evidence for the success of the protest. Unlike the June 1909 demonstration, the WSPU women "were not hurt in the least." Though they were arrested for inciting the crowd to riot and for assaulting the police, all charges were dropped. She argued that the government "was evidently at its wits end," because it recognized that arresting WSPU women would not prevent further protests from being organized.[53] She believed that the militant suffragettes' commitment to the vote would withstand any form of governmental attempt to stop their movement.

Emmeline Pankhurst quickly recognized Paul's devotion to the WSPU and her leadership potential. In recognition of her effectiveness as a demonstrator, Pankhurst invited her to travel by automobile to Scotland to help continue expanding the WSPU's influence outside of London.[54] On August 20, 1909, one Cabinet minister, Lord Crewe, spoke at St. Andrews Hall in Glasgow. Alone, Paul undertook the daring act of climbing to the roof of the building and hiding there "to wait till night to get into the hall through one of the windows. . . . About two o'clock, rain began to fall heavily and I was soon soaked. . . . When daylight came I lay on the roof face downwards. I had a black cloak on, and I did not think I could be seen."[55] A workman, however, discovered Paul and called the police. She was forced to climb down but did not go home. That afternoon, when she, and other protesters tried to force their way into the building, they were arrested and detained until Crewe left town.[56]

Soon thereafter, Paul was arrested for a third and fourth time, first in Berwick-on-Tweed and then in Dundee, becoming one of "the first suffragettes ever sentenced in Scotland and all Scotland was roused to it." She was sentenced for ten days, during which she went on a hunger strike, and she was released in four days as a result. Ten thousand people, according to newspaper accounts, surrounded the prison and threatened to riot.[57] When Paul returned to London in October, she abstained from further militancy for about four weeks. She instead helped organize bye-elections and frequently spoke during open-air meetings.[58] By late November, however, she had regained her strength from her last hunger strike and resumed heckling political figures. Paul and another WSPU member, Amelia Brown, engaged in one of the most daring acts of WSPU militancy. They dressed as charwomen and carried buckets and brushes to gain admittance into Guild Hall with the other maids. They hid and waited until that night, when Prime Minister Asquith was scheduled to speak in honor of Lord Mayor's Day. After Asquith began his speech, Brown threw her shoe to break a window, making a mess and arousing curiosity. Brown and Paul clarified the situation by shouting "Votes for Women," the WSPU's slogan, outside the doors of the meeting hall.[59]

Following their arrest, Paul and Brown went on a hunger strike and became the first WSPU members to be subjected to the government's new militant policy, forced feeding. The WSPU went to great lengths to publicize government-sanctioned forced feeding and to make martyrs out of the women who underwent such treatment. For example, WSPU leaders organized "Self-Denial Week" to create public awareness and respect for the "prisoners who face the torture inflicted upon them by the Government." Taking a moralistic stance, Emmeline Pankhurst argued that "great self-denial is demanded" of the women who are forcibly fed. She explained: "[T]he woman's revolution in England has in it women who have been willing to suffer in this conscious, definite, purposeful way" and are willing to risk their health and even their lives to further the suffrage movement.[60]

Paul attempted to conceal the forced feeding from her mother by telling WSPU leaders not to inform newspaper reporters that she was an American. Her efforts at anonymity, however, failed. Her mother read about her imprisonment on the front page of the *New York Times*.[61] Tacie panicked and turned to the American embassy, Christabel Pankhurst, and her brother-in-law for support. She wrote: "[I]t has been a dreadful time for me, the worriment and anxiety of it all. . . . Then there was an article that she was being forcibly fed, and her screams could be heard all over the prison. I then felt that I must do something."[62] Mickle Paul reassured Tacie that her daughter brought honor to the family because of her "cult of duty—as she saw it." He wrote: "She is brave and brainy and energetic and has a wide field of usefulness" and said that she showed the "independent thought and individual responsibility that marked the family in the earlier days."[63]

Pankhurst also offered Tacie encouraging words. She wrote that Paul "is so

much loved by the members of our union." "She is so unselfish, and has so much courage that she is always eager to take part in the most dangerous and difficult work." She told Tacie that she would dissuade Paul from participating in militant events. Whether or not she did so is questionable. The WSPU valued Paul's membership so much that they later offered her a paid position in the organization.[64]

Paul was not receptive to her mother's inquiries for over two weeks and became so impatient that she denied the accuracy of newspaper accounts of her imprisonment. She argued that even if the stories were true, "there is nothing so very alarming about being forcibly fed." With increasing brusqueness, Paul declared: "[O]ther women are doing it—why should not I? Their parents do not make a fuss about it." She told her mother not to send her any more money and to stop worrying about her because she could take care of herself.[65]

By the end of December, she finally wrote: "I will tell thee now what forcible feeding is like. I did not want to write about it before because I wanted to think about something else."[66] On the third day of her hunger strike the guards dragged her out of bed and tied her to a chair with sheets. The doctor fed her through the nose with a five- or six-foot long tube. She explained:

> One wardress sat astride the knees and held that part of the body quiet. One wardress stood on each side and held the arm and hand. One of the doctors stood behind and pulled my head back till it was parallel with the ground. He held it in this position by means of a towel drawn tightly around the throat. . . . Then the other doctor put the tube down through the nostril. . . . It rarely went down the first time. He would push as though he were trying to drive a stake into the ground, but it would not budge so he would pull it out again and grease it . . . and then try the other nostril.[67]

This shocking and revealing letter documented Paul's last act of defiance with the WSPU, though it was not her last experience with forced feeding. She continued to engage in this form of passive resistance in the American woman suffrage movement under the penalty of the same type of torture. When Paul adopted the hunger strike, she intentionally and directly challenged the authority of prison officials as well as the customs that shaped gender and class relations in England and the United States. In effect, her forced feedings amounted to legalized assault by the state.[68]

Paul politicized her forced feeding, but she did not publicly identify herself as a victim of abuse. As she distanced herself from the experience, she used it to gain media attention and public sympathy. She believed that her self-sacrifice demonstrated to the government the strength of her commitment to the cause and the forced feeding posed the ultimate test of her strength to overcome even the most horrendous obstacle. However, physically, she remained weak and disinterested in food for the rest of her life, while emotionally, even into her dotage, she

continued to have violent flashbacks of the experience.[69] In this regard, she did not succeed in overcoming state authority. She not only permanently damaged her health but also became consumed with an image of herself as a martyr, becoming fully fixated on equalizing women's status with men in every sense of the word.

After her release from prison, she required over two weeks' bed rest under the care of a physician. She recovered by early January 1910, resigned from the WSPU, and immediately returned to the United States, temporarily resettling in Moorestown, New Jersey. Reporters hounded Paul and her family with the hope that she would tell of her participation with the WSPU, especially her forced feeding experience. During January and February, she spoke publicly about her ordeals in jail. In each newspaper interview and public speech, she neglected to discuss how the forced feeding affected her. She preferred to focus on building American support for the WSPU.[70]

She also was invited to write an article in the *American Academy of the Political and Social Sciences,* a distinguished journal co-founded by her mentor, Simon Patten. In "The Woman Suffrage Movement in Great Britain," Paul defended the WSPU's militant tactics, arguing that this approach had helped women "throw off their mental bondage" and develop a "self-respect, a respect for their sex, unknown before." Such women were no longer willing to accept their subjection, laying the groundwork for the creation of a "new race of women" that "discarded the old ideal of physical and mental . . . dependence, and substituted the ideal of strength."[71] Remembering her brutal experiences with the police and prison officials in England, she began to articulate a conception of women as a class that would become galvanized by their collective strength and mutual rejection of male domination.

Outspoken, unapologetic, and uncompromising, Paul described members of the WSPU as exemplars of the new race of womanhood. She explained that the political awareness demonstrated by the WSPU indicated "the great change which has been going on . . . in the economic and social life of women." To Paul, the suffrage movement comprised a milestone marking another step in women's evolution. "To give votes to women would be a revolution, one is told again and again in Britain. But the revolution is already accomplished. The giving of the ballot would be but the public recognition of the change which social forces have brought."[72]

Paul continued to expound a progressive, yet limited view of women's lives in her dissertation "The Legal Position of Women in Pennsylvania." Based on her study of common-law traditions, she concluded that women's status had evolved "from complete subordination to the comparative freedom which has taken place in her legal position in this State." The basis of women's improved status, she wrote,

> is dependent upon the economic situation. The line of evolution . . . would seem to indicate that here at least it had been the increasing economic free-

dom of women and her increased participation, because of the economic changes in the great world of industry and communal existence, that had brought about such a change in her life of which her improved legal status was the expression.

Paul argued that women were better off in an industrial economy than they were when their responsibilities were centered solely on the home. As industrialization advanced, the change in women's status "has been one uninterrupted movement in the line of giving to woman greater and greater freedom from restrictions placed upon her by the common law."[73] Paul believed that the attainment of woman suffrage would continue the evolution of women's status, and that she could effectively influence that process.

Thanks to the support of Jane Addams, Paul was asked to lead NAWSA's Congressional Committee after she had completed her dissertation. She had built a respectable reputation among American suffragists who admired her bravery and commitment to the cause in England. NAWSA hoped to benefit from her vivacity and daring. Paul was more than ready to comply. As a NAWSA member, she is perhaps best remembered for leading a parade down Pennsylvania Avenue on the same day as Woodrow Wilson's presidential inauguration. This event captured the enthusiasm of suffragists who traveled to Washington, D.C. from across the country, demonstrating the unity of purpose across a variety of women's organizations. Such a blatant challenge to the cultural constructions of respectable womanhood culminated in public assaults against the protestors, both verbally and physically, while the police did little to intervene. Such an uproar certainly did not phase Paul. Indeed, she considered the march a success, drawing crowds away from the presidential inauguration, thereby showing Woodrow Wilson the power of the woman's vote and generating substantial favorable media coverage for the Nineteenth Amendment. Even the conservative, pragmatic NAWSA leaders viewed the parade in a positive light.

Over the next year, Paul attempted to keep constant pressure on the president and Congress, organizing a wave of deputations to see Woodrow Wilson and the formal presentations of suffrage petitions to members of Congress by representatives of state-level suffrage organizations nationwide. To ensure the strength of such efforts, she launched the Congressional Union for Woman Suffrage (CU), organizing this group within four years into the NWP, the first national political party that consisted solely of women. The CU quickly claimed victory in May 1913, when the Senate Woman Suffrage Committee reported favorably on the suffrage amendment for the first time in twenty-three years.[74] However, policy makers moved too slowly to satisfy Paul's drive to gain passage of the Nineteenth Amendment as rapidly as possible. To increase political pressure leveled by the suffrage movement, she returned to a strategy first learned as a member of the WSPU.

Using her position as the Congressional Committee chairperson, Paul built a loyal following among suffrage women at the state level and leveraged the visibility of the CU as a viable alternative to the more conservative NAWSA. She did not feel the responsibility to answer to NAWSA's leadership, and she used her position within that organization to build a power base for herself. First, she rejected NAWSA's policy of nonpartisanship, moving toward militant tactics to demonstrate the strength of organized women. The core of her campaign entailed redefining public space in a way that integrated women as influential policy makers and holders of political office. To achieve her goals, Paul called for blaming the party in power as a means to force the president and the Democratic Party to support the Nineteenth Amendment and push it through Congress. To effectively lay blame on the Democratic party for the failure to support woman suffrage, Paul launched a campaign to organize suffragists at the state level, especially suffrage states in the West.[75] By stepping up their local activity, the NWP worked to mobilize suffragists against Democratic candidates running for Congress. Such work, she explained, will "demonstrate to the Administration, to the majority Party in Congress, that the organization in Suffrage States does exist and that it is a power to be feared. . . . If in these months we can build up so strong an organization there that it really will be dangerous to oppose it, and if we can show Congress that we have such an organization, then we will have the matter in our hands." By readying the 4 million women in suffrage states, the NWP would appear as a unified political party of women for the purposes of using their vote to promote suffrage. Such unity and strength of purpose, Paul argued, would "terrify the men in Congress" and offer alternatives to suffrage organizations that "stand for feebleness of action and supiness of spirit."[76]

NAWSA failed in its attempt to prevent internal divisiveness by initially tolerating Paul's methods. Conflict began at the end of her first year as the head of the Congressional Committee. In December 1913, the treasurer reported during NAWSA's national convention that the Congressional Committee had failed to submit adequate financial reports so that she could complete the year's accounting process. She expressed her understanding that NAWSA was unable to finance the Congressional Committee's work, and that Paul agreed to raise money in the name of the organization. The treasurer explained that she had politely asked Paul how the National Treasury could best cooperate with the Congressional Committee, including how it should report on expenses for the suffrage parade held earlier in the year. In response, Paul informed her that she deposited the money received before the procession, explaining that the "small fund has been used for Congressional Work and is now about exhausted." The treasurer was uncertain whether Paul's response indicated an "unwillingness to establish financial connections between the Congressional Committee and the National Treasury" or a "failure to understand what is meant by financial connections." Though the treasurer had taken the matter before

NAWSA's National Board of Directors to review the situation, they ultimately decided not to take any further steps. The board reached this decision based on its concern that the Congressional Committee and their allied workers would accuse NAWSA of trying to wind them up in what had been called "its red tape," and that "their enthusiasm and interest would be crushed if they were not permitted to handle matters in their own way."[77]

At this point, Anna Howard Shaw decided to intervene. She determined that the CU reports would be submitted separately from its expenses to avoid future confusion regarding the use of NAWSA funds. Shaw also noted that the identical membership of the Congressional Committee and CU added to the confusion but made clear that the CU was accountable to the same standards as other NAWSA affiliates. Paul did not respond well to such demands, and she refused to submit separate reports. Though Shaw believed that each of us "should follow the tactics of our own conscience in the manner in which we work," she also argued that "greater confusion and dissatisfaction would arise within the ranks" of the organization and create factions if NAWSA retained Paul as the leader of the Congressional Committee.[78] With great haste, Shaw removed her from the position, describing her gratitude and recognition for Paul's "valuable work along lines of publicity and propaganda and the increased activity and interest of suffrage in Washington created by the Congressional Committee." Nonetheless, Shaw explained, it also was crucial that the Congressional Committee abide by NAWSA's constitution.[79]

Shaw selected Ruth McCormick as the new Congressional Committee chairperson, entrusting her with the responsibility to maintain amicable relations with Paul. After five days of negotiation, her efforts failed, and Paul withdrew from NAWSA. The following month, rumors and accusations began to fly. Paul allegedly claimed that NAWSA never allowed her to express her point of view, and CU state organizers were describing the organization as weak and ineffective.

As tension mounted between the CU and NAWSA, Shaw proclaimed: "[W]e are going to have a great deal of trouble and there will be no limit to the misstatements and misleading letters which will be sent throughout the country." She also believed that they "should take every opportunity to impress upon our auxiliaries the necessity of informing their members of the differences between the National Association, the Congressional Committee, and the Congressional Union."[80] Since the CU had successfully increased its presence at the state level, Shaw also contended: "[T]here never was a time when we needed more to put organizers out, to counteract the false impressions and false statements which are constantly being sent out from Washington. While some of the members of the CU deny that these statements emanate from Washington and, if we are to hold our own and make our people understand the true conditions of things, we have got to do the same public work."[81]

In addition to Shaw, McCormick and other NAWSA leaders began to describe the CU as "unscrupulous in its policies, deceitful, shrewd and skilled at deception."[82] When summarizing the situation, McCormick insisted that "Miss Paul had no right to make decisions for her association alone" and argued that NAWSA must decide "whether we are for an autocratic or democratic organization." She described the CU as "a farce" because "[m]embers pay twenty-five cents to belong, but have no voice in the government of the organization."[83] In addition to criticizing Paul's leadership style, she also attacked her personal character claiming that she was

> an anaemic fanatic, well intentioned from her point of view, but almost unbalanced because of her physical condition. She does not believe in spending more than 30 cents a day on her food, which illustrates her entire mental attitude toward the suffrage movement. She will be a *martyr,* whether there is the slightest excuse for it in this country or not, and I am really convinced that she will die for the cause, but it will be because of her 30-cent meals.[84]

McCormick thought that Paul had become so consumed by her political goals that she lost touch with reality. Despite her poor health resulting from her forced feeding, Paul was disinterested in food and ignored her personal health. She pursued her own agenda through any means necessary, and she was impervious to the opinions of other organizations. Increasingly, McCormick and her fellow NAWSA members emphasized the need to distance themselves from any affiliation with Paul and her organization.

Mary Ware Dennet, NAWSA's Corresponding Secretary and McCormick's friend, urged the Executive Board to stop working with the NWP. Though initially Dennet worked in good faith with Paul, she began to change her mind after finding a NWP member surreptitiously copying names and addresses from NAWSA's membership files.[85] By 1914, she had lost all faith in Paul's good intentions. Dennet wrote:

> I saw her yesterday. . . . She built up a nice wall around herself, and tried her best to find out what my plans were . . . I think the time will come shortly, if it is not here already, when we will have to take a firm stand as an entirely separate, though friendly enough organization . . . that will not be able to preserve the fiction of working along with them for common ends.

Dennet claimed that Paul had not organized a union of women that pursued suffrage; rather, she accused her of forming the NWP with the plan to exert her power over NAWSA. Dennet argued: "[W]hen Miss Paul got into this work she saw an opportunity to build . . . an independent organization. She put the Union to the front and chloroformed the National."[86] Dennett argued that NAWSA should

take a firm stand against Paul's leadership and work closely with media sources to cultivate compelling criticisms of NWP tactics.

Anna Howard Shaw, President of NAWSA, agreed with McCormick and Dennett. She wrote, "[A]s I hear reports that are being circulated, I am becoming convinced of the unwisdom of having anything particular to do with them. Miss Paul's inability to speak the truth, or to state a thing as it is, is beyond understanding." She argued that many women "who do not understand the situation might be dazzled by their brilliant, loud and spectacular work." However,

> so long as we keep them dangling on a string and letting our sympathies overcome our judgment and our moral energies consist of a tow-string instead of a back bone . . . will our work be delayed. . . . Personally, I have not done much else, except write letters in regard to it and denying statements which have been made by them.[87]

But that was the extent of Shaw's reaction to Paul's repeated challenges to her leadership. Paul's challenges to NAWSA's organizational strength were, to a certain extent, legitimate. Shaw was not as forceful a leader as her successor, Carrie Chapman Catt. She lacked the administrative ability to conciliate the increasingly turbulent differences between the national and state associations. At the end of her eleven-year presidency, the national treasury was virtually bankrupt following the unsuccessful 1914–1915 state referenda campaigns. In this context, many NAWSA members and suffrage sympathizers believed that the movement required new leadership. Paul helped fill that void.[88]

As Paul built her organization into a self-sustaining force and demonstrated the political savviness necessary to sustain the CU, she instilled fear in the hearts of NAWSA's leadership. These women were clearly appalled by her militant acts, and they were absolutely convinced that Paul would undermine the legitimacy of the suffrage movement. Paul proved these women wrong, playing a key role in propelling the suffrage movement forward. However, the tactics she used increasingly isolated her and her organization from the mainstream suffrage movement. After formally splitting from NAWSA, she evolved the CU into the NWP, a political party comprised only of women who used any means necessary to achieve one goal—passage of the Nineteenth Amendment. When blaming the party in power did not sway the president or Congress, Paul organized "Silent Sentinels," picket lines of women who stood silently in front of the White House carrying purple, white, and gold banners that asked questions such as: "Mr President, What will you do for woman suffrage?" From January to June, the District police allowed the women to gather outside of the White House. As wartime concerns pervaded public opinion, however, public impatience with the NWP mounted. The women were increasingly viewed as seditious, because they wielded signs that challenged the premises of American democracy and referred to the

president as "Kaiser Wilson." Despite the impending threat of arrest, the NWP re-
fused to disband, arguing that it was exercising its constitutional right to free speech.[89]

Lashing out at the president and questioning the foundations of American
government created an incendiary domestic altercation. Beginning in June 1917,
the police arrested hundreds of suffragists for obstructing traffic and held them in
either the District jail, the abandoned workhouse connected to the jail, or
Occaquan Prison in Virginia, for terms ranging from three days to seven
months.[90] Knowing that she would be arrested, Paul led a delegation of women to
the White House on October 29, 1917, receiving a sentence of seven months.

As a suffragette in England, Paul learned how to politicize the body to build
public awareness and criticism of forced feeding. She used her smallness and frail-
ness as a symbol of political starvation. In WSPU fashion, she protested her arrest by
refusing all food "until she and her companions received the same treatment as sev-
enteen murderers, who have the privilege of special food, air, exercise, and the news-
papers." She weighed a mere ninety pounds and suffered from health problems that
resulted from her forced feeding in England. After refusing food for seventy-eight
hours, prison officials transported Paul to the Asylum Hospital and fed her by
force.[91] Though Paul never spoke publicly about her ordeal, we do know how con-
cerned her sister, Helen Paul, was about her safety. According to the *New York
Times*, Helen believed that prison officials would kill her sister if they forcibly fed
her. "She has never been able to tell me about her experiences in England, it was so
horrible, and I know that she cannot go through it again." She did not, however, un-
derstand how martyrdom and self-sacrifice influenced Paul's understanding of the
suffrage movement.[92]

Paul was very much aware of her public image, and she carefully crafted the
persona of a self-sacrificing martyr, a persona she fully believed. Forced feedings ir-
revocably galvanized her to resist the government's refusal to grant women full po-
litical participation. Paul contended that the swift and harsh response from the
president and the police demonstrated the NWP's powerful influence as a political
party of women. She argued:

> The vigor with which the Administration is seeking to crush the picketing
> indicates . . . the effectiveness of this form of agitation. Every day that the
> Government sends women to prison for holding harmless banners . . .
> makes the position of the Government more indefensible and therefore
> strengthens our position. We are full of hope that if we can only continue
> and increase the agitation the situation may become sufficiently serious to
> lead the Administration to take action on the suffrage amendment.[93]

Those who supported Paul's tactics believed that she created a new spirit. Her sup-
porters were no longer simply eager to please or afraid to fight for their rights. Instead,

the only fear "is on the faces of the legislators." Women had a new respect for themselves, because they were free intellectually and politically. Recognized as a supreme politician, Paul's supporters assured her that her place in history would be secure.[94]

NAWSA, based on its concern about how Congress and the president would respond to Paul's militancy, attempted to build momentum for its own media and publicity strategies. With assistance from Ethel Smith and her contacts with the media, NAWSA attempted to convince press writers that the NWP's militant tactics toward the president emanated from a small group of women that did not really represent the suffragists of the country. She asked the media to help the public understand the distinctions between NAWSA and the NWP.[95] She explained that NAWSA was a federation of statewide suffrage leagues all over the country, numbering 2 million members, that did not support militancy or defiance of the law. Based on their fifty years of legitimate suffrage work, Smith claimed that NAWSA really represented the true interests of the suffrage movement, therefore, she asked media representatives to omit the word "suffrage" in reports of NWP activities and to instead use the words "militants" and "pickets" to identify them as a group wholly separate from NAWSA. According to Smith, "To call them suffragists brands all supporters of the principle to woman suffrage with a stigma utterly undeserved."[96] While attempting to strengthen relations with the media, NAWSA also rejuvenated its Washington Committee, gathering lobbying forces from all parts of the country to apply persistent pressure on Congress to pass the Nineteenth Amendment.

In the latter years of the suffrage movement, Paul continued to hold the Democratic Party responsible for preventing the completion of the suffrage movement, staging dramatic public protests and meetings that captured local and national media attention. Her actions significantly motivated NAWSA to assume a more assertive stance as the largest suffrage organization. By the time Congress passed the Nineteenth Amendment in 1920, Paul had undergone a complete transformation from the playful freshman and the curious graduate student to a fearless force within the WSPU and an outspoken, uncompromising leader of the American woman suffrage movement. In her search for a meaningful career, she found her niche as the leader of her own suffrage organization.

Paul viewed herself as a martyr who selflessly went to jail and endured forced feedings to secure a "more fundamental freedom." She continued such self-sacrifice into the 1920s, fully devoting her attention to drafting and redrafting versions of the state equal rights bills and the ERA. According to Elsie Hill, Paul "has been steadily the predominant council of the drafting committee. . . . One makes no mistake in working with Alice Paul. . . . She remains in her room all day these days and we do not interrupt her for anything."[97] Paul refused to adhere to beliefs other than her own and built a loyal following of women who shared her vision of a new class of women. She constructed this vision of womanhood based on her social work training and apprenticeship with the WSPU. At this early stage in her

life, she had already determined that the impoverished class accepted the social and economic limitations placed upon them by an industrial society. Because they chose not to change their behavior, she believed, they remained victims of high unemployment and low wages. By rebelling against political and legal inequalities, the militant women of the WSPU had already demonstrated their power as a group. Paul attempted to mobilize American women to build on the WSPU's accomplishments and to further the progression of a politically powerful class of women. For her constituency, mid-to-upper-class women, that meant breaking off the shackles imposed by antiquated political and legal precedents that maintained Victorian notions of womanhood. Paul believed that the time for a bold new style of womanhood was upon them, and she was poised to lead the way.

3

"[S]ome Group of Women Must Keep on Developing the Power of Women As a Class"*

The National Woman's Party, 1921–1923

Both Ethel Smith and Alice Paul emerged from the suffrage victory exhausted, in poor health, and more determined than ever to continue the battle to achieve full political and legal equality for women. We already know that Smith focused intently on labor legislation to equalize women's status in society and viewed the suffrage movement as a means to build support for the unionization of women workers, the eight-hour day and minimum wage laws for women. She continued to wage these battles following the suffrage victory. By the early 1920s, she had helped shape hard-fought legislative victories that were achieved after years of persistent lobbying, coalition building and grassroots organizing.

As Smith and her supporters celebrated ratification of the Nineteenth Amendment, they looked eagerly toward the future, hoping to retain the unity of purpose achieved during the suffrage movement and to build on their accomplishments in the movement toward equalizing women's position with men in both the labor force and society as a whole. However, Smith confronted formidable obstacles in the 1920s. She waged an uphill battle in her ongoing efforts to organize women into trade unions, to foster governmental responsibility for the conditions of women's employment, and to integrate the perspective of the women's labor movement into the larger, male-dominated labor movement. As Smith pressed forward, she at the same time was forced to contend with the threat of her most contentious opponent—Alice Paul—who introduced a legislative agenda that undermined the constitutionality of her approach to equal rights.

In the months following passage of the suffrage amendment in 1920, Paul took several preliminary steps to prepare her organization to assume leadership of the ongoing struggle to achieve equal rights for women. First, she prepared to introduce legislation at the state and federal levels to establish that women should have equal rights with men under the law. Rather than immediately going public with her intentions, she instructed her legal researchers to complete a preliminary survey of laws that affected the position of women in select states. By November 1920, this initial research revealed how systematically state laws excluded women from such basic citizenship rights as sitting on juries, divorcing a spouse, and controlling their

* Elsie Hill to Mrs. Mary E. Garbutt, Washington, D.C., April 10, 1921, reel 7, NWPP.

wages. Based on this evidence, she concluded that the right to vote had little mean-
ing if women remained subject to legal inequalities that prevented them from fully
participating in all aspects of social and economic life.

Second, Paul worked to awaken women from their apathetic state and mo-
bilize them to demand the equality they deserved. When viewing the situation of
women in the 1920s, she proclaimed, "The disgraceful situation in which women
find themselves today is their own fault. They remain a subject class because they
have no sense of solidarity." Because women had not united to rebel against their
subjection, men continued to prevent them from having what they wanted for
themselves. She argued, "Men will take all they can get in the way of service and
money from women, but they will not part with one bit of their power." Such per-
sistent forms of subjection prevented women from achieving their full potential in
politics, business, and professional pursuits.[1] To transform how American women
perceived themselves, Paul looked toward the future and worked to establish the
NWP as the leading women's organization that existed solely for women.

Finally, Paul hoped to build the support of a broad following of women's
organizations by appealing to their pride as participants in the most historic mo-
ment in women's history, the victorious passage of the Nineteenth Amendment.
To do so, she announced that the NWP would host a national convention in Feb-
ruary, 1921 to commemorate suffrage pioneers Elizabeth Cady Stanton, Susan B.
Anthony, and Lucretia Mott. Paul commissioned the artist Adelaide Johnson to
complete a marble statue of these women, and she arranged for a procession in the
Rotunda of the Capitol building.[2] During the ceremony, row after row of women
clad in white, wearing ribbons and carrying banners with the names of their re-
spective organizations, gathered to celebrate their contributions to the suffrage vic-
tory. By evoking the symbolism of the suffrage pioneers, Paul convinced hundreds
of women to participate in the dedication, forgetting the battles they waged
against the NWP in the years prior. NAWSA, which became known as the League
of Women Voters (LWV) after 1920, was the most noted absence on the list of
convention participants.

In addition to the goals of the dedication ceremony, Paul explained, "We
have called this convention together to close up the work connected with the suf-
frage campaign and to turn over to you the question of the next step." She
specifically told her audience that their input would be crucial in determining
whether the NWP would continue the battle for women's political equality along
different lines, or if it would disband.[3] One by one, representatives spoke before the
convention, outlining the work of their respective organizations to the applause of
an elated audience. The stage was set for conflict, however, because behind the
scenes Paul and her supporters had already established the agenda that they would
pursue for the remainder of the 1920s. While event participants assumed that their
views would influence future directions of the NWP, Paul ultimately rejected all

proposals for cooperation and publicly announced that her organization would pursue state equal rights bills as well as a federal equal rights amendment.

Paul believed that the perpetuation of long-held and antiquated gender discriminations justified the organization of women—as women—to change the law. She mobilized her followers under what she called a "feminist" program, which focused solely on achieving full political and legal equality for women.[4] She claimed that remaining forms of legal discrimination created a common experience among women that united them across racial and economic differences, and that their unwavering support to eradicate all legal inequalities would create a world in which women would have all of the same rights and opportunities as men. With this goal in mind, she reorganized the NWP under the same name and mobilized her followers to support an agenda designed to efficiently and quickly sweep away all sex-based distinctions embedded in American law and culture. She determined that the NWP would begin "with the legal disabilities as the most obvious and easy to attack. As soon as these are swept away, the organization plans to take up one of the other forms of discrimination and then another form, and so on, as long as any kind of discrimination against women exists."[5]

Paul's agenda called for the mobilization of forward-looking women who, with single-minded devotion, would follow her leadership without question. Her most ardent supporters were politically active, socially prominent, highly educated, and upwardly mobile. They were impatient and did not hesitate to demand their full rights as citizens. Unified by the "aim . . . to get as much power in the hands of women as there is in the hands of men," Paul and her followers embarked on an ambitious campaign to challenge tenacious Common Law notions of women as dependent and weak and to eliminate all legal obstacles that interfered with their right to pursue the career of their choice, to run for political office, and to achieve economic mobility based on the merits of their professional capabilities. Paul and her supporters argued that the establishment of full legal equality between men and women as a constitutional provision would create "a woman's and man's world with each sex participating equally in control of government, of family and of industry."[6]

She believed that focusing on one goal—achieving the full political and legal equality of women through state and federal equal rights legislation—would lead to quick victories at the state level and help build momentum for the NWP's lobbying at the federal level. She identified this strategy as "the most obvious," and easiest way to build on the political gains of the suffrage victory and to bring her vision to fruition.[7] Though convention participants also sought to build on the momentum of the suffrage victory, the great majority of these women considered her approach to equal rights too narrow and not reflective of the needs of the masses of women. When Paul went public with her agenda, many conference participants were hugely disappointed. (This disappointment was shared by members of the NWP.)

Some NWP members hoped that Paul would consider tackling the discrimi-

natory attitudes underlying the ongoing disfranchisement of African-American women. Mary White Ovington, President of the National Association for the Advancement of Colored People (NAACP) and member of the NWP's Advisory Council, asked Paul to organize during the convention a committee of women that was committed to "investigating and taking action to redress the inequities affecting African-American women."[8] Florence Kelley, also a member of the NAACP, the General Secretary of the NCL, and a member of the NWP's Advisory Committee, believed that the NWP had "welshed on the Negro question" and missed the opportunity to launch "one of the most hopeful events thinkable for this new year."[9]

Another member of the NWP's Advisory Council, Ella Rush Murray, submitted a minority report requesting that convention proceedings include recognition of the remaining political inequalities that affected African-American women, especially in the South. She asked that the NWP create a committee . . . "to bring pressure to bear on Congress for a special Congressional Committee to investigate the violation of the . . . 19th Amendment." Unlike Ovington and Kelley, however, Murray remained loyal to Paul's wishes and optimistically embraced her belief that all women, regardless of race, have the capacity to succeed simply by working energetically to capture media attention and to establish a presence on Capitol Hill.[10]

While internally NWP members were mixed on the issue of race, externally other women were insulted by Paul's stand on the issue. Most notably, Mary Church Terrell, Honorary President of the National Association of Colored Women (NACW), led a delegation of sixty African-American women to see Paul three days before the convention to get her to directly and accurately state her position regarding disenfranchised women. When looking back on the meeting, Terrell remembered that Paul refused to answer any direct questions, including whether or not she endorsed the enforcement of the Nineteenth Amendment. Because she would not discuss her perspective, Terrell concluded that Paul "displayed the most painful lack of tact I had ever seen."[11] Freda Kirchwey's scathing article in *The Nation*, "Alice Paul Pulls the Strings," further criticized how the women of the deputation were treated. She wrote that, "Miss Paul was indifferent to this appeal and resented the presence of the delegation."[12]

Paul refuted the claims of both Terrell and Kirchwey. She argued that "[We] . . . decided to give the same opportunity of appearing at the convention to negro women as was given to the white women."[13] As the leader of the NWP, she emphasized the need for preventing internal divisions. The disfranchisement of African-American women became one issue that she attempted to evade to prevent internal dissension. By admitting African-American women into the convention, Paul explained,

> we had a great deal of difficulty with some of the southern delegates. . . . Our
> entire North Carolina Delegation, for instance, left the Headquarters, even

refusing to register as delegates when they found the position we had taken with regard to the negroes, and it took considerable time before they were reconciled to attending the convention. They finally agreed to attend all of the sessions excepting the dinner to which they refused to come since we were allowing negroes to come to it. Mrs. St. Clair Thompson, our North Carolina chairman, for instance, did not receive her picket pin during the convention because she was unwilling to attend the dinner on account of the fact that Mrs. Terrell, a negro woman, was expected to attend the dinner and receive her pin.[14]

Considering that Terrell had picketed with the NWP during the suffrage years and was scheduled to receive a special suffrage pin awarded to all protestors who went to jail, it was unfortunate that Paul did not take a stronger stand on the issue. Instead, she continued to defend her position by saying, "I dislike to have the Party made to appear as willing to do an injustice to the negro women, who are included, of course, in the bill providing for the enfranchisement of *all* women without regard to color, and the negro women have so much to endure from the rigidities of the Southern people." She also felt that the NWP had recognized them as belonging to the same sex, which all of the states were forbidden to disfranchise.[15]

By preventing the NWP from officially affiliating with efforts to establish equal rights for African-American women, Paul alienated her most prominent supporters and helped precipitate the steady decline of her organization's membership. Rather than addressing this very important issue head on, Paul went on the defensive and complained that the NWP had been attacked from all sides. She felt that her work was done, because she had consented to allow representatives of African-American organizations to speak. Rather than offer her personal opinion, she attempted to ameliorate the tension that evolved around the issue of racial discrimination and avoid any recognition that the law did not affect *all* women in the same way.

It also is important to recognize that the early 1920s was the nadir of race relations in the United States. Taking a public stand on this issue would antagonize the NWP's Southern membership base and severely limit the NWP's effectiveness to achieve its legislative goals. Without the active participation of Southern women, Paul's lobbyists would lose their legitimacy among Southern members of Congress. Though she knew how her Southern constituents approached the issue of race, by avoiding the issue she tacitly accepted the perspectives of such women as Ellen Crump, state chair of the NWP's Mississippi branch. Early in the campaign, Crump specifically warned Paul, "The southern people are bitterly opposed to race intermixtures of any kind, and I am heartily in support of this. . . . I am unalterably opposed to aliens in our councils, and race intermixture of any kind."[16] She argued that the NWP could not "share with another race the government of ourselves," because white women's interests were independent from the interests

of African-American women. She continued, "[R]ace mixture-miscegenation, to me, is a crime against *GOD* and man. I have reason to think that this sentiment is the same with all races among those who have pride of race."[17]

In an oral history interview conducted in the 1970s, a long-term NWP member, Mabel Vernon, remembered that Paul shared Crump's sentiments. She was "very nice to individual Negro women," but "has those prejudices" when dealing with African Americans as a race.[18] Though Vernon obviously was not alone in her beliefs that Paul was racist, there is no specific record that she ever articulated a racist comment and no evidence that she (as an individual) was prejudiced. She explained her reluctance to take up issues pertaining to race as a pragmatic decision to remain focused on a single issue—the passage of state and federal equal rights legislation. She viewed equal rights from a predominantly class-based and formal legal perspective.

From the start, Paul struggled to cultivate the support of new constituents not so much because of her commitment to equal rights but because of the political philosophy that she and her supporters used to advance their legislative interests. Unlike Smith, she believed "that just as we came into the [suffrage] fight when the worst days of the struggle were over, so we are coming into the legal, educational, professional and economic struggle after a very great deal of progress has been made, and the hardest part of the battle is behind us."[19] This optimistic assessment of women's status applied primarily to the upwardly mobile, professional women who dominated the NWP's ranks. Such a sweeping statement, however, excluded the interests of Smith's wage-earning constituency.

At the same time Paul increasingly focused on meeting the needs of her constituents, she also entered into negotiations with Smith and her supporters to discuss the potential impact of the NWP's equal rights legislation on women's labor laws. After reviewing an early draft of the amendment and seeking advice from prominent attorneys during the period, Smith concluded that the ERA caused "much discussion and apprehension among the friends of social legislation."[20] Since Paul had never compromised on anything she believed in, it is questionable what her intentions were by agreeing to these meetings. Evidence shows that before meeting with Smith, she had already sought the opinion of at least one legal expert, clearly anticipating the conflict that eventually erupted.[21] Though the intent of the meetings was to keep the peace between all organizations involved in the conflict, Paul's attitude was considered evasive, because she refused to reveal her personal stance on women's labor laws. While publicly claiming that she did not have a position on the issue, at the same time she told her supporters that "most women may want to demand only a compromise measure giving much less than the total equality that we are after, we should still demand our final ideal and not compromise on our demand."[22] In another private correspondence, she also revealed, "I do not believe in special protective labor legislation for women but be-

lieve that protective labor legislation should be enacted for women and men alike in a trade or in a geographical district and not along sex lines." After substantial conflict erupted, she told her supporters, "[W]e have consulted many lawyers on this subject and the consensus of opinion among them is that the amendment will not affect welfare legislation for women."[23] Finally, she wrote, "[T]here may, of course, arise some temporary difficulties in making readjustments, but it seems to me that we can risk these if we are sure the big principle that we are trying to establish is right."[24] As we will see in the final chapters, this statement concealed a complex situation.

The conflict with Smith and her supporters was just what Paul needed. At this early stage in the NWP's campaign, such debates kept the NWP and its agenda in the public light, generating substantial attention among women's organizations and, at times, the media.[25] Such publicity was essential between 1921 and 1923, for a number of factors. Paul was "rather alarmed about our membership. Scarcely any members are coming in at all. Our membership for the whole country [is] still under 400, and if we do not begin to increase membership soon, we shall not be able to call ourselves a national organization any longer."[26] The decline in membership meant that the NWP lacked the resources to organize at the state level to build momentum for their state and federal equal rights legislation. Adding to this dilemma, the NWP lacked the financial resources to house a fully-paid staff. Fortunately, Alva Belmont commissioned the salaries of Paul's two most important supporters, Elsie Hill, the Executive Committee chairman, and Burnita Shelton Matthews, the leading force behind the NWP's legal research.[27] Finally, at a time in which the NWP struggled financially, opposition to its agenda picked up steam. Paul continued to welcome such controversy to generate public debate and potentially increase the NWP's membership base.

By the end of 1921, Paul had successfully held her opponents at bay, buying the much needed time to stabilize her organization and to develop a long-term strategy to build her membership ranks and garner sufficient backing to introduce a federal ERA to the Constitution. In addition, as a supreme politician, she was not beneath spreading false accusations about her opponents' actions. To explain to her most ardent supporters why the ERA campaign had not proceeded at a more rapid pace, Paul claimed:

> [T]he reason that we have delayed the introduction of the amendment was in order to have it drawn up so as to avoid the field of industrial legislation, since women are divided as to what legislation we ought to have in this field. We have taken the proposed amendment to most of the people who we were told were authorities on welfare legislation, and asked them to draw it up in such form as to safeguard their legislation. We have not been able to get them to draw up anything, however, as they state that any amendment or

blanket bill may imperil their legislation and that they do not want us to have either an amendment or a blanket bill.

According to Paul, she had attempted to work with her opponents in good faith to ensure that the NWP's proposed legislation would not touch welfare legislation at all. Paul felt that in return for her generosity and willingness to compromise, her opponents refused to respond to her requests. As a result, she had "abandon[ed] hope of aid from them in drafting the measure."[28] This was not a completely forthright explanation. Both women became involved in a highly technical legal debate that put them on the cutting edge of efforts to determine the regulatory function of the state and the bases for defining individual rights.[29]

As NWP state branches pursued ratification of equal rights bills, defenders of women's labor laws mobilized to oppose such legislation. Paul singled Smith out as the most vocal opponent to the activities of local NWP branches. She explained: "The Women's Trade Union League, under the leadership of Miss Ethel Smith, is conducting a vigorous campaign against our bills in the state legislatures, and the Consumers' League and League of Women Voters are also joining in this campaign." Smith's activities angered Paul, especially since she ensured the inclusion of a clause in their equal rights legislation that specifically limited its application to civil and legal issues affecting women, not industrial legislation. To explain Smith's opposition to NWP members, Paul rationalized that Smith's attitude was "probably merely a survival of the old suffrage fight."[30]

We know directly from Smith herself, however, that she was not harboring old animosities toward Paul. Though Smith did not support Paul's suffrage tactics, she never became too concerned about the NWP's activities. In addition, not only did she gladly accept Paul's invitation to attend and speak at the NWP's February convention at a time in which she was still recovering from severe exhaustion, she also was one of the few convention participants who felt optimistic about the outcome of the proceedings. Smith's animosity began a few months later as she increasingly believed that Paul did not care about protecting women's labor laws. By September, Smith concluded, "It is perfectly clear that they will not be diverted from their purpose to introduce the amendment. . . . Furthermore, I'll wager anything I possess that Alice Paul herself is fundamentally opposed to special legislation for women."[31] Her suspicions were correct. Paul opposed labor laws for women, because restrictions on the length of women's working day, rate of pay, and type of work performed limited the terms of the labor contract and prevented women from competing freely and equally with working men. As a result, "the lack of equal opportunity brought about by sex legislation has resulted in many cases in the woman's [*sic*] losing her position" and being forced to struggle professionally and economically.[32] According to Paul, "Feminine opponents of the equal rights amendment promulgated by the National Woman's Party are in the same

intellectual conditions of women in the harem or the negro before the abolition of slavery—too apathetic of their conditions to want to get out of it."[33]

Finally, in early 1922, Paul responded directly to her critics by saying, "[T]he object of our organization should not be sacrificed or compromised in order to get [the] endorsement" of women such as Smith. Paul was not one to compromise her position, and she emphasized the flawless nature of her campaign. She argued, "[T]he Woman's Party is working for a righteous program and one that therefore will ultimately become the law in one form or another."[34] However, she later contradicted herself when responding to an inquiry from the WTUL's Elizabeth Christman. Paul told her that the NWP had taken no position on women's labor laws, and that her legal researchers were still investigating the impact of equal rights legislation on women's labor laws.[35]

Despite what Paul told both her supporters and critics, it is clear that she increasingly focused on the federal ERA as the most effective means to "remove not only the discriminations under the control of separate states but also those existing under the national jurisdiction." She explained:

> It would seem that the most dignified, swift and permanent way to equalize the legal and civil status of women with men would be to write that principle of equality of rights, privileges and immunities into the basic supreme law of the land, and for that reason our legal advisors are attempting to phrase a national constitutional amendment.[36]

Paul understood the complexities of American law and the political process. In 1922, she attended George Washington University and the Washington College of Law, acquiring legal training on women's legal status and, especially focusing on Common Law traditions that restricted women's freedom of contract and exclusion from full participation in the workplace.[37] From her dissertation research, we know Paul believed that women's status had evolved from complete subordination resulting from strict domestic responsibilities to increasing freedom created by industrial expansion and urbanization. She built on that analysis as a law student and used this argument to justify the continuation of her ERA campaign.[38]

Paul's commitment to develop the power of women as a class required building a new public image of respectability for her organization. She surrounded herself with strong-minded, talented women who unequivocally shared her vision. Alva Belmont, wife of Cornelius Vanderbilt, assumed the presidency of the NWP in October 1921, contingent upon Paul's agreement to become vice president. Though Belmont served in this capacity for the next twelve years and donated large sums of money to ensure the continued success of the NWP, her title was largely honorary.[39] While Belmont exercised significant influence in terms of money, Paul remained at the reins of power. According to one NWP member,

"One makes no mistake in working with Alice Paul as a leader. She remains in her room all day these days and we do not interrupt her for anything."[40]

With Belmont's financial backing, Paul and her supporters were well prepared to launch an elaborate media and public education strategy that evoked the cultural and historical symbolism of American government and the history of women's political activism. First, in May 1922, the NWP selected a headquarters "of great historical interest, rich in stories of great men where great women will now assemble." Purchased in full by Belmont, the new headquarters stood at the center of government.[41] Through press releases and public education material, the NWP explained in detail the historical significance of its purchase, linking the organization to the broader history of the nation and establishing its unique position within that history. The NWP's materials made clear that its headquarters had been known as the "Old Capitol" building in the early nineteenth century and had served as the site of President James Monroe's inauguration. When the building had not been in the service of the government, it had been the "home of distinguished statesmen and jurists. To mention a few of its residents, Senator John C. Calhoun of South Carolina lived and died here; Senator Spooner of Wisconsin and Supreme Court Justice Field also occupied the house at various times." By evoking the history of distinguished policy makers, the NWP attempted to create a new future for the property "as a visible symbol of the new relations of women to the problems of national life."[42]

Thousands of women "of all opinions, occupational groups and political faiths participated in the dedication ceremony—not necessarily in support of the legislative program of the National Woman's Party, but in honor of the establishment of the first permanent national political headquarters of women at any capital in the world."[43] The ceremony did not simply celebrate the purchase of the building itself but also the advancement of professional women. Delegations of doctors, dentists, lawyers, artists, businesswomen, and those in other occupations participated in the dedication ceremony, heightening public awareness of women's overall professional and economic accomplishments.

With these prominent, highly successful women on public display, the NWP introduced a new declaration of women's rights. This declaration translated the visible accolades of professional mobility into a profound political message that situated the NWP's agenda on a continuum of historic moments in American political history. By evoking historic symbolism, the document aimed to electrify women to "dedicate [them]selves anew with the glorious task of establishing justice and complete equality between men and women."[44] The document proclaimed:

> We hold it to be a well founded grievance that the great historical charter, bills of rights, declarations, constitutions, and statutes which widen the bounds of liberty were all drawn up and adopted by men alone without the

participation or consent of women, and that they not only failed to recognize the rights of women but in many instances impaired and injured these rights, so that Woman's position was worse after the promulgation of such charters, constitutions, and so forth, than before. We view with burning indignation the mediaval [*sic*] restrictions and disabilities embedded in the state Constitutions and in the Laws, both state and Federal.[45]

By referring to their document as the "Magna Charta," the NWP harkened back to the historic symbolism of the original charter as a proclamation of human rights during a period of tremendous exploitation of men and women. The NWP's Magna Charta was described as a continuation of great charters throughout history that demanded equal rights and opportunities. From the declarations of women's rights during the French Revolution to Mary Wollstonecraft's *Vindication of the Rights of Woman*, the Magna Charta captured the spirit of all that came before, establishing a framework to benefit all of humankind. The document underscored the NWP's commitment to free "Woman from subjection to man and the mind of Man himself from base prejudices and low ideals with regard to Woman."[46] In other words, the Magna Charta called for ending the stereotypes and discriminatory attitudes that shaped American culture and politics.

To demonstrate the overwhelming need to challenge Victorian stereotypes about women's place in society, Paul continued to generate public education materials that emphasized the persistence of the nation's most tenacious forms of discrimination. She believed that creating a foundation of knowledge would be "the most effective way to increase public awareness of legal discriminations that affected women and to challenge existing prejudice."[47] In the months following the 1921 convention, she mobilized a group of devoted women attorneys to produce "the first comprehensive legal study of the position of women ever made in the United States."[48] As the Research Committee produced a series of pamphlets that outlined the discriminatory nature of laws in each of the forty-eight states, the organization incurred an estimated debt of $10,000. As an outstanding fundraiser, Paul felt confident that she could raise that money through her personal connections and by galvanizing new communities of women through the distribution of the digests.[49] She eagerly tasked her researchers with the job of completing all of their research before the NWP's November, 1922 conference. Without this research, Paul explained, they could not be prepared with any program for the next Congress and state legislature if they did not pick up the pace. She impatiently concluded, "[I]f we cannot be prepared with a legislative program, it seems to me we might as well go out of existence."[50]

Producing the digests was a time-consuming effort that required long hours each day in the Supreme Court Library, scouring volumes of case reports, statutes, and constitutional amendments produced by each state.[51] Adding to the daunting

nature of this task was the fact that information was selected by the higher courts in each state, meaning that additional research was required to ensure that issues pertaining to women's rights were not excluded from the final reports produced by the states. As the NWP's lawyers examined state digests, their primary task was to highlight issues affecting women's subordination under the law, most notably Common Law restrictions, such as women's exclusion from jury service, lack of control over earnings, and property and restrictions on the right to contract. Since these restrictions were ingrained in American culture and politics rather than specifically enumerated in constitutional law, this research not only intended to raise awareness of such limitations but to mobilize a constituency dedicated to eradicating such inequalities quickly, without apology or compromise.

To complement the work of the Legal Research Committee, Paul organized councils of NWP members by profession to raise awareness of the extent to which women still struggled for equal opportunity and recognition in their profession and to develop strategies to eradicate the prejudice and tradition that limited the opportunities of professional women. In the long run, the creation of such councils also would "create a strong group of women lawyers, doctors, or writers for advice and counsel of special problems" and help build the legitimacy of the NWP's cause among women within the various professions.[52] For example, the secretary of the Physician's Council wrote to Dr. Alice Hamilton, a proponent of women's labor laws, to explain the substance and purpose of the NWP's Research Committee. She explained that through investigation and public education, the Physician's Committee could play a significant role in raising awareness of existing discriminations in the field affecting women. Specifically, she told Hamilton how the NWP addressed their research on intern opportunities for women in the medical profession. This research revealed that out of 462 hospitals included in the survey, only forty admitted women as interns. As the Physician's Committee raised awareness of this issue, they successfully captured the attention of the American Medical Association (AMA), "stirring up discussion of the whole question of intern opportunities for women." She used this example to illustrate her belief that the NWP expressed "the feminist theory of life that women shall have complete freedom for training and self-expression in every field as individuals and not as a sex." Through the councils, the NWP classified its members by profession, with the hope to "open the doors of opportunity and recognition to women in every profession" and to establish recognition of women as equals with men in all professions.[53]

Despite the evidence of remaining discrimination's affecting professional women, Paul's critics complained that the NWP's research did not focus on discriminations against all women. Florence Kelley resigned from the NWP's Advisory Committee in 1921, claiming that Paul's organization "will not be every woman's party." She argued that "[f]rom the membership of the Woman's Party, wage-earning women, who now number approximately ten million, are, and always have been,

conspicuously absent."[54] She believed that "young women, who are not in daily touch with the wage earners, are easily captivated by empty phrases about equality of opportunity."[55] Kelley attempted to convey to Paul the importance of recognizing that wage-earning women lacked the leisure time to "conduct long, arduous, costly political campaigns." Consequently, "[T]hey are beneficiaries of the efforts of others in the long struggle for political equality."[56] Indeed, the numbers of wage-earning women were disproportionately ". . . larger than those in professional fields in the labor force in general. For example, during the 1920s, women in medicine, law, and higher education comprised less than 1 percent of all gainfully employed women.[57]

Though some wage-earning women were among the ranks of the NWP, they were not Paul's primary constituency. Considering the NWP's minority status in the women's movement and her unrelenting drive to achieve her goals, she cultivated elite women as potential members of the NWP, solicited their financial support and the use of their names to promote an image of legitimacy for the organization. With this in mind, Paul worked closely with Hazel MacKaye, director of Pageantry for the NWP, to develop a long-term plan to "stimulate the interest of these women" and to impress them with the work conducted by the organization.[58]

Paul found a kindred spirit in Hazel MacKaye. Together they orchestrated a series of pageants to sell state and federal equal rights legislation to the public.[59] Paul believed, "[I]t is a day when everything, whether merchandise or ideas, has to be 'sold' to the public." She argued that the NWP needed to "awaken women to a consciousness of their often en-slaved and invariably inferior status in the world." MacKaye understood that Paul's equal rights agenda was "not sufficiently popular to recruit more than a few members of the community. Most of the people will have to be appealed to through their personal desires and ambitions, not their principles."[60] MacKaye's primary goals included cultivating new members, raising money, and facilitating political action. The methods of achieving these objectives included devising the appropriate strategy to present the pageant in each community. "People must be made to feel that it is a beautiful 'show,' that it has prestige . . . that they will feel a pride in being concerned in it and that it will give them a good time." She described pageantry as a means to an end, with the ultimate goal of gradually enlightening women about their legal status and mobilizing them to take action against the inequalities imposed upon them by antiquated laws.[61]

To capture a supportive public audience, MacKaye linked Paul's ERA campaign to a leading celebrated event in women's history, the 1848 Seneca Falls Convention. As "the birthplace of the principle of Equal Rights . . . it was fitting that the launching of the Lucretia Mott amendment for full and complete equality should also take place here."[62] She organized three pageants in 1923 to commemorate the seventy-fifth anniversary of the Declaration of Sentiments, written by the Seneca Falls Convention, and to draw attention to the introduction of the Lucretia Mott Amendment, the formal name that Paul gave the ERA.[63] She explained, "During

this year, the Woman's Party is holding a series of celebrations . . . with a view to calling the attention to the whole country the inspiration and courage of the great women who first conceived and demanded a state of society in which the rights of women would equal the rights of men." In addition, these celebrations were designed to inspire women across the country to join the NWP's campaign and to assume active roles in carrying the ERA campaign to a victorious conclusion.[64]

The first conference, held in Seneca Falls on July 20–22, 1923, became the model for all subsequent pageants as they were reproduced throughout the United States. While they publicized the historicity of the NWP's campaign, Paul decided that they should limit participation in the conference to NWP national leaders and state chairwomen only. She chose to restrict participation in this way, because the "organization had not developed sufficiently as yet to enable us to have a successful convention on a delegate basis."[65] By concealing from public view the size of the organization, publicity surrounding the conference portrayed the NWP as a formidable organization that continued the long-held struggle for equal rights and wielded the power to dramatically transform American law and culture.

When describing the significance of the event, one source proclaimed that "the campaign for the Lucretia Mott [A]mendment has begun." Indeed, during the conference, Paul announced her plan to introduce a federal ERA to the Constitution. Conference participants "unanimously adopted the plan of Miss Alice Paul for carrying the feminist demands to [C]ongress with a simply worded amendment which covers the whole field of equal rights." The resolution presented by Paul read:

> Whereas, only one point in the Equal Rights program of 1848, that of equal suffrage, has been completely attained, and whereas the National Woman's Party, as stated in its declaration of principles, is dedicated to the same Equal Rights program as that adopted on this spot seventy-five years ago,
>
> Be it resolved, That, in order to bring the complete equal rights ideal to the victory that was won for suffrage, we undertake the following program: The securing of an amendment to the United States Constitution, stating, "Men and women shall have equal rights throughout the United States and every place subject to its jurisdiction."

By selecting Seneca Falls as the place to introduce the ERA, Paul demonstrated that her "sense of the dramatic is as highly developed as her sense of a psychologic situation." As the "birthplace of the principle of Equal Rights . . . it was fitting that the launching of the Lucretia Mott [A]mendment for full and complete equality should also take place here."[66] According to Paul, "We believe that this Declaration is so fundamental and comprehensive in its provisions, that it will appeal to every thoughtful and forward-looking woman."[67]

Following Paul's pronouncement of the ERA as the NWP's foremost goal,

members and supporters participated in ceremonies dedicated to the suffrage pioneers. First, women from all over the United States participated in an automobile procession "over the same path that a few Rochester women traveled seventy-five years ago to attend the first woman's rights convention held in Seneca Falls." The procession ended at Mount Hope Cemetery, the burial site of Susan B. Anthony. Following presentations by women speakers, over 2,000 women laid wreaths and flowers over her grave that "formed a mound of green and bloom, and rich autumn shades in a fadeless immortelles," thereby marking this site as a permanent and sacred shrine.[68] Through a series of press releases and articles printed in the NWP's newspaper, *Equal Rights*, readers were told about the warm welcome received by the NWP from the mayor, local officials, and community members. The event was described as another example of the history being made by the NWP every day, "marking another milestone along the road to full and complete equality."[69]

To continue its celebration of the seventy-fifth anniversary of Seneca Falls, the NWP called a second memorial pageant in Colorado Springs. To advertise the second pageant, MacKaye explained that "women from all over the West would meet in Colorado Springs to celebrate the successful completion of the equal rights movement and to forecast its future victory."[70] The memorial pageant traced the origin of women's demand for equality and the progress of such efforts into the 1920s. Dramatic performances depicted Lucretia Mott, Susan B. Anthony, and Elizabeth Cady Stanton at the Seneca Falls Convention, a scene revealing other leaders of the suffrage campaign who helped advance the equal rights cause and demonstrating the proliferation of professional and occupational groups of women.

According to the program for the Garden of the Gods pageant, "The women of America today owe to these suffrage pioneers and to the women who carried on the equal rights struggle for more than half a century, whatever they may enjoy of freedom." The NWP's message was that "complete equality has been won in only one field, the franchise." The pageant intended to educate participants about the remaining forms of discrimination that affected women, such as those that deprived mothers of control of their children, gave the father the right to will a child away from the mother, and discrimination against women in inheritance laws, property laws, and laws of contract, to name a few. By raising their awareness of the persistence of such discriminations at the state level, the NWP hoped to galvanize women to join its ranks and/or to contribute financially to the cause.[71] The pageant also included a procession of women carrying banners bearing slogans used during the suffrage movement that were used to articulate a concerted demand for "an amendment to the United States Constitution giving Equal Rights to women." The governor of Colorado and the mayor of Colorado Springs both spoke in behalf of the NWP and its legislative campaign. Overall, the event generated substantial publicity, drawing the attention of an estimated 20,000 people, and demonstrated women's increasing participation in public life.[72]

The third pageant "will, undoubtedly, be one of the most important Conferences of the Woman's Party held in recent years, for the final plans will be made . . . for the introduction of the Equal Rights amendment" to Congress.[73] MacKaye designed this ceremony, held November 17–18, in Washington, D.C. to create sufficient publicity around the ERA. The NWP organized two major publicity events to correspond with the introduction of the final phrasing of the ERA. First, a deputation to President Calvin Coolidge on April 6, 1921, marked "the first time that the Equal Rights program has been brought to the President's attention."[73] Paul believed that the ERA could be introduced in Congress by December 1921, and that Coolidge could use his power as president to put the power of his administration behind the immediate passage of equal rights legislation.[75] Approximately 200 women met with the president to convey the extensive support for the ERA that existed among women throughout the United States. Despite their efforts, Coolidge's Congressional Address dealt "with many questions of far less importance than the present legal status of women, and it is a pity that he failed to see the relative importance of things."[76]

The conference closed with the NWP's celebration of the seventy-fifth anniversary of Seneca Falls. During the ceremony, like previous events, 100 women filled the rotunda of the Capitol building carrying the banners bearing the NWP's colors of purple, white, and gold. As this large group of women descended on the Capitol building, the women encircled the statue of the suffrage pioneers, thus concluding its celebration where the NWP first began in 1921. During the ceremony, speakers interpreted "the meaning and significance of the past and [voiced] the determination of our Party to make the future worthy of its heritage."[77] Returning to the suffrage statue commissioned by the NWP for its February 1921 convention, the event consisted of a choir of twenty young girls, singing the words carried by Inez Milholland on her banner in the first suffrage procession: "Forward out of error, Leave behind the night, Forward out of darkness, Forward into light." One hundred banners lined the halls of the Capitol building, circling the audience and then forming a semi-circle around the statue. Following them came women from all of the states, carrying wreaths made of state flowers that they would lay at the base of the statue.[78]

To capture the public's imaginations and to explain the sentiments evoked by the pageant, MacKaye explained: "From a small gathering in an obscure upstate village, the woman's movement has grown to such proportions in these seventy-five years that the three women most responsible for its inception are now honored together with the men who have helped to liberate our country by being commemorated in marble within the nation's capitol." She believed that it was "a stirring thought—one to kindle the imagination and to urge women on with renewed zeal and faith to make the dream of these great souls come true." She described the pageant as "a symbol of the program of women since those first early days."[79]

As MacKaye continued to organize pageants throughout 1923, Paul continued to work with her legal advisors on a state-by-state basis to build support for equal rights bills and broader support for the NWP.[80] Finally she felt prepared enough to formally launch the ERA campaign. In late 1923, Senator Charles E. Curtis of Kansas "stood upon the floor of the United States Senate and announced that he wished to introduce a resolution to amend the National Constitution." As he read the words, "Men and women shall have equal rights throughout the United States and every place subject to its jurisdiction," according to NWP publicity sources, the "spirits of those three brave women whom the world recognized as pioneers in the Equal Rights movement—Lucretia Mott, Elizabeth Cady Stanton, and Susan B. Anthony—seemed to hover over the gathering." When Daniel Anthony of Ohio introduced the proposed ERA to Congress, the "forward movement of women reached a high mark in its ascendancy."[81]

When evaluating the success of the NWP's combined legislative and publicity campaign, MacKaye emphasized the importance of attracting such large numbers to each pageant because she believed "that our cause is getting better known throughout the country, which is our main purpose in giving the pageant."[82] Conversely, Elsie Hill remarked that "99 percent of the women in the United States don't even know that an ERA has been introduced to Congress."[83] Paul also worried that NWP membership remained so low that it had to concentrate on adding new members so it could tell Congress that a large number of women supported the ERA. To effectively evaluate the impact of the NWP's pageantry, it is necessary to examine what Paul's opposition was doing between 1921 and 1923. By looking only at the NWP's correspondence during this period, it is difficult to discern the full range of issues with which Paul and her supporters grappled. Examining Smith's activities during this period helps tell a more complete story.

4

"Women's Biggest Battle Is Yet to Be Fought"

Ethel M. Smith and the Women's Trade Union League,
1921–1923

Alice Paul specifically invited Ethel Smith to speak before the NWP's 1921 convention to outline the WTUL's legislative platform. Despite the controversy Paul stirred during the suffrage movement, Smith told her she would be happy to "tell the convention briefly the scope of our national program, especially with reference to legislation." During her presentation, she clearly summarized the WTUL's main objectives, explaining that the organization "stood for collective bargaining through trade unions; a maximum 8-hour day and 44-hour week; a just wage; a wage based on occupation and not on sex; full citizenship and equal economic rights for women." At the convention's end, Smith did not immediately see Paul as the threat she later considered her to be.[1] In a letter to one of her colleagues, she wrote: "I doubt very much whether the Woman's Party would undertake a program antagonistic to ours. They gave us rather special recognition in connection with the ceremonial Tuesday night, and there are one or two signs which suggest to me that they like us rather too well to want to fight with us." When reporting on the convention's outcomes, she emphasized that the "unveiling of the Susan B. Anthony statue was most wonderful," and that the WTUL's banner "evoked the most applause of any." The whole pageant, in Smith's estimation, was wonderful.[2] Though many who attended the convention criticized Paul's leadership and her equal rights agenda, she hoped to build a working relationship with NWP members. As an expression of her faith in the importance of a cooperative effort among politically active women, she optimistically negotiated with Paul over the next year about how to phrase the NWP's proposed equal rights legislation so that women's labor laws would not be threatened.

In the months following the convention, as Paul went public with the details of her legislative initiatives, she understood fully how extensively women such as Smith would oppose the NWP. She welcomed that opposition, not only for its publicity value but also because she believed the principles for which she advocated were essentially correct. Rather than admitting this outright, Paul concealed her true feelings about women's labor laws. Publicly, she announced that the NWP would not move forward with a federal ERA until her legal researchers had completed their study of the remaining forms of legal discrimination in each of the states. Privately, Paul told her followers that she personally opposed all legislation premised on women's differences from men. Within a year of the NWP's February convention,

Smith assumed a leadership role in combating the NWP's agenda. She quickly demonstrated the leadership skills to challenge Paul while pursuing entirely different methods to achieve her goals. Through a direct and hard-hitting approach to equal rights, Smith generated sophisticated media and public education strategies that challenged men and women to reexamine their most basic assumptions about gender stereotypes.

The debate that took shape over the NWP's equal rights legislation forced Smith to increasingly challenge herself to define the layers of her political philosophy. As a self-proclaimed wage-earning woman and trade unionist, she maintained a firm commitment to the importance of economic organization in the lives of wage-earning men and women. She argued that unionization promoted unity between men and women in the labor force and helped cut competition between organized and unorganized workers. In addition to union organization, Smith supported specific legislative measures that promoted an active relationship between the labor movement and the state. Though she advocated laws passed through the lobbying efforts of the AFL and its affiliates, she directed her attention to female-specific measures, because women's experiences substantially differed from working men's. She argued that women who lacked union representation tended to work in low-paying, seasonal, highly exploitative, and unhealthful conditions. To protect these women's rights, Smith supported cross-class alliances between wage-earning and professional participants of the labor and women's movements. Such a cooperative effort, she argued, not only promoted the interests of women but also the interests of the community as a whole.[3]

Like Paul, Smith articulated a specific political philosophy that omitted any reference to racial or ethnic distinctions. Both women emphasized the importance of economic rights in working women's lives as they pursued their competing conceptions of the most expedient methods to gain public legitimacy for women's equality. Smith's approach to equal rights differed significantly from Paul's. She supported legal change such as the implementation of piecemeal legislation written to address specific issues and, if necessary, amending the U. S. Constitution as the most effective methods to abrogate discriminations in the workplace. To Smith, state and federal governments had the responsibility to work with reformers to fulfill their regulatory responsibilities to citizens. Throughout the 1920s, she conveyed this opinion in her written work and lobbying efforts as she endeavored to inform the public and policy makers about the WTUL's reform agenda, the nature of its alliances with other reform organizations, and its contributions to the labor movement.

During its forty-eight years of operation, the WTUL worked to "serve the interests of wage earning women and to acquaint the public more fully with the unhealthful and sometimes shocking conditions under which women often were employed."[4] WTUL President Margaret Dreier Robins proclaimed that the unorganized woman worker

has to accept conditions as she finds them, low wages, long hours, abusive language, insanitary [*sic*] conditions, locked doors, fire dangers, work destructive of her physical strength . . . [and] of her moral and spiritual development. Alone she cannot even protest against these conditions. . . . She loses her job when she asserts her fundamental right to have a voice as to the conditions under which she works.[5]

She argued that employers who exploited working women's rights consequently challenged democratic society's concept of "free people." According to Robins, "It is idle to speak to men and women of self-government . . . when their entire thought and all their activities are engrossed by the daily needs." Collective action and legislative enactment, she argued, created greater opportunities for working people. By arguing that the right to self-government was directly related to the cooperative good, not just personal interest, Robins challenged the liberal individualist principles that then dominated the political culture of the period.[6]

Smith agreed with Robin's emphasis on the mutuality of interest between individual and community interests. She wrote that the "environment, the community and society, must be safe before life can exist or prosper. Community welfare promotes individual welfare, and therefore freedom."[7] Smith believed that the most effective way to ensure the collective good was to promote a cooperative effort with other reform organizations. She believed that the WTUL's main concern was the "fundamental issue of a woman's right to work in fair competition with men."[8] She described the WTUL as clearinghouse for working women's problems and as an effective instrument for collective action. As an affiliate of the AFL, the WTUL initially aimed to further both its agenda and the wishes of Gompers and the Executive Council. However, as the AFL increasingly attempted to assert control over the WTUL's agenda, the alliance between the two organizations became tenuous and contentious.[9]

The AFL was founded in 1886 under the leadership of Samuel Gompers as a federation of craft and industrial unions. Highly skilled and powerful craft unionists dominated the organization, creating policies designed to maximize labor's bargaining power and to establish union control over competition for skilled jobs. "To this purpose they strove to define the limits of each craft, to restrict entry by means of rigorous apprenticeship, and to establish union supervision over apprenticeship and hiring."[10] AFL leadership liked to speak of itself as the "House of Labor"—the premiere representative of the entire American labor force. However, its definition of workers and the labor movement conceptualized work in terms of manufacturing, or at the very least work that involved heavy manual labor."[11] The AFL's Executive Council maintained and implemented policies of exclusion, only admitting non-skilled labor when expedience warranted such a change in policy. Since Gompers perceived his task as welding a homogeneous whole, AFL policies reflected tremendous concern with the needs and rights of skilled male labor.

Publicly, Gompers expressed his support for the organizational work of the WTUL. For example, when he addressed the mass meeting of the WTUL's Fifth Biennial Convention of the WTUL on June 7, 1915, he proclaimed, "I could not deny myself the privilege, the pleasure and the honor" of attending the convention to convey the importance of "the solidarity of labor in the unions of labor . . . for the assertion and protection and maintenance and promotion of the rights and the interests of the toilers, whether men or women."[12] His proclamations of support, however, are questionable considering that Agnes Nestor, the WTUL's National Legislative Secretary, revealed that she was the only woman delegate out of 222 participants representing eighty-six national and international unions at the AFL's 1915 Convention.[13]

To fill the void created by the AFL's male-defined policies, Smith argued that "women should be aroused to the necessity of effecting trade union organization . . . to protect themselves." She explained that the WTUL worked to defend working women's desire to effectively contribute to the labor movement. Similarly, WTUL publicity emphasized its attempt to represent the women's movement's response to the "increasing numbers of women in industry and the growing complexity of their problems" by attempting "to voice the aspirations of these workers and grapple with their special difficulties."[14]

Smith, however, differed with Gompers on the issue of women's shared experiences with male workers. Though she maintained the importance of economic organization, she believed that the AFL did not effectively ensure working women's right to compete fairly with working men. In the post–World War I period, she argued, "[T]he woman problem has taken on a new and acute stage. . . . The latent opposition of men to women as wage earners has become an open challenge." Efforts to attain equal pay for equal work in fair competition with men, she contended, will be the most important battle waged by the women's labor movement.[15]

The AFL inadequately represented the rights of women workers, according to Smith, and did not uphold its stated policy of equal rights for all workers. AFL affiliates sometimes admitted women but frequently excluded them from holding important offices within the organization. Officers of various locals tended to evade questions pertaining to the status of women within their ranks, preferring to avoid any serious examination of gender exclusion. As Smith assessed why the AFL excluded women, she argued, "The real difficulty is the age-old prejudice and the actual ruthlessness of the competition for jobs. When it comes to this, the men being older in industry, older in trade unionism, and holding the better paid jobs already, find ways and means to keep women out of the jobs which they regard as theirs by prior right." Subsequently, according to Smith, the "situation that results is one of actual though not avowed discrimination against women by working men themselves."[16] She directly confronted the tenacity of gender discrimination in American culture and attempted to raise the consciousness of working men to

reexamine their attitudes toward working women. Smith believed that both men and women would benefit from improved working relations between the sexes and ultimately create a more unified and stronger labor movement.

Smith served on a committee formed by the WTUL to further delineate the need to overcome gender stereotypes in the workplace. In its written report, the committee drew an analogy between women and "colored men." According to the report, "[i]n the economic world colored working men and all working women have been similarly handicapped by prejudice and exploitation, to their own disadvantage and the disadvantage of white men . . . but equal rights have come more rapidly for colored men than for women" in the labor force.[17] As Smith and the other members of the committee described the similarity of experience between African-American men and working women, they emphasized the importance of union organization for all exploited people to overcome economic inequalities. Like Gompers and many other reformers of the period, however, the committee neglected the impact of racial differences among women, emphasizing instead the opportunity that the WTUL afforded wage-earning women to transcend their class and to assume positions of leadership in the women's and labor movements and in the federal government.

Smith proclaimed that "almost every well-known woman in the American labor movement today has reached her position through the door of opportunity opened by the League." In cities where the WTUL sustained an affiliate, "local women leaders are found on its personnel, while the national executive board of the organization includes such outstanding examples of able leadership as Melinda Scott of the hat trimmers; Agnes Nestor of the glove workers . . . and Rose Schneiderman, of the capmakers."[18] Smith countered the claims of many historians who emphasized the dominance of middle-class women in the WTUL over its wage-earning constituents. Many working-class women assumed influential positions within the organization. For example, Mary Anderson, a Swedish immigrant and one-time boot and shoe worker, became a paid organizer for the WTUL and later was selected as the director of the United States Women's Bureau. Agnes Nestor, an Irish immigrant, served as the head of the WTUL's National Legislative Committee, while Rose Schneiderman, a Polish immigrant and member of the capmakers' union, served as the WTUL's president from 1926–1950. Wage-earning women's acceptance of leadership positions in the WTUL often meant that they were co-opted by middle-class values to varying degrees. Few historians, however, have focused on how women such as Schneiderman and Anderson viewed their own positions in the labor movement.[19]

Smith's reform career exemplifies a process through which a wage-earning woman could pursue her personal political interests by becoming an active and paid participant in the women's and labor movements.[20] As the legislative secretary and Washington correspondent for the WTUL, Smith earned the reputation as that organization's expert on legislation. She actively studied congressional de-

bates pertaining to women's issues and lobbied and mailed letters to members of relevant committees and subcommittees in the House of Representatives and the Senate. As the head of the Washington news service, Smith was responsible for interpreting news that dealt with questions affecting working women and publicizing the work of the WTUL. To do so, she gathered newspaper articles from around the country, analyzed their content, and prepared statistical documentation of the information relevant to her personal and professional interests.[21]

To address questions that affected working women, Smith followed a range of legislative debates that combined wage-earning and professional women's interests, promoted the unionization of women in industry and reform of private and government labor relations. She believed that her publicity work served an important function in her efforts to promote the WTUL's contributions to the women's and labor movements. She argued

> [E]very one of us knows that the organizations that get before the public most often in a creditable way are the organizations that grow; we know that nobody, not even our own members fully understand our story unless they hear it in every possible way; we know that the general public, which is the audience we must reach, is slower still to understand. And last of all, we know the conviction—sometimes the fatal conviction that is carried by the printed item in a newspaper. Whether they admit it or not, people *do* believe what they read in the newspapers.

According to Smith, "newspapers are the *most* important medium of communication for us." She urged the WTUL to provide sufficient income to operate the press service, arguing that such expenditures would benefit every aspect of the league's work, including organization, education, legislation, and finance.[22] In addition, as director of the WTUL's Publicity Service, Smith repeatedly emphasized the importance of building alliances with other national reform organizations that shared the league's legislative interests. Her outspoken support for the WJCC best exemplifies this belief.

Founded in 1920 as a clearinghouse for national women's organizations, she described the WJCC as "the outcome of a movement on the part of the great national women's organizations to pool their resources and cooperate for the support of Federal legislation." Through a mutual effort, representatives of the WJCC followed congressional debates on legislation of interest to their constituents by dividing into subcommittees on each bill or legislative principle.[23] Combined, the members of the WJCC tracked and lobbied for approximately twenty measures that were mainly designed to better the lot of women and children.

When Smith learned that WTUL leadership opposed joining the WJCC, she tenaciously fought to sway them to her perspective. The vehemence with

which she argued her point demonstrated her unremitting belief in the advantages of cooperative efforts. In a series of letters, Smith and Agnes Nestor, the chair of the National Legislative Committee, debated the value of the WJCC. She wrote to Nestor:

> To me the ideal of women for women—*all women*—is so big and potent that it grieves me to the heart to think that my own group should be the one—the only one—to desert the standard at this critical time. The League has what it has through the efforts of its allies as well as of its trade union members. Such national legislation as it has obtained it could never have [been] obtained without these very organizations who are not inviting us into their councils. Our refusal cannot possibly be made graciously. Not by any possibility can we do it, in my judgment without looking selfish and un-friendly, and without forsaking our claims of loyalty, women to women.[24]

To her, "all women" referred to those who were represented by the organizations that comprised the WJCC. Participating organizations, such as the Young Women's Christian Association, National Consumers' League, Women's Christian Temperance Union, National Association of Business and Professional Women's Clubs, and Association of Collegiate Alumnae, were dominated by white women. The women to which Smith referred were, as she understood them, much like herself, in that they were politically active and believed in the efficacy of legislative reform to improve the lives of their constituents.[25]

Nestor expressed her concern that affiliation with the WJCC would entail in-volvement with legislative issues that the WTUL did not support and distract Smith from her responsibilities. Feeling personally insulted by Nestor's apparent lack of confidence in her abilities to represent the WTUL's interests, Smith protested:

> I am your representative on the ground. I have lived in Washington twenty years, and I have spent five of those years working for legislation by Congress. I would be stupid, indeed, and unfit for my job, if I did not know something of the men on Capitol Hill, of their reactions, and the possibility of getting action through those respective organizations. To do that very thing has been my job these five years, since the suffrage amendment passed, several women's organizations through which we have worked . . . have established a national joint committee for conference and cooperation. Most of the organizations individually, and certainly the group collectively, are stronger than we are. We shall have to work with them, or else play a lone hand.

She continued: "Now, is it unreasonable for me to ask you and the other Board and Committee members to trust my judgment some what on this matter?" She

told Nestor "in all earnestness that for us to refuse to join this Committee will render my legislative work for the League almost hopeless!"[26] Smith allayed Nestor's fears by convincing her that membership entailed "nothing but mutual understanding and a *channel for cooperation if we desire it.*" She also told Nestor that meeting with the WJCC would save her "*days* of fruitless chasing of particular Congressmen or senators," because "it often takes three or half a dozen trips to find one man to learn one thing about a particular parliamentary jam."[27] In late December, Nestor agreed to forward Smith's recommendations to the Executive Board, which approved the motion.

By convincing Nestor to support her position, Smith brought the WTUL into an historic alliance. She believed that a strong display of solidarity would build an image of the WJCC as a legitimate and influential lobbying group for all women. She was correct. During its first year of operation, the WJCC earned the reputation as the most powerful lobby on Capitol Hill. Representing at first eleven and then later fourteen of the largest women's organizations in the United States, the WJCC "for the first time in the history of the country has united the interests of women."[28] Through a concerted effort, participating members worked to build support for their measures "on the sound basis of actual conviction on the part of Congressmen backed by a clear demand on the part of their constituents."[29]

As the WTUL's representative in the WJCC, Smith could keep track of all legislation supported by the league and at the same time benefit from the support of other women's organizations that shared similar legislative interests. Her participation with the WJCC paid off, enabling her to successfully pursue her biggest legislative concerns—reforming practices in government employment and situating women in positions of leadership to influence federal labor policies. Most notably, Smith joined the WJCC subcommittee that successfully assisted the WTUL in lobbying Congress to create a permanent bureau in the Department of Labor to study women's employment.[30]

The Women's Bureau, founded in 1920, worked to "formulate standards and policies which shall promote the welfare of wage-earning women . . . and advance their opportunities for profitable employment."[31] Smith viewed the creation of the Women's Bureau, the first federal government department devoted strictly to working women's rights and interests, as a success for four primary reasons. First, the lobbying campaign that pressured Congress into passing the bill demonstrated the influence of women's organizations in achieving their legislative goals. Mary Anderson, the Women's Bureau director, emphasized Smith's central role in the creation of this pathbreaking federal agency. She wrote: "Ethel Smith was the legislative representative of the national League in Washington and under her direction many of us were alerted when the bill was coming up in each house so that we could telephone friendly representatives and senators and ask them to be sure and be on the floor for the discussion and vote."[32] Initially, Smith celebrated the

Women's Bureau as an institutional achievement, arguing that it created awareness within the government for the need to "utilize the intellectual equipment of women as well as the skill of their hands." She quickly realized, however, that the creation of this new federal agency did not automatically assure that women would be entitled to the same recognition accorded to men. This awareness provided the first of many opportunities for Smith and her supporters to continue demonstrating their power as a lobby group.[33]

Second, the selection of Anderson as the Women's Bureau director provided a professional position of authority for a woman within the federal government. Originally her rank provided her with a salary commensurate to other department heads, however, during the second year of the bureau's existence, Congress allowed a $75,000 appropriation but attached a proviso restricting salaries. The proviso limited the income of the technical staff to $1,800 a year, except for three positions that paid $2,000. Smith described this stipulation as an "outrageous discrimination against women by the Government as an employer because the same bill carries provisions for men employed in comparable work in other bureaus at almost twice the sum allowed the expert staff of the Women's Bureau."[34]

Working in alliance with the WJCC's Women's Bureau subcommittee, Smith emerged as an outspoken critic of Congress' refusal to recognize the status of women experts in federal employment. She chastised Congress for writing into law discriminatory policies directed specifically at the bureau.[35] She angrily proclaimed: "Equal pay for equal work is a vital principle of justice and sound economics. As women we vigorously protest against its violation by Congress, which has here written into law a discrimination against women in standards of pay as compared with men." Smith continued, "The Bureau's work, highly technical as it is, can be satisfactorily performed only by women technically trained and fully experienced. Such women cannot and should not be asked to work for less than men receive for similar work." Congress "discriminated against all women by this act which reduces the salaries of women experts in government employ below the pay of male experts in comparable work."[36]

In the struggle to combat the reduction of the Women's Bureau appropriation, Smith again emphasized the importance of a strong alliance between women's organizations. She wrote:

> Persistence pays—especially in a good cause. The organized women of the country have proved that. Congress the other day passed the Labor Department appropriation bill with a $5,000 increase in the appropriation for the Women's Bureau, making a total of $105,000. The salary provisions were left as of last year when, after a vigorous campaign on our part, Congress was persuaded to liberalize the restrictions it had imposed upon the salaries of the women experts on the Bureau staff.

"Thus we may congratulate ourselves upon the cumulative benefits of the efforts we have had to make during the past three years with reference to the Women's Bureau Appropriation." Smith led the three-year lobbying effort in support of the Women's Bureau, successfully gaining a $60,000 increase in the original $40,000 appropriation and a liberalization of the salary restrictions.[37]

The third main reason that Smith so strongly supported the Women's Bureau concerned its obligation to represent wage-earning women's interests by formulating standards and policies that promoted their welfare and advanced their opportunities for profitable employment. In 1922, Anderson wrote:

> According to the last report of the Bureau of the Census we have over eight and a half million women in gainful occupations. This means that every fourth worker is a woman. The Women's Bureau is charged with the responsibility of developing policies and standards and conducting investigations in the industries of the country which shall safeguard the interests of women workers and thus make their service effective for the national good.[38]

Women's Bureau experts applied advanced social science methods to their investigations of the conditions of women's work. These methods included comprehensive investigation policies that included the compilation of statistical data and study of legal issues affecting their constituents' interests. Based on their interpretive reports, the Women's Bureau offered recommendations to the industries studied and to the federal government for formulating employment policies.[39]

Finally, Smith worked closely with Anderson and the Women's Bureau in the campaign to enforce the merit system and pay equity for women employed in the federal civil service.[40] One of the first studies completed by the Women's Bureau researched the extent to which government service enforced discriminatory hiring and promotion practices. The Women's Bureau submitted the first part of its study to the Civil Service Commission in late October.[41] This section emphasized "the fact that women were excluded from 60 percent of the examinations held from January 1, 1919, to June 30, 1919." Only ten days after receiving the bureau's report, the commission "passed a ruling opening all examinations to both women and men," but upheld the provision of an 1870 statute that allowed appointing officers to specify whether a man or woman was desired to fill available positions.[42] Thus Congress responded both favorably and swiftly to the Women's Bureau findings.

The rapidity of response created hope for the continuation of such amicable relations among the Civil Service Commission, Congress, and the Women's Bureau. Part two of this study revealed that 91 percent of women appointees were concentrated in clerical service and that their salaries were "below that which any number of men qualified to fill the positions will accept." To accurately compare the difference in wages among men and women, the Women's Bureau studied the pay

of persons appointed to government service during January and February 1919. During this period, approximately 8,000 people were appointed, out of which 4,689 were women and 3,270 were men. Over 86 percent of all women were appointed at a salary ranging from $900 to $1,299 a year. Ninety-one percent of the women appointed were concentrated in clerical positions.[43]

The study also argued, "Another condition that appears to influence the proportion of men and women appointed to various positions is the weaker bargaining power of women." Over 80 percent of the women were willing to accept the advertised minimum salary of $900. The Women's Bureau researchers concluded:

> Not until the entrance salaries to be paid in each occupation are fixed for probational, temporary, and excepted positions in accordance with the responsibilities and difficulties of the tasks to be undertaken, not until the classes of work within each occupation are so well determined and their salaries fixed so that the persons marking examination papers will be able to mark each applicant's class and salary status on the examination paper will it be possible to eliminate the inequalities which have arisen through custom in the beginning salaries offered to women and men.[44]

The report was submitted both to the Civil Service Commission on Reclassification of Salaries and the Joint Commission on the Reclassification of Salaries. The study raised serious questions about discriminatory employment practices in the federal government and became a hotly contested issue throughout the 1920s.

When Smith testified before the Senate Committee on Civil Service in 1921, she emphasized her personal qualifications as a witness. She argued that during her fifteen years in government service, she could not recall any time that she was paid according to her title. Most of the time she claimed that she was not on the payroll for the division in which she worked. She continued:

> I want, therefore, to lay before the committee this morning a protest on behalf of the women in the civil service. The women in the civil service want a new order of things, and they protest against the present conditions imposed upon them by Congress and the department heads. They want a new order in which the traditions that rate women's work at lower pay than men's because it is done by women shall be discarded for the standard that requires equal pay for corresponding work and equal opportunity for promotion, irrespective of sex.[45]

She attempted to inform Congress of the extent to which working women in federal and private service were limited in employment and advancement opportunities. "Women are the victims of . . . convergent forces to keep them down in the low-paid groups." As she attempted to convince Congress of the necessity to regulate federal

employment, she emphasized that "there are 36,000 women employees in the departments in Washington and 32,000 men." Despite outnumbering men as employees of the federal government, women received, on average, $200 less than men.[46]

She protested: "We look to Congress to correct the existing discriminations by means of the proposed reclassification law," known as the Sterling-Lehlbach bill.[47] She contended that the U.S. government, "having seen the light with regard to the political status of women, ought certainly to take the next step, and, insofar as it is concerned, to set a worthy example in paying them according to their work, by test of skill and experience and efficiency, irrespective of outside employers." Smith argued that Congress had the duty as an employer to set employment and wage standards in the federal civil service. She argued that government employment should not "merely follow the private employers" and the "competitive standard." As the employer of the largest workforce in the country, she stated, "We think it is time that the United States Government set a better standard."[48]

In April 1922, Federal Employees Union (FEU) Number 2 called a mass meeting of government employees, mostly women, to discuss the topic of "Opportunity for Women in the Civil Service." Smith, a member of FEU #2, spoke again in favor of the Sterling-Lehlbach bill. She argued: "We need it because there is in the Government service so much that is wrong, so much that is unequal." She explained, "In the Government service, as in business, the problems of the women who work are more acute than the problems of the men. The women are massed in the lower grades of pay. There are about 30,000 in the Government service in Washington and you will find that their average salary is $200 less a year than the average salary of the men." She emphasized that there "is virtually a dead line for women at $1,200 to $1,800" and that under the Sterling-Lehlbach bill, the same rate of pay must be given to women. The bill classified women and men according to their rank, rather than their sex, and it contained rules for promotion that would make it possible for women to progress to higher positions.[49]

Conflict among the Civil Service Commission and the Bureau of Efficiency slowed the progress of reclassification legislation.[50] At the committee meeting of the WJCC, Smith reported that Senator Reed Smoot of the bureau proposed counter legislation to defeat the Sterling-Lehlbach bill. Herbert D. Brown, chief of the Bureau of Efficiency, drafted the Smoot-Wood bill, as it was called, "which gives the Civil Service Commission no authority placing all the authority in the hands of the Department heads and the Bureau of Efficiency."[51]

On March 4, 1923, Congress passed the Civil Service Reclassification Bill. As the chairperson of the WJCC's Women's Committee for Reclassification of the Civil Service reported:

The final form contains most of the essential elements of the Sterling-Lehlbach bill, but the Administrative agency as set up in the law represents a compromise

between the two reclassification plans which had been proposed respectively in the Sterling-Lehlbach and Smoot-Wood bills. A three-headed board, consisting of the Director of the Budget as Chairman, a member of the Civil Service Commission, and the Chief of the Bureau of Efficiency, will have the duty of carrying out the provisions of the Act.[52]

Smith described the Classification Act as the most important piece of civil service legislation since the first civil service act. If honestly and adequately administered, she argued, the act "should guarantee a thorough-going merit system in the Civil Service." Its provisions determined that civil service positions would be defined according to the requisite duties and qualifications, and that the development of salary scales would be determined according to the job performed and the workers' skill level. Along with the enforcement of the merit system, the act established as law "the first federal mandate for equal pay for equal work, irrespective of sex" in government employment.[53]

The act also called for the creation of what was known as the Personnel Classification Board to coordinate the work of the Civil Service Commission and the Budget Bureau. The board's responsibilities included the development of an adequate system of personnel records, careful review of promotions, greater uniformity of hours worked, leaves of absence, and retirement provisions.[54] When critics began to accuse the board of ignoring its responsibilities, however, Smith assumed a leading position in the ensuing investigations.

She believed that Senator Reed Smoot had created the board to fulfill his own personal agenda of building a stronger position of authority in Congress. She, and many other people involved in the debate over the Sterling-Lehlbach bill, contended that there was no adequate reason for the operation of the Bureau of Efficiency as an institution separate from the Civil Service Commission. In the legislative campaign, of which she was a part, the main goal was to eliminate the board and to protect the authority of the Civil Service Commission.[55]

The Women's Bureau, WJCC, WTUL, and NFFE, organizations with which Smith was affiliated, all worked together to plan a united front in support of eliminating the board. These women demanded to investigate the board's records and urged Congress to do the same. Members of the board consented to this request. In response to their findings, an amendment to the Classification Act was proposed because of "widespread protest against the administration of the Personnel Classification Board, and the showing, by the Board's own records, that it has not carried out the purpose of the Act."[56] Representative Lehlbach, chairman of the House Committee on Civil Service, introduced an amendment to abolish the Personnel Classification Board and to transfer its powers to the Civil Service Commission. He criticized the Personnel Classification Board because it "[w]ith amazing effrontery . . . turned upon the law which created it and proceeded to de-

stroy every provision of it except that bringing itself into being." The board failed to specify the duties and qualifications for each classification in the federal civil service and thus did not promote the intended unity of policy.[57]

The Women's Committee for Reclassification of Federal Civil Service supported Lehlbach's assertions.[58] Smith argued that the need to eliminate the board was of particular importance to women, because it had failed to establish specifications of duties and qualifications for employment. As a result, Smith explained, the board made the sex equality provision of the law unenforceable, "because without such specifications there is no means of determining what is equal work. This provision has been counted upon to correct discrimination against women that prevail in the civil service and to set a standard in that respect for private industry."

The Women's Committee for Reclassification organized a deputation to the chairman of the Personnel Classification Board, President Coolidge, chairman Lehlbach of the House Committee on Civil Service, and Chairman Madden of the House Appropriations Committee.[59] Congress passed the Lehlbach bill in 1924 in response to the women's lobbying efforts. Smith explained that the Personnel Classification Board was abolished because it has clearly violated the Act of Congress which created it. The report says among other things:

> The provisions intended to eliminate the evils of inequalities due to different standards, to favoritism, and political considerations, by providing classes based on specifications of duties, to which all persons doing like work in all the departments throughout the Government services would be allocated, have been scrapped.[60]

The Lehlbach bill transferred the authority to enforce the Classification Act to the Civil Service Commission. Once this had been achieved, other factors regarding discrimination within federal employment remained at issue. Nonetheless, the women who supported the elimination of the Personnel Classification Board demonstrated the effectiveness of a cooperative effort in achieving their primary reform goals.

While seeking civil service reform, Smith also built alliances with men and women who supported minimum-wage laws, playing a leading role to continue the WTUL's long-held commitment to minimum-wage legislation.[61] As part of the WTUL's original agenda, its leaders argued for minimum-wage laws for women to address the fallacy that they relied on the support of men. In recognition of the status of independent women wage earners, Smith argued for minimum-wage laws that provided a "sufficient reward for labor to provide health-giving food, good clothing, shelter with sunlight . . . education and recreation—books and music—to tide over periods of sickness or unemployment."[62]

The 1918 Washington, D.C. minimum-wage law for women and children created a Minimum Wage Board with three members: Jesse Adkins, President of

the National Consumers' League, served as the board's chairman and representative of the public's interest; William B. Bruerbach represented employers; and Smith was selected by the Washington, D.C. Central Labor Union as labor's representative.[63] In sum, the 1918 law called for a cooperative alliance among business, labor, and the public and promoted a method of preventing strikes and strengthening workers' right to collective bargain.

To ensure a successful alliance among labor, the public interest, and business, the board inquired about various occupations that employed women. If it found a substantial number of women in any industry receiving less than $16, the board was mandated to call a conference to correct this difficulty. One member of the board was required to be present at each hearing. All three members had the power to issue subpoenas, to call witnesses, and to examine the books of any business accused of employing women at an illegal wage. When evaluating the board's success, Adkins argued that conferences "result in a very much better feeling between employers and employees. Each sees the other's side and comes to respect it."[64]

Overall, Smith described the minimum-wage law as a significant success. She reported that minimum-wage orders increased the wages of about three-quarters of the 17,000 women in private employ in Washington, D.C., from $12 a week to amounts ranging from $15 to $16.50. She also argued that employers in the District supported the minimum-wage law. For example, the Merchants and Manufacturers Association claimed that business was better in the District than in other parts of the United States. "Employers in the District . . . testify that their experience with the minimum wage law shows it to be advantageous to employer, employee, and the community."[65]

In addition to the support of business interests, the AFL, a one-time strong opponent of minimum-wage laws, endorsed the work of the board. Gompers acknowledged Smith's work as a member of the Minimum Wage Board. He wrote to her to congratulate "the working women of the District in their victory against those who would reduce their wages in these times of high prices. You and your associates have accomplished a great purpose."[66] To inform the AFL of the extent to which the minimum-wage law enhanced its program, Smith wrote, "It has brought a wage increase of approximately 38 percent to more than 10,000 working women, most of whom were formerly far below the bread line, and it has stimulated organization among them to the extent of two new local unions affiliated with the American Federation of Labor."[67] Contrary to the claims of opponents to the law, minimum-wage orders neither reduced the number of women employed nor caused the displacement of women by men. AFL Secretary Frank Morrison wrote: "If there has been any displacement of women by men, it has been so slight as to be negligible in comparison with the thousands of women whose condition has been improved by the law."[68]

The Women's Joint Legislative Conference, a group of women reformers in New York State, asked Smith to speak at a hearing before the Joint Committee on

Labor and Industry on March 9, 1921. When she was not granted time to present her case, she wrote to the chairman of that committee. She informed him:

> I am a member of the Minimum Wage Board of the District of Columbia, which has for 2 ½ years administered a law similar to that proposed in the Cotillo Bill in New York. I am also Secretary of the legislative committee of the National Women's Trade Union League, and as such may speak on this subject for the largest national body of organized working women in the United States. . . . I ask you to accept my statement, therefore, from two viewpoints—1. that of an official of the District of Columbia making to you a statement of fact based upon official records and 2. that of a wage-earning woman, a trade unionist, speaking as the representative of thousands of other wage-earning women.[69]

As she attempted to convince the chair that organized women supported minimum-wage laws, she also emphasized the noncontentious nature of the law itself. She explained that the Washington, D.C., women's minimum-wage law passed with almost no opposition, and that organized labor and business interests expressed their mutual support for such legislation.

Despite Smith's reassurances of the minimum-wage law's success, Congress cut the appropriation that paid for the operation of the Minimum Wage Board. Before the end of 1921, the Budget Bureau voted to cut the board's allowance from $5,000 to $3,300. As of December 1921, Smith complained that the decrease in funding "will so cripple the Minimum Wage Board that the law cannot be enforced. The board is not enforcing wage orders affecting more than 12,000 women in four industries and minor boys and girls in stores." Though members of the board offered their services on a voluntary basis, the law provided salaries for two secretaries whose duties included

> making the wage studies and investigation of all business establishments in the District of Columbia where women are employed, the inspection of pay-rolls to determine whether or not the law is being observed, besides the keeping of office records, certification of every woman newly employed, arrangements for conference with employers and employees, correspondence, and other secretarial duties.

Following the cut in the board's appropriation, one of the secretaries could no longer be employed. Smith argued that one person could not be in the office and in the field at the same time. By attempting to save money, the Bureau Budget took "wage money away from the very lowest paid women in the District of Columbia—for the minimum-wage law affects only women who are getting less than a living wage."[70]

"As a result of the protests against the cut in the appropriation for the Minimum Wage Board of the District of Columbia, the House Appropriations Committee increased the budget estimate of $3,000 to $4,000." Minimum-wage supporters felt that the appropriation should be restored to its original $5,000. Though they were able to get the appropriation up to $4,000, the $1,000 shortage meant that they could only employ one person in the Minimum Wage Office. Having to cut one member of their research staff put board members at more of a disadvantage as they attempted to enforce a minimum-wage law affecting nearly 20,000 women. Smith lamented, "Wage orders already issued cover more than 12,000, and there are still industries for which no orders have been issued nor wage determined—which means much more work to do."[71]

While contending with minimum-wage funding cuts, Smith also was frustrated by the failed movement to pass a Child Labor Amendment. She linked minimum-wage laws to the movement to eliminate child labor. She explained: "The effect of the minimum wage for minors in the District of Columbia had been a marked reduction in the number of minors employed, especially the youngest ones, thus indicating the usefulness of the minimum-wage law as a supplement to the child labor and educational laws."[72] Since many child laborers were forced out of economic necessity to financially assist their families, they were an easily exploited segment of the workplace. Minimum-wage laws that affected children discouraged employers from seeking child laborers and provided legal recognition of women's economic contributions to their families as permanent members of the labor force.

Smith's support of the child labor laws extended her network of allies into the child welfare dominion.[73] As a lobbyist for the WTUL and WJCC, she worked to build support for a proposed Child Labor Amendment. As a member of the WJCC's subcommittee for the Children's Amendment she worked to develop an effective publicity campaign to enhance public awareness of the WJCC's campaign to regulate child labor. She attended congressional hearings on the subject and reported to the WJCC when hearings on the amendment were held.

All organizations represented within the WJCC supported the Child Labor Amendment. To express their unity of opinion, the representatives signed a letter that was presumably submitted to members of Congress. The letter claimed: "No single measure which women's organizations have endorsed has gained so wide and determined support as this one. While all of our organizations have worked by better states laws, we find that a minimum national standard is essential to the adequate protection of American children."[74] Through the mutual alliance between all groups that favored restrictions on child labor, an effective campaign was organized. Educational material was distributed to the public that explained the dangerous conditions of child labor and particularly criticized the Supreme Court for its insensitive neglect of such an important issue.[75]

When submitted to the states, however, the Child Labor Amendment encountered "an opposition so powerful, so ruthless, and so determined to mislead

the public, that almost never was the real issue discussed." In Massachusetts especially, "the state was flooded with propaganda of unparalleled misrepresentation through every agency that money can buy." The National Association of Manufacturers opposed the Child Labor Amendment and "laid their plans for the referendum in Massachusetts for the definite purpose of making that the first drive in their national campaign for the defeat of the referendum."[76] To counter this and other attacks, Smith traveled to Boston to help the local WTUL gather sufficient votes to ratify the amendment.[77]

The WJCC Child Labor Amendment subcommittee appointed Smith to lead the publicity campaign in support of the amendment. She conducted an educational drive that included gathering statistics on child labor and producing pamphlets to be distributed to the public. The WJCC commended her for "the splendid piece of work involving an immense amount of labor, skill, and devotion."[78] Nonetheless, the amendment did not pass, thus silencing the movement to restrict child labor until the New Deal.

Though Smith eagerly anticipated the legislative needs of her constituents, she continued to struggle with her health. Her lifelong friend, Mary Anderson, explained to Robins:

> Ethel Smith looks, as you know, very badly and today she is having a thorough examination by a specialist. We feel something is radically wrong, and I am glad that she has at last gone to a doctor to be examined. You will remember at the luncheon that day in Washington when you asked her what she would like to do for a vacation. She said she would like to go abroad, and I know of course that she has not the money—at least all of it—to make such a trip, and still it would be the best thing possible for her because it would send her away for all summer, and it would take her completely out of the environment of Washington and the work. . . .

In light of Smith's poor health, Anderson wrote: "I was wondering if some of us could not get together and make it possible for her to go overseas.[79] Smith was such a valuable friend and respected member of the WTUL that Robins and Dreier pooled their resources to send her to Europe for the first time. Upon her return, however, she engaged in the biggest battle of her reform career.[80]

Between 1921 and 1923, defending women's labor laws remained at the forefront of Smith's agenda. She and Paul continued to debate their competing approaches to equal rights based on their distinct class backgrounds and political philosophies. While Paul's individualistic approach to equality gained momentum, Smith's collective approach increasingly became suspect at a time in which those who supported an active state were oftentimes labeled "socialists." As she struggled within this conservative political climate, Smith's attempts to represent the diversity of women's interests through legislative means were increasingly defeated.

5

The ERA v. Women's Minimum Wage

The Legal Debate Between Paul and Smith, 1921–1923

From the preceding chapters in this book, we already know that between 1921 and 1923, Smith emerged as a seasoned lobbyist who was recognized for her expertise on such issues as civil service reform, equal pay in public and private employment, and women's minimum-wage. She also had built a reputation for her trade union activities, commitment to collective action and media talents. During this same period, Paul struggled to build a solid membership base for the NWP, with a focus on garnering support from the nation's wealthiest women. With the backing of Alva Belmont, the NWP purchased a headquarters on Capitol Hill, and launched a series of extravagant public pageants to celebrate the history of the equal rights movement. Behind the scenes, Paul returned to law school, while her legal researchers compiled state-by-state documentation of discrimination that perpetuated women's second-class status.

We also know that Paul and Smith shared many of the same concerns. Both women were driven by their commitment to challenge cultural stereotypes that impeded women's economic security and viewed legislation as a vehicle to equalize women's social, political and economic status in society. They also wanted women to have the opportunity to demonstrate their capacities in the workplace and to compete on an equal basis with men. This only could be possible when women received equal pay for equal work, and were given the same opportunities for workplace advancement. The methods used to pursue their legislative objectives varied due to their different personal politics, organizational affiliations, political philosophies and leadership styles. Paul was impatient, and wanted to immediately eliminate all remaining legal equalities that affected women. The solution, she believed, was simple. State and federal equal rights legislation would sweep away all Common Law vestiges that identified women as weak and dependent on men and set the country on a path toward establishing equal opportunities for men and women. Though elimination of sex-based discriminations dominated her goals, she advanced a legislative agenda that primarily accounted for the needs of professional and business class women. Because women doctors and lawyers, for example, had already broken through the gender barriers within such male-dominated professions, Paul worked to organize upwardly mobile working women to strengthen their demands for equal opportunity in the workplace, to showcase their accomplishments, and to eliminate all legal barriers that restricted their professional advancement.

Though Smith agreed with the principles that Paul advanced, she believed

that there could be "no more complex issue under the sun than that of sex equality. . . . It involves the relationships of men and women as husbands and wives, as parents and children . . . personal liberty is involved, often in conflict with social welfare, property rights are at stake, child welfare, legal status . . . public health."[1] In her view, Paul advanced an exclusionary agenda that benefited one class of women at the expense of another. Between 1921 and 1923, Smith spent an inordinate amount of time trying to reason with Paul and her supporters about the potential damage the ERA would pose to women's eight hour, minimum-wage and health/ hygiene laws. She was not, however, opposed to state equal rights bills because they targeted specific inequalities, indicating that Smith was willing to compromise with Paul and did not simply criticize all of the NWP's legislative activity.[2]

Without a doubt, Paul and Smith believed that their approaches to equality would enhance women's social and economic status if women worked together, as women, to demand the same rights and opportunities as men. Neither of their arguments was strictly limited to gender issues. Rather, women's distinct class-based economic interests were at the heart of their legislative campaigns. The ERA dispute involved the larger question of how the state should balance individual rights with the economic interests of business. Therefore, it is important to integrate their competing perspectives into a larger legal debate that shaped the period. By doing so, we may understand the ERA debate beyond competing definitions of feminism, while at the same time recognize how central these women were to the evolution of freedom of contract, the proper exercise of government authority, the changing role of the courts, and the gradual expansion of legal interpretations of individual rights.

The ERA debate took shape at a time in which women were largely excluded from public policy, and the philosophy of laissez-faire individualism reigned supreme. Between 1921 and 1923, Paul elaborated an approach to women's equality premised on her acceptance of natural selection. Her understanding of equal rights helped defend a conservative form of jurisprudence, now known as legal formalism.[3] At a time in which she found few supporters and her organization suffered from internal divisions and declining membership, formalist thought provided the much-needed support for her views on gender equality.[4] As the dominant mode of juristic thought from the 1870s to the 1930s, formalists frequently denied the constitutionality of state laws that regulated the conditions of the labor contract. These jurists believed that freedom of contract, the most fundamental individual right, ensured economic expansion and the prosperity of American citizens.[5] Overall, formalists translated the principles of laissez-faire into constitutionally acceptable doctrine, developing race and class-specific analyses of due process that granted unlimited freedom of contract. To justify their definition of contract rights, formalist jurists created the doctrine of substantive due process, which not only expanded the power of the courts, but also maintained the hegemony of white, propertied male interests,

while at the same time proclaimed a universality of individual human experience. By embracing this legal philosophy, Paul sought to expand modern day definitions of due process to incorporate the rights of her upwardly mobile constituency.

Since the passage of the 1918 Washington, D.C. minimum-wage law and her participation on the board that enforced the law, Smith had worked closely with a group of lawyers who argued that formalists articulated a "mechanical juris-prudence," informed by immutable legal principles that ignored the different social, political and economic circumstances of individual lives.[6] These jurists, now known as legal realists, called for a more flexible form of judicial reasoning that was respon-sive to the changing demands of an industrializing economy. Leading realists allied with women like Smith, arguing that women's labor laws provided an effective counter to formalist thought. In this way, female-specific legislation became a strat-egy used to combat conservative legal thought that refused to recognize class as a constitutionally acceptable basis for labor laws.[7] In the long run, realists argued, pro-tecting the regulatory powers of state government against formalist judicial reason-ing benefited not only women, but also men.[8]

Paul's views on equal rights significantly complemented formalist thought. Like the formalists, she opposed regulation of the labor contract, arguing that such regulations limited women's ability to compete freely in the marketplace and to gain economic self-sufficiency. She believed that efforts to regulate the conditions of women's labor, in effect, eliminated their opportunity to pursue certain occu-pations. To Paul, "It seems incredible that any woman living at this period of his-tory should approve of passing a law barring women from these occupations, instead of leaving the matter to natural selection."[9] In her mind, the ERA was more progressive. It would abolish all remaining gender-based legal discrimina-tions and extend traditional economic and political rights possessed by white, propertied men to women of the same race and class.[10]

Smith believed, as did Paul, that unregulated contract rights served the in-terests of professional and business class women. Yet, she argued, any effective ap-proach to women's equality must recognize that equal rights did not apply to women in exactly the same manner. Criticizing Paul's views as overly theoretical, Smith defined equal rights according to the needs and experiences of women in different classes and professions.[11] To accomplish this, she advocated female-specific laws that regulated the terms of the labor contract. Smith believed that "it is hard to see why, if [women's labor laws] are good for women, they would not be good for men."[12] She explained that she preferred to see legislation that was not gender specific but, "the fact that they were not so enacted when they were first proposed, two or three generations ago . . . is due primarily to the fact that em-ployers resisted the proposal to regulate competition among the workers, and leg-islatures were more susceptible to the employers' than to the workers' appeal." Because the courts "interdicted the general legislation for men and women," she

and her collaborators "pursued the possibility of legal regulation of the working conditions of women. . . ."[13] Smith believed that a female-specific approach to legislation effectively challenged traditional male-dominated legal viewpoints, establishing a dialogue that was sensitive to women's different needs but that did not sacrifice the interests of one group of women to the purposes of another.[14]

To develop a compromise measure that would give both sides of the debate what they wanted, Smith negotiated, at first, in good faith, believing that a collective front would move both organizations closer to their goals. The tension that built between them was not only reflective of the complexity of the issues at hand, but also the distinctions in their leadership styles. Smith was direct and open-minded; Paul was evasive and focused on a single issue. Smith advocated for piecemeal reform based on the study of labor conditions within specific industries; Paul preferred sweeping measures to change the word of the law. While Paul believed that women could contest in the courts any failure to uphold the provisions of the ERA, Smith preferred to work through state legislatures, fearing the unpredictability of judicial reasoning, particularly at a time in which laissez-faire individualism dominated legal thought. Both women sacrificed their health and personal lives, choosing to devote all of their energy to pursue equal rights as they defined it. As Paul and Smith negotiated their differences in the months following the NWP's 1921 convention, both women sought support from attorneys and judges who might be sympathetic to their competing viewpoints, and offer the legal insight necessary to draft a version of the ERA that would uphold the interests of all groups involved in the debate. Though Paul contended that she negotiated in good faith with an array of legal advisors, she consistently evaded all direct questions regarding her stance toward women's labor laws. She told her opponents that she personally did not take a stand on the issue and that the NWP's research on state-level discriminations against women would be crucial to determining her view toward such legislation. Her attitude led Smith, and others, to determine that Paul was not completely forthright and that she could not be trusted.[15]

Paul's correspondence with fellow NWP members during this period reveals that she did indeed oppose women's labor laws. Building on her detailed study of women's Common Law status, she argued, "no permanent harm will be done if the amendment should happen to interfere with protective legislation for women, as this probably would force the enactment of this legislation by trade lines instead of along sex lines . . . which would be better in the long-run for both men and women."[16] As she argued her position from a legal point of view, Paul continued to elaborate upon her optimistic assessment of the link between industrial expansion and enhancing women's economic opportunities. She believed that any legal recognition of women as a separate class prevented them from competing freely with men in the labor force.[17] As a trained lawyer, she also understood that nobody could "forecast with absolute certainty what the Supreme Court will do in

any matter," a point that Smith repeatedly emphasized as she attempted to nego-
tiate with Paul.[18] In December, Paul finally admitted, "Personally, I do not believe
in special protective labor legislation for women. . . ." She continued, "I think that
enacting labor laws along sex lines is erecting another handicap for women in the
economic struggle."[19]

Paul's evasiveness helped build publicity for her organization and the ERA.
After nine months of dispute with Smith and other opponents to the ERA, Paul
proclaimed, "the amendment has been skyrocketed into unexpected fame by the
attitude of certain women. . . ."[20] One reason for this unexpected fame, as Paul
called it, was due to the turn of events that erupted when she and her legal advisors
sought the opinions of two of leading influences in the development of legal realist
thought, Roscoe Pound and Felix Frankfurter. She worked closely with two attor-
neys who were affiliated with the NWP, relying most heavily on Albert Levitt, a re-
cent Harvard Law School graduate who considered Pound as his mentor.[21] As a
Vice-President of the NCL and Dean of Harvard Law School, Pound was a well-
known legal reformer and influential figure in efforts to transform legal concep-
tions of social and economic conditions.[22] He viewed Levitt as an ally and agreed
to offer suggestions for drafting the ERA in a way that would not imperil women's
labor laws if the NWP would not publicize his opinions.[23] He supported Paul's de-
sire to eliminate disabilities and inequalities that limited women's legal rights, but
preferred piecemeal, state-by-state legislative reforms over the sweeping provisions
contained in the amendment. However, he concluded that in "the present temper
of the courts it is hard to draw up anything that may not be used to defeat social
legislation."[24]

While negotiating with Pound, Paul also instructed Levitt to seek assistance
from Frankfurter, legal counsel for the Washington, D.C. Minimum Wage Board,
"with the intention of getting his help in drafting an amendment which would con-
serve welfare legislation as he viewed it."[25] Involved in the movement to gain passage
of the Washington, D.C. minimum-wage law for women in 1918, Frankfurter com-
mitted most of his time and effort to defending this law in the courts between 1921
and 1923. When Levitt and Paul approached him in 1921, defending the legality of
the 1918 law dominated his interests. After reviewing the amendment's language,
Frankfurter told them that the ERA "is fraught with the greatest dangers." He ar-
gued, "[I]t seems to me incredible that a Constitutional amendment aimed at the
removal of disabilities should be proposed without first having made a thorough
study of the disabilities to be removed in the various states. I confess I do not see how
any intelligent amendment can be drawn without prior knowledge of what is sought
to be changed—not generally but specifically."[26] As Frankfurter commented on ad-
ditional ERA drafts, he stated his complete opposition to a national amendment
dealing with the removal of existing disabilities affecting women, preferring to leave
the matter to state government. He determined that he had neither the time nor the

confidence to draft an ERA proposal that would not provide a basis upon which opponents to women's minimum-wage laws could develop an attack against them. Levitt could not change Frankfurter's mind. He told Paul, "There is no possibility of his giving any time to a constructive piece of work. He will not draft an amendment which will protect welfare legislation. . . . The net result of the interview is nothing."[27]

By using Levitt's connections with Pound and Frankfurter, Paul helped to bring the ERA into national prominence.[28] To achieve this, however, she and leading NWP figures violated Levitt's trust by falsely citing Pound and Frankfurter as favoring the ERA. Paul claimed, "Dean Pound approved several of the drafts which we submitted as safeguarding [women's labor] legislation. . . ."[29] Elsie M. Hill, Temporary Chairman of the NWP, claimed, "We have the opinion of Dean Pound of Harvard that this measure is correctly drafted and appropriate for federal amendment action."[30] Anita Pollitzer, the NWP's Executive Secretary, also announced that Pound said a longer draft "is in good legal form and is suitable either for a bill or for a constitutional amendment."[31] At no point, however, did Pound consent to supporting the ERA, nor did he permit the NWP to publicly use his name.[32]

In July, Levitt told Paul that Frankfurter "was much vexed and perturbed at the fact that you had quoted him" as stating his willingness "to phrase an amendment which would meet your needs and at the same time protect welfare legislation. . . ." Levitt angrily continued:

I assured him that he must have been misinformed concerning your remarks about Dean Pound . . . as I had your solemn pledge that under no circumstances would you bring them into discussion at all nor in any way whatsoever. . . . I based my assurances upon the limited acquainted [sic] I had with you and upon the word of confidence which you had given me and which is always understood in any thing that I do for you and the National Woman's Party.[33]

Levitt's confidence waned, however, after discussing this controversy with Pound. Again, he told Paul,

I cannot for the life of me understand how anyone could have misinterpreted what I said to you in regard to quoting the people whose advice I had sought. I repeated and repeated in varying tones of emphasis the statement that under no circumstances, for no purposes and to no one was any quotation to be made. . . . But—it is really my fault in that I misjudged your capacity to appreciate what it meant to me to use my friendship in behalf of an important problem and its solution. For the first time in my life I am in the position of one who has broken faith and loyalty to his friends who have trusted him.

Levitt told her that he had already apologized to Pound for the situation and not to exercise "the fool notion of wanting to write" to him. He also emphasized to Paul that "after this I cannot confer with anyone whose judgement I value on your behalf."[34] Though Paul consistently irritated Levitt, he continued to work for her, not so much because he supported her leadership, but because when he married Elsie Hill, "he married the Woman's Party."[35]

For five months, he willingly drafted at least seventy-five versions of the proposed amendment, believing that Paul intended to safeguard women's labor laws. He told her, "For over ten years I have been in constant association with those whose primary efforts are directed towards the protection of women and children in industry. . . ."[36] By December 1921, Levitt argued, "I am honestly of the opinion that Miss Paul is willing to sacrifice welfare legislation for the sake of putting a general theoretical principle into the federal constitution. I am persuaded that this principle can be put into the federal constitution and at the same time conserve welfare legislation."[37] He questioned Paul's integrity, accusing her of being "interested in welfare legislation only as a political card" that she could play to gain the support of Smith and other prominent opponents of the ERA. Levitt proclaimed that he did not care what Smith or the others "say or think about the amendment. . . . I do care that the NWP does not sacrifice welfare legislation for a *possible emancipation of women.*"[38]

Levitt's views were not too far removed from those of Smith's and Frankfurter's. As the labor representative on the Minimum Wage Board, Smith worked closely with Frankfurter between 1921 and 1923, while they anxiously defended the Washington, D.C. women's minimum-wage law against its critics. She expressed great concern that the ERA could be used to undermine women's labor laws. She told one NWP member, "I am, as you know, the women's representative on the Minimum Wage Board of the District of Columbia, and our law is now having many vicissitudes in the courts. One or two lawyers whom I know have expressed considerable apprehension as to the effect of your blanket amendment upon the minimum wage and other labor legislation."[39] Smith and her supporters struggled to defend women's labor laws as lawsuits were increasingly filed against eight hour and minimum-wage laws for women. The Washington, D.C. minimum-wage law had been in the courts since late 1920 and was on its way to the Supreme Court by the end of 1921. While this litigation was proceeding "employers in the laundry industry, for example, are withholding the wage from the laundry workers, who can recover only by bringing civil suit, individually, and thereby losing their jobs."[40]

Smith helped keep Frankfurter apprised of the proposed ERA's status as he prepared to defend the Washington, D.C. women's minimum-wage law in the courts. He substantiated her belief that Paul's amendment "writes into the Constitution of the United States a dangerous lawsuit jeopardizing the effort of the nation and the states to deal justly with its women workers." He argued that the ERA

would "render impossible every effort at legislation protective of women workers," because female-specific laws would be unconstitutional.[41] He continued,

> The Woman's Party is concentrating upon reform and upon sentiments of special concern to a comparative handful of professional and leisure class women, who seem either indifferent to or ignorant of the consequences they will bring upon millions of wage-earning women. The proposed amendment threatens the well-being, even the very life, of these millions.[42]

His advice substantiated Smith's belief that women's labor laws best protected the interests of her constituents. After seven months of legal negotiations with Paul, and as she increasingly struggled to defend the legislation she supported, Smith increasingly believed that the proposed ERA, regardless of its phrasing, threatened her reform work.

After conferring with Frankfurter, Smith increasingly questioned Paul's stated concern for women's labor laws. She suspiciously warned WTUL members that the "amendment to the federal constitution proposed by the National Woman's Party is causing much discussion and apprehension among the friends of social legislation." She continued, "We contend that the introduction of such a resolution in Congress and the state legislatures . . . would give advantage to all opponents of working women's laws and encourage them to seek repeal, both in Congress and in the legislatures." Smith concluded, "In other words, whatever the purpose, however sincere the women who propose this amendment, they would be offering themselves as an instrument to the exploitation of working women."[43] She believed that women's labor laws established standards in industry that had progressively helped to strengthen all laborers.[44]

Smith substantiated her position that the ERA threatened women's labor laws on the basis of much legal advice. According to Smith,

> I have found no one as yet among the attorneys we have consulted who believes it possible to draft a blanket *federal* constitutional amendment which would not jeopardize our social legislation. Therefore I have not offered and do not expect to be able to offer any suggestion for modification of that amendment. To my mind there is no justification whatever for introducing a blanket constitutional amendment at all.

She told Paul that "the inequalities we all want to remove should be attacked separately. . . ." By passing carefully proscribed reforms, she believed, the NWP and other women's organizations would not be at odds with one another. Still assuming Paul's good intentions, Smith emphasized that her legislative approach comprised "the only means not dangerous to the social legislation we are anxious to preserve."[45]

Smith further articulated her concerns to her greatest ally, Florence Kelley, who led the NCL's fight against the NWP. She wrote, "It is perfectly certain that they will not be diverted from their purpose to introduce the amendment, especially now that they have Mrs. Belmont's money to use for a campaign for something. Furthermore I'll wager anything I possess that Alice Paul herself is fundamentally opposed to special legislation for women."[46] Belmont, the NWP's benefactress, provided the much-needed funds for Paul to pursue a legislative campaign that few other people supported. Smith suspected that with adequate financial backing, Paul would eventually end all official discussion regarding the proposed ERA. Indeed, she was correct.

Claiming that she had negotiated with Smith and the others in good faith, Paul argued, "As far as I can see the best thing to do is to go ahead with the amendment in its present form, since no one seems able to suggest a form that will make it certain that it will not touch the field of protective legislation for women."[47] Paul impatiently claimed that "various legal authorities have been working on the drafting of this amendment for some considerable time" and that she had "consulted the leaders of the movement for women's welfare legislation in order to secure their help in drafting the measure in a way that would not touch upon their legislation." She emphasized her willingness to negotiate with her critics, but criticized them for not providing "any suggestions as to ways in which they thought the amendment could be improved."[48] Though the state-by-state investigation of legal discriminations affecting women was not complete, she determined that the amendment draft was in satisfactory form and that it could be introduced in Congress.[49] As she prepared to move forward with the ERA, Paul convinced Senator Charles Curtis of Kansas, the assistant Republican floor leader and Simeon Fess of Ohio, the national Congressional chairman of the Republican Party, to introduce the measure in their respective chambers.[50] In doing so, however she did not divulge the extent to which the ERA had generated controversy. Smith, however, did heighten policy makers' awareness of the issues that shaped the ERA debate. Based on what he learned from Smith and her supporters, Senator Curtis stated that he preferred that the NWP reach an agreement with their critics before he introduced the ERA. Congressman Fess told Paul that he would not introduce the ERA if it threatened women's labor legislation because he favored such laws.[51]

Opponents to the NWP believed that before officially opposing Paul, they should call a meeting between her and other concerned women who challenged the proposed ERA.[52] In December 1921, legislative representatives of seven national women's organizations met with Paul to discuss the possible threat the ERA posed to social legislation and labor laws for women passed in fifteen states. Smith explained that the conference was arranged to determine if the NWP "would agree to withhold their amendment until or unless it could be modified in such a manner as

to satisfy the other women's organizations that it would not endanger the legislation women have already secured in some states and are still working for in others." As a representative of the WTUL, she argued that they could not support the amendment in its present form. She believed that it sacrificed the interests of working women for "the relatively small possible gain to a much smaller group of women."[53]

In response, Paul continued to avoid revealing her actual antagonism to women's labor laws. When she was specifically asked to explain her position on the matter, "Miss Paul stated definitely that the Woman's Party did not desire to touch the industrial legislation in this amendment." As one of her supporters put it, "[S]he and her associates did not believe that the proposed amendment would interfere with existing labor laws for women, and furthermore that they felt it was up to the people who advocated such laws to safeguard them by suggesting suitable language for this amendment."[54] Both Kelley and Smith emerged as the leaders of the conference, taking the most adamant stand against Paul. They told her that they had attempted to find a safe method of drafting the ERA that would not threaten women's labor laws. However, their attorneys informed them that "it was practically impossible to frame a blanket law which would not open the way to such various constructions by the courts as to involve numberless law suits, delays . . . and interferences with laws already on the statute books."[55]

Smith expressed her belief that if the ERA passed, then critics of welfare laws would immediately pursue injunctions and lawsuits against such legislation. She argued that "all the objects sought by the blanket amendment can be obtained by separate legislation for the classes of women who need it. . . ." More specifically, Smith, "[o]n behalf of the hundreds of thousands of wage-earning women in the National Women's Trade Union League," urged Paul to pay sufficient attention to the prospect that the ERA would result in long and unnecessary court battled that would impede the operation of existing laws.[56] Paul admitted that "of course she expected law suits and reiterated that to avoid this contingency was not the concern of the National Woman's Party." In response, Smith asked her, "Will you pay all the expenses of the lawsuits which this amendment will involve?" Miss Paul said, "Of course not." Kelley responded, "No, *we* will have to pay it."[57] The December conference did not resolve the differences between the NWP and its opponents. At this point, Smith told Paul,

> We think that if the National Woman's Party takes upon itself the responsibility of proposing a *blanket* law which even seems to jeopardize existing social legislation, it is morally obligated and naturally would wish to take the responsibility of safeguarding *any such existing legislation that it considered desirable.* For reasons which I shall mention, it is the obvious inference at present that the National Woman's Party, or at least Miss Alice Paul, actually does not care to protect the women's laws working women desire to protect.[58]

Smith inferred from Paul's avoidance of the question that she opposed female-specific legislation. To set the record straight, she told Paul, "We ask the National Woman's Party to declare itself on this issue, because we believe the women of the country who have secured the passage of the social welfare laws are entitled to this information" so that they may form an accurate opinions regarding the desirability of the ERA.[59]

In a formal letter to Paul, on behalf of the WTUL, Smith proclaimed, "On the basis of legal advice from attorneys who have made a study of the special fields of constitutional and industrial law . . . ," the WTUL believed that "the so-called "equal rights" blanket amendment proposed by the National Woman's Party to the federal constitution would seriously interfere with existing laws which women have worked for years to secure."[60] She told Paul "that prominent lawyers have thus been cited on both sides of the question of constitutionality, seems to us in itself conclusive indication that . . . the matter [would] be carried to the Supreme Court," thus interfering with the administration of such laws.[61] She concluded that since lawyers disagree on the matter, the courts would, too. Before eliminating further discussion with Paul, Smith asked her one last time to state her position on women's labor laws. She told Paul, "[T]he situation . . . entitles us to know the position of the National Woman's Party on the phase of this matter, which seems to us to be, after all, the crux. . . ."[62]

She had lost her optimism about Paul's willingness to compromise even before the December meeting with the NWP. In early December, Smith told her colleague, Rose Schneiderman, "So far as I know, everybody agrees that some of the things the Woman's Party is aiming at are things we all could support. . . ." However, she also predicted that before long, Alice Paul herself would definitely align herself against legislation for women that did not apply to men. "In other words she will take the same general course that the Pankhursts took in England, a course which . . . makes the British working women feel that they were clearly deserted and betrayed by the suffrage leaders in England who had used them during the suffrage campaign." Smith determined, "I am unable to see any way whatever of uniting with them because there is no way I can discover of making their amendment safe from our point of view." She wearily proclaimed, "I am convinced . . . that they do not care whether they disturb labor laws or not."[63] In a letter to Maud Younger, a prominent NWP member and labor leader, Smith expressed her belief that "the National Woman's Party, or at least Miss Alice Paul, actually does not care to protect the women's laws working women desire to protect." She told Younger, "the continued absence of a declaration on this subject leaves the implication that the Woman's Party leadership is willing to destroy those laws" or subject them to a lengthy litigation process. Such a process, she explained involved "loss of health and wages during pendency of the suits." In conclusion, Smith argued that the NWP "shows itself ruthless, to say the least, in its

dealing with working women."[64] Similarly, in a letter to Paul, Smith argued that the NWP had the responsibility "to declare itself on this issue because . . . the women of the country who have secured the passage of the social welfare laws are entitled to this information. . . ."[65]

By early 1922, Smith cut-off communication with Paul and earned a reputation among NWP members as "the most venomous member" of the opposition to the ERA. She used her influence as a lobbyist to meet with members of Congress to generate a greater awareness about why working women opposed the ERA.[66] She also used her journalistic abilities to generate significant publicity to explain why her constituents opposed blanket legislation. In several publicity pieces, she proclaimed that working women, unlike members of the NWP, "distinguish between equal rights in theory, and equal rights in fact, especially as applied to industrial conditions and labor laws for women."[67] Women's labor laws, Smith argued, "help to bring the working women *up toward* an equal footing with the working man. Without them she is far below such footing economically." According to Smith, "[W]hat happens is that the laws for women bring up the standards for men in the same industries, because the men's and women's work is interdependent, and when the women stop work at the end of the day the men have to."[68] For Smith, labor laws for women comprised a larger agenda for reforming labor conditions. Though women's labor laws excluded men, she contended that different types of labor were interdependent. Therefore, when one group of workers benefited from legislation that regulated working conditions, other groups, in the long run, benefited as well. Overall, she described the proposed ERA as "indiscriminate" and "reckless," because it threatened to destroy the standards created by government regulation of women's labor.

To prevent Paul from succeeding at her goal, Smith organized a conference of working women's representatives to meet on February 26, 1922. Participants in the conference declared their opposition to the ERA because it endangered protective legislation. Delegates articulated their belief that Paul and her supporters pursued a theoretical conception of equal rights that did not account for the different material realities of women's lives.[69] In their declaration of principles, these trade union women stated that blanket legislation, both state and federal, "is not the best means of attaining the desirable ends of the proposed measures." They contended that everything sought by blanket legislation could be obtained by separate laws. "Disabilities or inequalities of one kind existing in one state frequently do not exist in the next state. The conditions should be studied and the remedy applied where it is needed, without forcing the sacrifice of one group of women to another." Based upon their stated beliefs, conference participants "voted to call upon the National Woman's Party to discontinue its effort for blanket legislation . . . and offered their cooperation in any effort to correcting discriminations by remedying particular wrongs. . . ."[70]

As she reported on the conference, Smith emphasized the views expressed by prominent wage-earning women in the WTUL. She cited, for example, the distinctions that Frieda Miller of the Philadelphia WTUL made between "equality that is real and equality that is theoretical." According to Miller,

> The trouble with those who speak of equality and opportunity in large phrases is, that they do not examine the word opportunity. Men have been in industry longer than women and have established their standards. Women came in later and are still under special disabilities in industry. Genuine equality requires that they shall have such laws as will bring them nearer to the standards which men have won by their longer experience and stronger organizations.[71]

Similarly, other conference speakers articulated their belief that the proposed ERA would threaten labor laws that applied only to women. These women believed that the implementation of the ERA would provide the legal means of throwing women's labor laws into the courts, thus subverting the legal standards that helped prevent lockouts, overwork, and low wages.

Gompers backed the proclamations issued by women at the February conference. At a meeting with NWP members, he "called Miss Smith to his office to be present during a conference with Miss Younger, who had asked for an appointment to discuss the blanket amendment." According to Smith, "I fancy Maud Younger didn't expect me and hardly enjoyed herself." Gompers was "exceedingly cordial and pleasant" to Younger, "giving her every chance to present her case, but when she had finished, he demolished all her lawyers' opinions." He told her, "I cannot support this amendment. I go farther than the lawyers who say the courts may construe it as invalidating existing laws protecting wage-earning women. I say it *will* so construe it." He added, "I should like to see the time when wage-earning women are strong economically as men, and hence could do without protective laws but the industrial equality actually existing is so great that we cannot stand for the repeal of laws we have secured to bring women somewhat nearer an equal footing with men. I must oppose this amendment, and I must in conscience so advise my associates."[72] By early 1922, eleven national organizations representing an array of constituents, expressed opposition to the ERA.[73] Paul dismissed all criticisms of her agenda and continued to prepare the amendment for introduction in Congress.[74] Tensions brewing between Paul and Smith were taken to new heights in 1923 as their debate shifted to a focus on the Washington, D.C. minimum wage law and the Supreme Court case that would decide its future. The crux of both women's competing viewpoints was located within the litigation surrounding the case, *Adkins v. Children's Hospital* 261 U.S. 525 (1923). *Adkins* invalidated a 1918 Washington, D.C. minimum-wage law that established a legal floor on the rates that an employer could pay women workers.[75] The Supreme Court ruled that the

law denied the hospital and its employees liberty of contract without due process. According to Chief Justice Sutherland,

> The right of a person to sell his labor upon such terms as he deems proper is, in essence, the same as the right of the purchaser of labor to prescribe the conditions upon which he will accept such labor from the person offering to sell. . . . In all such particulars the employer and employee have equality of right, and any legislation that disturbs that equality is an arbitrary interference with the liberty of contract which no government can legally justify in a free land.[76]

Sutherland continued by saying that any arbitrary interference with freedom of contract substantially impaired a long-held constitutional right. He argued that the Washington, D.C. law disturbed the equality of right guaranteed by contract rights. Though typically the Court did not restrain freedom of contract, Sutherland noted, exceptional circumstances sometimes warranted regulatory laws.

By precedent, the Court upheld legislation if it served a public interest, especially laws protecting the health, morals, and safety of citizens. According to the Court, such laws properly exercised the states' police powers. The Court, however, feared that state government would misuse its legislative power. According to Justice Peckham, the Fourteenth Amendment due process clause authorized the Court to prevent the unbounded use of state authority. He argued that the "claim of the police power would . . . become another . . . name for the supreme sovereignty of the state, to be exercised free from constitutional restraint," unless the Court used judicial review to determine the proper exercise of state legislative power.[77] Another justice argued that the women's minimum-wage law accounted for the needs of only one party to the contract. "It ignores the necessity of the employer by compelling him to pay not less than a certain sum, not only whether the employee is capable of earning it, but irrespective of the ability of his business to sustain the burden, generously leaving him, of course, the privileges of abandoning his business as an alternative for going on at a loss."[78]

In effect, the Court propounded a standardized interpretation of equal rights contingent upon freedom of contract. Within the traditions of legal formalism, the Court emphasized the individual right to freely negotiate the terms of the labor contract, whether employee or employer. This freedom, according to the Court, placed all persons on an equal economic plane. In addition, the *Adkins* decision maintained a gender-specific application of the citizenship rights enumerated in the Fourteenth Amendment. Beginning in 1894, the Supreme Court ruled that states could confine the word "persons" in the Fourteenth Amendment to men alone.[79] The Court defined equal rights according to a male-defined mode of juristic thought that valued free contract rights over the regulation of labor conditions. Because *Adkins* failed to recognize the complex relationship between gender

and class-related issues, the case demonstrated not only the tenacity of legal formalism, but also the extent to which formalist thought perpetuated gendered legal constructions.

Paul and the ERA helped incorporate women's equality into more conservative traditions of judicial reasoning that recognized gender "equality as sameness" in legal thought. Her acceptance of formalist interpretations of contract incorporated women's equality, as she perceived it, into male-defined conceptions of rights. Rather than focus on the different material circumstances of women's lives, she offered an ideal attainable to professional and business class women whose economic mobility hinged upon non-governmental interference with the labor contract. Smith rejected Paul's optimistic understanding of the courts as well as her formalistic approach to women's equality. She argued instead that any method seeking equal rights must respond to the demands of an industrial economy. To Smith, *Adkins* undermined all of the issues that she had advocated for in her career. The decision challenged the wage standards of 1,500,000 women and potentially depressed wage standards for all workers. She argued that the Minimum Wage Board "raised wages in every industry it touched, which shows that without the law, most women were getting less than a living wage."[80] In addition, while the *Adkins* decision was pending," Smith complained that the women's minimum-wage law was not enforced. She explained, "hotels reduced wages by more than half, and other establishments have been known to have made reductions." After the Court declared the law unconstitutional, she reported that "the cuts are coming fast and furious." She wrote, "A whole chain of stores . . . has reduced the wages of its saleswomen by 50% and the girls are not earning but $8 and $9 per week."[81] In addition, Smith anticipated that the decision would invalidate the minimum-wage laws of thirteen states, thereby affecting the wages of what she estimated as 1,500,000 women workers in those states.[82]

To Smith, *Adkins* exemplified the Court's ignorance of social issues and public interests.[83] As a representative of the Washington, D.C. Minimum Wage Board and on behalf of the WTUL, Smith called a conference for May 14 and 15 at its Washington, D.C. headquarters to examine the possibilities of remedying the deleterious effects of the *Adkins* decision.[84] In her letter that invited socially minded men and women to the conference, she requested that various labor and women's organizations send representatives interested in proposing a possible course of action to protect existing minimum-wage laws. Members of twenty-seven different organizations responded to her call. Participants included a diverse mixture from the labor and women's movements, organized religion, and public interest groups.[85]

Despite some tension between the AFL and WTUL, the conference resulted in the type of well-defined cooperative response that Smith so strongly supported. Bringing together such notable reformers as Gompers, Kelley, Father John Ryan, Grace Abbott and Mary Anderson, the proceedings highlighted "the significance

of the movement of women workers to organize for their own protection through the establishment by collective agreement with employers, of proper standards and conditions of employment. . . ."[86] Participants discussed methods of cooperation to protect existing social legislation against further formal legal encroachments.

To publicize the conference, Smith reported on the shared concern for protecting working women's legislation, especially minimum-wage laws. She reported that conference members concluded,

> The United States Supreme Court has invalidated the Minimum Wage Law of the District of Columbia, thereby depriving nearly 20,000 women workers of its direct protection and calling into question the similar laws of twelve states, the wage standards of 1,500,000 women in those states and potentially depressing the wage standards of all the 9,000,000 women workers in the United States.[87]

To determine a course of action that all sides could agree upon, conference members appointed a Committee of Three to organize a larger committee of the groups represented in the conference. The committee consisted of Smith, Matthew Woll, Vice-President of the AFL, and at first Kelley, who stepped down to be replaced by Father Ryan of the American Association of Labor Legislation.[88]

As a selected member of the Committee of Three, Smith worked in a cooperative effort with the thirty-four men and women representatives selected to form the larger conference. These individuals included such noted reformers as Edith Abbott, John Andrews, Mollie Ray Carroll, Maud Wood Park and Samuel McCune Lindsay, one of Paul's former college professors, whose task it was to develop a legislative program to remedy the conditions created by the *Adkins* decision.[89] The larger group addressed proposals to curtail the power of the Supreme Court.

Smith supported efforts to increase state and congressional authority over the federal judiciary as a way to counter the Court's refusal to recognize the diversity of women's lives. Expanding her criticisms of the *Adkins* decision beyond women's interests, she explained,

> Our protest in the minimum wage case is not only against the wrong to women wage earners, but against the usurpation by the judiciary of a power more dangerous and destructive than ever before existed in the history of our or any other government. Nowhere has any government vested in men so far removed from the source of their selection such power as has been assumed by the United States Supreme Court.

By April 1924, the Supreme Court had not only challenged women's minimum-wage laws but the very foundation on which Smith defended her legislative work.

The formal legal doctrine articulated in the *Adkins* decision, she argued, "Leaves out from start to finish the social point of view, the public interest, and, in fact, the human element."[90] In effect, the 1923 *Adkins* decision undermined female-specific legislative approaches to women's equality and provided Paul with sufficient backing to introduce the ERA in Congress during the same year.

Smith accused Paul of attempting to maintain formalist interpretations of contract under the guise of extending such rights to *all* women. She argued that Paul offered working women empty promises of equality. Smith blamed her for intentionally ignoring the differing circumstances in women's lives, especially wage-earning women's exploitation in the workplace. Silent on the legal and economic rights of women of color, Smith emphasized the class-specific needs of wage-earners, especially women.[91] Ignoring Smith's accusations and fortified by the *Adkins* decision, Paul officially launched her ERA campaign. Senator Charles Curtis and Representative Daniel Anthony (Susan B. Anthony's nephew) introduced the ERA into both houses of Congress. To defend the amendment against tremendous opposition, the NWP celebrated the *Adkins* decision. Based on the Court's ruling, an article in the NWP's newspaper *Equal Rights* stated, "[O]ne can feel that the world is at last beginning to realize that women are adult human beings and should be legislated for with other human beings, and not as a class apart who can only be permitted to enter the industrial field under special protection."[92]

Despite such proclamations, Paul did not enjoy widespread support.[93] She continued to disregard the legislative work of the organizations that opposed her, claiming that the ERA represented the continuing progress in the evolution of women's legal status. If her critics refused to recognize her contributions, she believed, then they helped perpetuate legal recognition of women as dependent, fragile and weak.[94] Smith denied the validity of Paul's criticisms. Instead, she claimed that the NWP, combined with the Supreme Court, threatened the progress of the industrial labor reform created by women's labor laws. She further articulated her position in a series of newspaper articles and pamphlets in which she linked Paul's equal rights agenda with the Court's reasoning in *Adkins*. She argued that the Court lacked sufficient understanding of industrial labor conditions. Citing Justice Sutherland's opinion in *Adkins*, she criticized his formalist interpretation of contract for helping perpetuate legal interpretation of laborers as commodities that served the profit motives of business interests.[95]

Smith believed that Paul helped perpetuate political and legal thought that did not best serve the interests of a modernizing industrial society. She argued that the ERA debate represented the "conflict between the laissez-faire idea, the individualistic philosophy of the 18th century, carried down to the present day by the non-industrial classes, and the socialized, collective view of life and the welfare of the great masses of working people." According to Smith, "Women who have thought straight on the question of sex inequalities, but have neither experience

nor contact with the industrial struggle, are often unable to see that social and industrial inequalities are problems at least coequal with the sex problems." Smith criticized Paul for ignoring the social aspects of equal rights. She argued that the NWP consisted of a group of ultra-feminists who were more concerned with advancing their ideal of equal rights at any expense than redressing the inequities of the labor contract.

Though Paul accurately predicted that the female-specific approach would be used to limit women's economic opportunities, Smith's criticisms of the sweeping content of the ERA were of commensurate value. She stated that the ERA would "write into the fundamental law a statement of principle, a theoretical advance toward equality for men and women." According to Smith, "It is because we are facing facts and not theorizing that labor law for women is advocated." Smith feared that the ERA's vague content would throw women's labor laws into the courts for endless litigation. The ERA encouraged the legal protection of economic interests over the material realities of women's lives. The complexities of equal rights could not simply be defined in economic terms alone. Reformers seeking full legal equality, according to Smith, must assume the responsibility for not threatening existing reforms promoting that goal. Equal rights legislation must recognize social and political inequities rather than define equality in absolute terms. Smith wrote, "What are rights in terms of law? What are equal rights? Nobody knows finally until the courts decide in each case."[96]

Paul's and Smith's debate summarized the basic dilemma that has persisted in gender equality discourse throughout the twentieth century. The juridical equation of gender equality as sameness, so deeply ingrained in American legal thought, irreparably divided the women's movement. On the one hand, Paul's interpretation of equal rights helped perpetuate formalist dominance of legal thought by incorporating women's equality into arguments for economic interests and threatened the inroads made by advocates of legislative strategies that emphasized gender differences. On the other hand, Smith's definition and approach to women's equality played a crucial role in the realist triumph over formalist thought in the 1930s. The female specific approach created the legal precedents that helped expand traditional interpretations of equality to incorporate not only economic rights, but also the civil rights of individuals.

The tenacity of gendered constructions in the law, however, outweighed Paul's and Smith's arguments. The ERA debate must be examined within the legal context of the 1920s. Most historians and feminist legal theorists neglect this aspect of the debate, assuming the dominance of equality based jurisprudential strategies, the approach that has shaped much of late twentieth century feminism. This is a misleading construction that silences not only Paul's voice and the limitations of the ERA but also the voices of other women, such as Smith, who were just as devoted to women's equality.

CONCLUSION

Two Paths to Equality

The Difference It Makes

The preceding chapters portray the ERA debate between 1921 and 1923 as a case study of the legislative and legal strategies used by national women's organizations in the first half of the twentieth century to advance equal rights for women. Using a biographical method, this study responds to more than twenty-five years of historiography portraying the debate as either a feminist dichotomy or a disagreement over women's sameness to or difference from men. Focusing on the two main leaders of the debate reveals that Paul and Smith were savvy political actors who believed in the power of the political system and accepted the concept of equality as the most effective means to equalize women's position in society. Both believed that a rights-based approach to women's equality would confront stereotypical notions of gender in law and culture and eliminate gender-based pay inequities and workplace segmentation. Their conflict is a telling story of the inextricable relationship between personal politics, collective action, and the intersection of law and culture on the social construction of gender.

Paul's and Smith's personal politics shared a number of commonalities. Both women turned to the language of rights in response to the inequities of unregulated industrial capitalism. Smith's relationship with her father bore direct relation to her burgeoning interest in equal rights. His enduring financial struggle and faith in the merit system instilled in Smith a tenacity of spirit and moral commitment to protecting the interests of working women. Paul's firsthand experience with the urban poor propelled her away from social work as a means to mitigate the vicissitudes of an industrial economy. Instead she opted for the militancy of the WSPU and their impatient demand for equal rights with men without delay. Both women suffered from poor health and exhaustion as they worked tirelessly to defend their beliefs.

Their personal politics reveal the centrality of class to their definition of women's equality and choice of constituencies. Paul and Smith believed that women should organize as women to demand their full rights as citizens. By mobilizing on the basis of their shared experiences with gender exploitation, both believed that their constituencies could wield substantial political power and change society and culture. To accomplish this, Paul organized her members into professional councils to raise awareness among women about the discriminations limiting their economic opportunities and to motivate them to work for their removal.[1] At the same time, Smith worked to bring women workers into the labor movement, arguing, "We've got to make our own fight, women for women."[2]

Both believed that women needed to learn how to use their influence for social and economic change. Paul relied on extravagant pageants to evoke the history of women's demand for equal rights in the United States, to publicly challenge women's culturally ascribed role, to generate sensational media attention, and to motivate women to join ranks with the NWP to advance the ERA. Smith promoted the power of unionization to mobilize a vocal women's labor movement, and she developed and implemented an aggressive public education campaign through national media and labor movement publications, public speaking engagements, and congressional testimony. She argued that men ignored women out of habit, and that the gradual integration of organized women into the larger labor movement would help break down such gender stereotypes and build respect for women as permanent members of the labor force.

Paul and Smith disagreed, however, over social constructions of womanhood, as well as over the impact of class and the role of the state in regulating the lives of women. As Paul worked to mobilize her followers into professional councils and to educate a broader constituency, she increasingly focused on the needs and interests of upwardly mobile women. Working almost exclusively on behalf of mid-to-upper-class women not only provided her with the financial means to sustain the NWP at a time in which her membership plummeted but also lent some respectability to her organization at a time during which the nation turned inward and suspicious of those who challenged the status quo too forcefully. Conversely, Smith believed that true equality must be based on the consideration of different social and economic circumstances of women's lives. She advocated for a cross-class approach to mobilize women as a group, focusing primarily on the importance of unionizing and educating wage-earning women, equalizing their status in the labor movement, and then proceeding to the challenges confronted by professional and business-class women.

In the short run, both ultimately failed in their attempts to redefine legal conceptions of women's equality. Equality based legislation was premised on an ideal that both benefited and limited women's opportunities in ways that were not always foreseeable. The pursuit of equal rights enabled some women to gain access to the male-dominated American legal and political processes but did not challenge the gendered assumptions that shaped such processes. The ERA debate reveals the tenacity of gendered construction in the law and the limitations of pursuing a rights-based approach to women's equality. An analysis of the debate between Paul and Smith demonstrates that equality as a form of jurisprudence perpetuated many of the inequalities that they sought to challenge.[3] Neither Paul's nor Smith's viewpoints were to blame for the limitations of equal rights as a basis of change for women's lives. Situating their debate within the larger legal debate between formalists and realists helps create a broader context for understanding the obstacles that both women attempted to overcome.

As both women sought legislative change to fulfill their competing equal

rights agendas, they accepted certain aspects of the law to achieve their stated goals. Between the 1870s and the 1950s, formalist interpretations of legal rights reigned supreme. Based on the principle of laissez-faire individualism, conservative jurists maintained a limited conception of civil rights that guaranteed freedom of contract, especially the labor contract. Though an alternative form of jurisprudence attempted to legitimate government regulation of contract rights, the male-defined assumptions inherent within contract theory remained unchallenged. Paul's and Smith's view on equal rights developed within this legal context.

Legal realists experienced a few victories in an attempt to shift conservative legal thought to a more responsive basis of judicial reasoning based on the study of social and economic conditions. The first victory, *Muller v. Oregon*, is best remembered for upholding Victorian notions of women as weak and dependent.[4] While it is true that the Supreme Court did use that language, the case also established a powerful precedent for the long-fought struggle to establish a basis of judicial reasoning that held the state accountable for regulating conditions that prevented women from competing equally with men in all aspects of their lives. *Muller* and other cases like it were decided at a time in which no precedent had been established to recognize gender-based arguments for equal rights. The preeminence of the sexual contract remained unchallenged and virtually invisible for almost 100 years.[5] In fact, the courts have only seriously sustained legal dialogue about women's equality since the early 1970s. Women such as Smith should not be judged without considering this context. Applying late-twentieth-century standards to evaluating the ERA in the 1920s superimposes a predetermined paradigm for understanding what was at stake for both sides of the debate.

It also is interesting to note that the NWP remained virtually alone in its support for the ERA throughout most of the twentieth century. Despite this, Paul is remembered as a cultural and historic icon among women's organizations which have preserved the memory of her as a selfless martyr, a persona she carefully crafted during her lifetime. But no study has ever embraced Paul in all of her complexity. From the isolated Quaker enclave of Moorestown and the urban slums of New York City and London into the national spotlight, Paul abandoned social work to aid the poor, and she pursued a more rapid means for social and economic change. As she abandoned social work, she also increasingly associated with elite women and developed a definition of equal rights that benefited the interests of such women. Her unapologetic demand for the elimination of political and legal inequalities in the law ensured her place in American history. It is indisputable that she advanced a forward-looking vision of a world in which men and women shared the same rights, and it is clear that Smith and her supporters shared that vision. However, few studies have tackled her political philosophy within the context of the 1920s or grappled with the relentless tactics she oftentimes used to advance the ERA.

Rather than unraveling the complexities of Paul's leadership, most studies

have accused women such as Smith for failing to challenge women's secondary status in the labor force and helping to perpetuate conceptions of sacred motherhood. An analysis of Smith's family and career helps refute such criticism. As an activist in the suffrage and labor movements, she articulated an approach to equal rights that recognized women as permanent members of the labor force who were entitled to the same opportunities as working men. She assumed a leading role in advancing a legislative strategy that accounted for the different conditions and types of labor that women performed. As she attempted to equalize the conditions of women's work, she emphasized the disparity between different material circumstances in women's lives and called for methods to work across those differences through collective action and government regulation. Therefore, Paul was not alone in her determined search for equality.

Coalescing Paul's and Smith's different approaches to equal rights within the larger legal context of the period helps clarify typically unexamined explanations for the sources of discontent between them. As their competing viewpoints were played out in the *Adkins* case, contract rights remained supreme, and the vote was used to deny the need for state regulation of women's labor. Since the *Adkins* decision legitimated Paul's legislative agenda so much that she could mobilize her supporters in Congress to officially introduce the ERA, she did achieve a short-term victory and helped strike a severe blow to Smith's vision of social and economic change for women.

In addition to the crisis generated by the *Adkins* decision, Smith was chosen by her peers to assume a leading role confronting a slanderous attack against the WTUL and WJCC. In the years following the *Adkins* decision, the climate of opinion continued to reject efforts to expand federal authority over issues that impacted the private concerns of individuals. Writing under a pseudonym, "An American Citizen," Mrs. Havilund Lund attempted to show "how interlocking directorates are used to disseminate propaganda through numerous worthy organizations of American women." In a series of articles, Lund claimed that the WJCC supported the Sheppard-Towner Act to manipulate women for the political purposes of building its bureaucracy. Because the "heart of everyone is touched by an appeal to care for mothers and babies," the WJCC could effectively manipulate the uninformed into relinquishing individual rights and other constitutional freedoms to the control of Socialist principles. Lund, a conservative, white, affluent woman, opposed expansion of federal authority. Consequently, she lashed out against the women of the WJCC, accusing them falsely of pursuing an agenda that intended to subvert basic American constitutional principles.[6]

Smith publicly refuted Lund's accusations, explaining that the women involved with the WJCC attempted to modernize the relationship between the state and its citizens. Insofar as this applied to the Sheppard-Towner Act, the women who supported this legislation seriously believed that government should assume

responsibility for the serious nature of maternal and infant mortality in the United States. She angrily proclaimed, as long as "women's organizations contented themselves with work that contemplated merely palliative measures of a philanthropic sort, no criticism was encountered." However, "when they sought to discover the causes and remedies for poverty, sickness, unequal opportunity, and war," their opponents accused them of radicalism, socialism, and communism, and "tried by innuendo to discredit social, industrial, and war-preventive measures."[7]

In the long run, however, Smith's viewpoints established legal precedents that helped expand traditional interpretations of equal rights. She continued to defend the WTUL's legislative agenda until the late 1920s, when she returned to civil service employment. As one of the women most noted for her expertise on women's labor conditions, she assisted the government in developing policies that were responsive to the social and economic needs created by the crisis of the Great Depression and New Deal. From 1929 through World War II, she worked on the Unemployment Census and for the Information Service of the Bureau of Home Economics in the Department of Agriculture, the National Recovery Administration as a labor advisor on the minimum-wage codes, and the Federal Social Security Board to help develop a specialized information service about the new Social Security Act.[8] Other labor legislation advocates called into government service during this period included Rose Schneiderman, Molly Dewson, and Eleanor Roosevelt. Alice Paul was not among these women because during the war, she continued to push her ERA agenda, while women such as Smith were committed to envisioning practical solutions to the nation's most pressing problems.

The lessons learned from the ERA debate of the 1920s indicate that efforts to redefine equal rights in ways that overcome formal legal equality must consider the confining aspects of contract not only in legal terms but also with regard to more subtle cultural mechanisms that help legitimize gender-based inequalities.[9] The debate reveals the importance of accepting and exploring differences among women to challenge delusive conceptions of the term *women* as a universal concept.[10] Those concerned about equal rights must coalesce across their differences to bring recognition of the diversity that shapes their lives. Only by coalescing across differences and accepting the varied implications of gendered constructions in law and culture will advocates of equal rights directly challenge the forces that divide them and develop flexible and adaptive strategies that will overcome the most tenacious forms of institutionalized discrimination.

Moreover, in light of present-day attacks on issues that equalize women's position in society, perhaps it is time to abandon equal rights as a basis of legislative and legal change. Equality remains a male-defined concept. It assumes that all people are similarly situated, and it is not flexible enough to account for individual differences according to gender, class, or race. Equal rights is a social construct, not just a form of jurisprudence, that upholds a universal standard of equality that typically ex-

cludes the interest of some groups to the interests of others. At a time in which women have organized according to a multiplicity of concerns, equal rights theory creates a self-imposed obstacle with the potential to divide women across their differences and divert them from their originally stated goals. If today's focus is on building recognition of the varieties of women's experiences, then equal rights as a basis of legislative and legal change is not the way.

NOTES

Introduction

1. Cynthia Patterson, "The Beginnings of Modern Feminism: The National Woman's Party's Campaign for the Equal Rights Amendment in the 1920s" (Ph.D. dissertation, Northwestern University, 1987), 71–75, 170–73; Lynne M. O'Leary-Archer, "The Contentious Community: The Impact of Internecine Conflict on the National Woman's Party, 1920–1947" (Ph.D. dissertation, University of Southern California, 1988), 28–30; Susan Becker, "An Intellectual History of the National Woman's Party" (Ph.D. dissertation, Case Western Reserve University, 1975), 203–07.

2. Leila Rupp and Verta Taylor, *Survival in the Doldrums: The American Women's Rights Movement, 1945 to the 1960s* (Columbus: Ohio State University Press, 1990).

3. Alice Kessler-Harris, *Out to Work: A History of Wage-Earning Women in the United States* (New York: Oxford University Press, 1982), 206–07, 212–13; Alice Kessler-Harris, "The Paradox of Motherhood: Night Work Restrictions in the United States," in *Protecting Women: Labor Legislation in Europe, the United States, and Australia, 1880–1920,* ed. Ulla Wikander, Alice Kessler-Harris, and Jane Lewis. (Chicago: University of Chicago Press, 1995), 337–39.

4. Miriam Cohen and Michael Hanagan, "The Politics of Gender and the Making of the Welfare State, 1900–1940: A Comparative Perspective," *Journal of Social History* 24: 3 (spring 1991): 469–84.

5. For examples, see, "Are Women's Clubs 'Used' by Bolshevists?" *The Dearborn Independent,* March 15, 1924, reel 4, Mary Anderson Papers; Ethel M. Smith to Mary Anderson, Washington, D.C., April 3, 1924, reel 4, Mary Anderson Papers; Ethel M. Smith, "Super Patriots Continue Attacks on Women," Washington, D.C., May 13, 1925, NWTUL of America, History and Data, 1920–1927, reel 17, Records of the National Women's Trade Union League (hereafter cited as WTUL); Ethel M. Smith to Rose [Schneiderman], Washington, D.C., May 6, 1927, NWTUL of America, Attacks On, 1925–1931, reel 16, WTUL; Ethel M. Smith to Mrs. John D. Sherman, Washington, D.C., June 2, 1927, NWTUL of America, Attacks On, 1925–1931, reel 16, WTUL; WJCC, "Summary of Report of

Special Committee," n.d., NWTUL of America, Attacks On, 1925–1931, reel 16, WTUL.

6. See Benjamin Twiss, *Lawyers and the Constitution: How Laissez-Faire Came to the Supreme Court* (Princeton, N.J.: Princeton University Press, 1942); David Wigdor, *Roscoe Pound: Philosopher of Law* (Westport, Conn.: Greenwood Press, 1974); Roscoe Pound, *The Formative Era of American Law* (Gloucester, Mass.: Peter Smith, 1938).

7. *Santa Clara v South Pacific Railroad*, 116 US 394 (1886); In *Re Lockwood* 154 US 116 (1894).

8. Roscoe Pound, "Mechanical Jurisprudence," *Columbia Law Review* 8 (December 1908): 605–823.

9. See Morton Horwitz, *The Transformation of American Law: The Crisis of Legal Orthodoxy, 1870–1960* (Boston: Harvard University Press, 1987), Joan G. Zimmerman, "The Jurisprudence of Equality: The Women's Minimum Wage, the First Equal Rights Amendment, and *Adkins v. Children's Hospital*, 1905–1923," *Journal of American History* (June 1991): 188–225.

10. Joan Scott, *Gender and the Politics of History* (New York: Columbia University Press, 1988), 7.

11. Diane Kirkby, *Alice Henry: The Power of Pen and Voice* (New York: Cambridge University Press, 1991), 132–38.

12. Nancy Schrom Dye, *As Equals and As Sisters: Feminism, the Labor Movement, and Women's Trade Union League of New York* (Columbia: University Press of Missouri, 1980).

13. Diane Kirkby, *Alice Henry: The Power of Pen and Voice*, 132.

14. Kathryn Kish Sklar, *Florence Kelley and the Nation's Work: The Rise of Women's Political Culture, 1830–1900* (New Haven, Conn.: Yale University Press, 1995), 256–58.

15. Kathryn Kish Sklar, "The Greater Part of the Petitioners Are Female," in *Worktime and Industrialization: An International History,* ed. Gary Cross (Philadelphia: Temple University Press, 1988), 103–33.

16. William A. Gamson, "Social Psychology of Collective Action," in *Frontiers in Social Movement Theory,* ed. Aldon D. Morris and Carol McClurg Mueller (New Haven, Conn.: Yale University Press, 1992), 55–57.

17. Mary Anderson to Mrs. Richard Border, n.p., June 7, 1951, reel 3, Mary Anderson Papers.

18. Though Smith is usually not listed in guides to manuscript collections, her correspondence can be found in: Records of the National American Woman Suffrage Association (hereafter cited as NAWSA); *The Woman Citizen*; Papers of the National League of Women Voters (hereafter cited as LWV); Records of the National Women's Trade Union League and Its Principle Leaders, 1903–1950; Records of the Women's Joint Congressional Committee (hereafter cited as WJCC);

Women's Bureau General Correspondence; Records of the National Federation of Federal Employees Union (hereafter cited as NFFE); *The Federal Employee;* Papers of the National Consumers' League (hereafter cited as NCL); Felix Frankfurter Papers; Proceedings of the American Federation of Labor (hereafter cited as AFL); *American Federationist;* National Woman's Party Papers, 1913–1974 (hereafter cited as NWPP); National Woman's Party Papers: The Suffrage Years; Papers of the New York Women's Trade Union League (hereafter cited as NYWTUL).

19. Nancy Cott, *The Grounding of Modern Feminism* (New Haven, Conn.: Yale University Press, 1987), 21.

20. T. H. Marshall and Tom Bottomore, *Citizenship and Social Class* (Cambridge: Cambridge University Press, 1950), 17–18, 22–28.

Chapter 1

1. Ethel M. Smith, "An Informal History of the Virginia-Kentucky Pattesons in Illinois, Their Forebears and Their Kin, Including the Lewises of Llangollen," 1948, Schlesinger Library, 68.

2. Ibid., 68, 72, 79.

3. Ibid., 70–71.

4. Carroll H. Wooddy, *The Growth of the Federal Government, 1915–1932* (New York: McGraw-Hill, 1934), 488. In response to the inefficient and time-consuming publication of the Eleventh United States Census, Congress created the Census Office in 1899 to systematize and expedite the completion of the Twelfth Census. Designed originally as a temporary branch of the federal bureaucracy, Congress created the Census Bureau as a permanent institution in 1903, housing it in the Department of Commerce.

5. Smith, "An Informal History," 71; Ethel M. Smith, Testimony on Reclassification of Salaries, Senate Committee on Civil Service, 67th Congress, 1st session, May 17–June 16, 1921, 462; Ethel M. Smith to William M. Steuart, Washington, D.C., August 24, 1929, NFFE Archives.

6. Smith, "An Informal History," 71; Smith, Testimony on Reclassification of Salaries, 462; Wooddy, *The Growth of the Federal Government,* 353. The United States Fish Commission, today known as the Bureau of Fisheries, was created by a congressional joint resolution on February 9, 1871. The commission investigated the causes of the decline of fisheries and developed a study of all phases of fisheries. The index to the Fish and Wildlife Service Draft Inventory indicates that the papers of the Division of Scientific Enquiry contain material relevant to the period of Smith's employment with the Fish Commission. However, upon examination of Division Reports (boxes 511–515), Divisions Functions (boxes 502–509); Interoffice Memoranda (boxes 516–526), and General Classification Files (boxes

164–168), it is clear that these sources focus almost exclusively on the late 1930s–1960s. See Record Group 22, National Archives, University of Maryland, College Park.

7. Ibid., 71. Cindy Aron, *Ladies and Gentlemen of the Civil Service: Middle-Class Workers in Victorian America* (New York: Oxford University Press, 1987), 3, 42, 111, 219.

8. Florence Patteson Smith, "Equal Rights in the Service: Discrimination Against Women in the Federal Service on Account of Sex, and the Remedy Sought," *The Federal Employee* 2: 3 (March 1917): 111. Ethel Smith's sister, Florence, began her civil service career as a librarian for the Department of Agriculture. In 1920, she accepted a position in the newly formed United States Women's Bureau, housed in the Department of Labor. "This meant library research in a new field for [her], and her work soon widened to include not only analysis of other people's results but the writings and reports on her own findings." She conducted investigations on the "working conditions of women in berry fields and orchards of the northwest and the operation of State minimum wage laws for women." She served as an active member of NFFE and helped unionize workers in the Department of Agriculture. She also was a member of the NCL and WTUL.

9. Ethel M. Smith, "Speech at the Annual Meeting of the Civil Service Reform League Convention," Philadelphia, April 1919, 5, NWTUL 1919, Box 75 Women's Bureau General Correspondence.

10. Sklar, *Florence Kelley and the Nation's Work*, 256–58.

11. Ibid.

12. Robyn Muncy, *Creating a Female Dominion in American Reform, 1890–1935* (New York: Oxford University Press, 1991).

13. Smith, "An Informal History," 71.

14. Ethel M. Smith to William M. Steuart, Washington, D.C., August 24, 1929, NFFE.

15. Cindy Aron, *Ladies and Gentlemen of the Civil Service*, 29. Columbian College became one of the first professional schools opened in Washington, D.C. in the mid-nineteenth century. Its different departments, for example, its law school, opened "with the specific purpose of attracting government clerks who worked during the day and attended classes in the evening." Potential professional employees "saw the nation's capital as the place to learn their future professions."

16. Aron, *Ladies and Gentlemen of the Civil Service*, 29. I would like to thank Brian Selinsky, associate registrar at George Washington University, for providing the dates that Smith attended and courses she took.

17. Smith, "Testimony on Reclassification of Salaries," 162; Smith, "An Informal History," 72.

18. Florence Smith, "Facts about Working Women," *Bulletin of the Women's Bureau* 46 (Washington, D.C.: U.S. Government Printing Office, 1925).

19. Smith, "An Informal History," 73, Smith, "Testimony on Reclassification of Salaries," 462.

20. Smith, "An Informal History," 72.

21. Ibid., 73–74. Smith later returned to government employment in 1930 and served until she retired in 1948. During this period, she worked on the Unemployment Census and for the Information Service of the Bureau of Home Economics in the Department of Agriculture. Smith also worked for the National Recovery Administration as a "labor advisor on the minimum wage codes." In 1935, she assisted the Federal Social Security Board "to help develop a specialized information service concerning the new Social Security Act for the wage earners entitled to its provisions."

22. Ethel M. Smith to Maud Wood Park, Washington, D.C. [1917], container 47, reel 32, NAWSA.

23. Ethel Smith to Harriet Tayler Upton November 8, 1915, container 50, reel 34, NAWSA; Ethel Smith to Harriet Taylor Upton, August 9, 1915, container 50, reel 34, NAWSA. For examples of NAWSA's critique of Alice Paul, see Anna Howard Shaw to Member of Official Board, New York City, December 18, 1913, container 50, reel 34, NAWSA; Anna Howard Shaw to Abby Scott Baker, December 24, 1913, NAWSA; Anna Howard Shaw to Ruth McCormick, New York City, January 5, 1914, container 50, reel 34, NAWSA.

24. Ethel M. Smith to Anna Howard Shaw, Washington, D.C., August 6, 1915, container 50, reel 34, NAWSA; Ethel M. Smith to Harriet Taylor Upton, Washington, D.C., August 9, 1915, container 50, reel 34, NAWSA.

25. Smith, "An Informal History," 74.

26. "To Serve Suffragists As Executive Secretary," *The Woman Citizen* 48: 15 (April 1917): 85; Ethel M. Smith, "Safeguarding Industrial Standards," *The Woman Citizen* 1: 2 (June 9, 1917): 30, 34; Ethel M. Smith, "What a Congresswoman Has Done for Working Women," *The Woman Citizen* 1: 8 (July 21, 1917): 136; Ethel M. Smith, "A Liberty Sandwich," *The Woman Citizen* 2 (May 4, 1918): 453. Examples of Smith's press releases are scattered throughout container 47, reel 32, NAWSA. These articles are dated from May through July but do not record the year of release. Also see, Ethel M. Smith to Grace Wilbur Trout, August 13, 1915, NAWSA; Ethel M. Smith, "Senatorial Folly and the Suffrage Amendment," *Life and Labor Bulletin* 8: 3 (March 1919): 62–64.

27. Smith, "Safeguarding Industrial Standards," 30; Smith, "The Woman's Labor Movement," *The Federal Employee* 4: 4 (April 1919): 217.

28. Ethel M. Smith (signed by Catt), "Letter to Wage-Earning Suffragists," Washington, D.C., 1917, Ethel Smith Correspondence, reel 19, NAWSA; Maud Wood Park and Ruth White to National Congressional Committee, Washington, D.C., June 4, 1917, container 47, reel 32, NAWSA.

29. Ethel M. Smith (signed by Catt), "Letter to Wage-Earning Suffragists"; Maud Wood Park and Ruth White to National Congressional Committee.

30. Ethel M. Smith (signed by Catt), "Letter to Wage-Earning Suffragists"; Maud Wood Park and Ruth White to National Congressional Committee.

31. Smith, "Safeguarding Industrial Standards," 34.

32. Carrie Chapman Catt to Ethel M. Smith, New York City, August 3, 1917, container 47, reel 32, NAWSA.

33. Paul Van Riper, *History of the United States Civil Service* (White Plains, N. Y.: Row, Peterson, and Company, 1958), 275; Robert Morton Godine, *The Labor Problem in the Public Service: A Study in Political Pluralism* (Cambridge: Harvard University Press, 1951), 104–05; Sterling Spero, *Government As Employer* (New York: Remsen Press, 1948), 178–81; Eldon Johnson, "General Unions in the Federal Service," *Journal of Political Economy* 2: 1 (February 1940): 24–27; Florence Etheridge, "National Federation of Federal Employees First Annual Convention: Abridged Summary Proceedings," *The Federal Employee* 2: 10 (1917) 573–75; Florence Etheridge, "Government Employees Unite In Live Organization," *Life and Labor Bulletin* 7: 12 (September 1917): 199; "National a Reality: President Gompers Issues Call for Convention of Federal Employees Unions at Washington, September 24, 1917," *The Federal Employee* 2: 5 (May 1917): 219.

34. Godine, *The Labor Problem in the Public Service*, 104–09; Harvey Walker, "Employee Organizations in the National Government Service: The Formation of the National Federation of Federal Employees," *Public Personnel Studies* 10: 5 (October 1941): 130–35; Paul V. Betters, *The Personnel Classification Board: Its History, Activities and Organization* (Washington, D.C.: The Brookings Institution, 1931); Luther Steward, "President Steward's Report: A Clear and Concise Summary of the Work and Progress of Our National Federation for the Year Ended June 30," *The Federal Employee* (September 4, 1920): 5. NFFE supported reclassification legislation to standardize job descriptions, grade levels, and salaries for the different levels of federal employment. The movement to reclassify government positions was a long and arduous struggle. After a series of bitter arguments and political compromises in Congress, NFFE achieved its goal with the passage of the Classification Act in 1923. The history of reclassification reform requires significant study. Existing sources tend to focus on similar issues and lack analysis of the alliances created between NFFE and other labor organizations.

35. Spero, *Government As Employer*, 54, 181.

36. Ethel M. Smith, "Take Politics Out of the Civil Service," *The Federal Employee* (September 17, 1921): 2.

37. Report of the President to the Third Annual Convention of the National Federation of Federal Employees, San Francisco, September 8, 1919, 2; "The Story of the National Federation of Federal Employees' Union," folder 1, box 178, National Federation of Federal Employees' Union 1900–1955, Cornell University. Also see Luther Steward, "President Steward's Report: A Clear and Concise Summary of the Work and Progress of Our National Federation for the Year Ended June 30," *The Federal Employee* (September 4, 1920): 5.

38. Report of the Legislative Committee of the National Federation of Federal Employees Covering the Regular Session of the Sixty-Fifth Congress, December 2, 1918, to March 4, 1919, 5, NFFE Archives.

39. Smith, "Speech at the Annual Meeting of the Civil Service Reform League Convention," 1.

40. Ethel M. Smith, "What Reclassification Means to Women," cited in George A. Warren, "Women Urge Square Deal for Women in Federal Service," *The Federal Employee* 7: 4 (April 1922): 12.

41. Florence Etheridge, "Political Activity and the Federal Employee," *Life and Labor Bulletin* 7: 10 (October 1918): 206.

42. Harvey Walker, "Employee Organizations in the National Government Service: The Period Prior to the World War," *Public Personnel Studies* 10: 3 (August 1941): 72–73. Theodore Roosevelt issued the first gag order in 1902. He issued a second, more stringent one in 1906. After assuming the presidency, William Howard Taft continued to uphold Roosevelt's policies regarding civil service reform. The restrictions imposed by the gag order remained intact until 1912, when Congress passed the Lloyd Bill.

43. Florence Patteson Smith, "How Federal Employees Have Become Articulate," *Life and Labor Bulletin* 10: 4 (April 1920): 108.

44. Report of the President to the Third Annual Convention of the National Federation of Federal Employees, San Francisco, September 8, 1919, 2; "The Story of the National Federation of Federal Employees' Union," folder 1, box 178, NFFE.

45. Report of the President to the Third Annual Convention of the National Federation of Federal Employees, San Francisco, September 8, 1919, 2.

46. Ethel M. Smith to Edward Keating, Washington, D.C., May 5, 1919, NWTUL Correspondence 1919, box 75, Women's Bureau General Correspondence.

47. Edward Keating, "The Reclassification Problem," *The Federal Employee* 4: 4 (April 1919): 199.

48. Smith, "Speech at the Annual Meeting of the Civil Service Reform League Convention," 5.

49. "The Discrimination against Women in the Government Service" (from the Summary of a Report by the Women's Bureau, U.S. Department of Labor), *Life and Labor Bulletin* 10: 2 (October 1918): 13. Also see "Civil Service Rules Permit Discrimination," *The Woman's Journal* 48: 3 (January 20, 1917): 1; "Government Not Fair to Women: Discrimination Found in All Branches of Service—Civil Service Examinations Closed," *The Woman's Journal* 48: 6 (February 10, 1917): 32.

50. Smith, "Speech at the Annual Meeting of the Civil Service Reform League Convention," 2.

51. Ethel M. Smith, "We Ask No Favors," *The Federal Employee* (September 24, 1921): 1.

52. Smith, "Speech at the Annual Meeting of the Civil Service Reform League Convention," 4; Smith, "The Woman's Labor Movement," 217; Smith, "An Informal History," 73.

53. [Ethel M. Smith], "To Standardize Women's Wages," *The Medical Women's Journal* 27 (February 1920): 61; Smith, "Family History," 73.

54. "Towards Better Working Conditions for Women: Methods and Policies of the National Women's Trade Union League of America," *Bulletin of the Women's Bureau* 252 (Washington, D.C.: U.S. Government Printing Office, 1953): 5.

55. Elizabeth Payne, *Reform, Labor, and Feminism: Margaret Dreier Robins and the Women's Trade Union League* (Chicago: University of Chicago Press, 1988); Mary Dreier, *Margaret Dreier Robins: Her Life, Letters, and Work* (New York: Island Press Cooperative, 1950).

56. "Towards Better Working Conditions for Women," 40–41; "Report of Secretary of Legislative Committee WTUL," June 5, 1921, reel 2, WTUL. Also see Kirkby, *Alice Henry*, 132–34; James J. Kenneally, *Women and American Trade Unions* (St. Albans, Vermont: Eden Press Women's Publications, 1978), 80–83.

57. "Towards Better Working Conditions for Women," 42; Ethel M. Smith, Congressional Testimony, May 12, 1920, Hearing Before the Committee on Public Health and National Quarantine, 66th Congress, 2d, S3529, 57–58.

58. "Women's Eight Hour Bill," [1918], reel 13, WTUL-LC; Ethel M. Smith, "Washington Committee Holds Organization Campaign," *Life and Labor Bulletin* 7: 6 (June 1918): 127–28.

59. Margaret Dreier Robins to Ethel M. Smith, Chicago, March 3, 1918, reel 25, Margaret Dreier Robins Papers; Smith, "Washington Committee Holds Organization Campaign," 127–28; Proceedings of the Seventh Biennial Convention of the National Women's Trade Union League of America, 15, NWTUL 1919, Box 75, Women's Bureau General Correspondence, 1919–1948, National Archives.

60. Ethel M. Smith, "Report in Washington News Service of the National Women's Trade Union League," [1918], Headquarters Records, 1921, WTUL.

61. Smith, "The Woman's Labor Movement," 215.

62. Ethel M. Smith, "Girl Cigar Makers on Strike," *The Federal Employee* 3: 5 (May 1918): 422.

63. Ethel M. Smith, "Low Wages Send Cigar Makers on Strike," *Life and Labor Bulletin* 7: 5 (May 1918): 93; Smith, "A Liberty Sandwich," 453.

64. Smith, "Girl Cigar Makers on Strike," 421; Ethel M. Smith, "In the Dooryard of the World's Largest Employer," *Life and Labor Bulletin* (June 1921): 179.

65. Smith, "Low Wages Send Cigar Makers on Strike," 92–93; Smith, "In the Dooryard of the World's Largest Employer," 179; Ethel M. Smith, "Washington Committee Holds Organization Campaign," 128; Ethel M. Smith, "Woman's Organization Week: An Account of the Active Campaign Just Conducted by the Women's Trade Union League in the Interest of the Better Orga-

nization of the Working Women of Washington," *The Federal Employee* 3: 6 (June 1918): 534–38.

66. Smith, "Girl Cigar Makers on Strike," 422.

67. The women of the Bureau of Engraving and Printing founded the first federal employees' union in 1909. The WTUL played a key role in assisting the bureau's women in their organizational efforts. See Mary Anderson, "Organizing the Bureau of Engraving and Printing," *Life and Labor Bulletin* 8: 1 (January 1918): 11; [Ethel M. Smith], "Congress Refuses to be 'Coerced' by the Bureau of Engraving Women," *Life and Labor Bulletin* 7: 8 (August 1918): 175; W. J. Voss, "Women's Union at Bureau of Engraving Observes Twentieth Anniversary," *The Federal Employee* 14: 3 (March 1929): 11.

68. Ethel M. Smith, "Congress Grants Inadequate Raise to Women Workers," *The Woman Citizen* 3 (August 10, 1918): 215.

69. Smith, "Congress Refuses to Be 'Coerced' by Bureau of Engraving Women," 175.

70. Ethel M. Smith, "Justice in Sight for 4,000 Women," *Life and Labor Bulletin* 7: 7 (July 1918): 151.

71. Smith, "In the Dooryard of the World's Largest Employer," 179.

72. Smith, "Justice in Sight for 4,000 Women," 151; Smith, "Congress Grants Inadequate Raise to Women Workers," 215.

73. Smith, "Congress Refuses to Be 'Coerced' by Bureau of Engraving Women," 175.

74. Smith, "Congress Grants Inadequate Raise to Women Workers," 215.

75. For a history of minimum-wage laws in the United States, see "The Development of Minimum-Wage Laws in the United States, 1912–1927," *Bulletin of the Women's Bureau* 61 (Washington, D.C.: U.S. Government Printing Office, 1928), 1–106; Clara Mortensen Beyer, "Minimum Wage Laws in the United States," *Life and Labor Bulletin* 7: 6 (May 1929): 3–4.

76. Ethel M. Smith to Chair, House Committee on Labor and Industries, New York State Legislature, Washington, D.C., March 22, 1921, Minimum Wage, 1913–1935, reel 16, WTUL. Edward Keating not only supported NFFE's legislative interests, but also was a defender of the Washington, D.C., women's minimum-wage law in Congress.

77. [Ethel M. Smith], "Minimum Wage Bill for Women in the District of Columbia," *Life and Labor Bulletin* 7: 5 (May 1918): 103.

78. [Smith], "Minimum Wage Bill for Women in the District of Columbia," 103; *Third Annual Report of the Minimum Wage Board of the District of Columbia for the Year Ending December 31, 1920* (Washington, D.C.: U.S. Government Printing Office, 1921), 5.

79. Clara M. Beyer was an instructor of economics at the University of California from 1915 to 1917 and at Bryn Mawr in 1918. She served as a member

of the War Labor Policies Board and as secretary of the Consumers' League of New York from 1918 to 1921. She also worked as a researcher for the Women's Bureau. For examples of her work, see "The Minimum Wage at Work in the District of Columbia," *Proceedings of the National Conference of Social Work, Chicago, 1917–1939* 47 (1920): 298–305; "History of Labor Legislation for Women in Three States," *Bulletin of the Women's Bureau*: no. 66 (Washington, D.C.: U.S. Government Printing Office, 1929), "Minimum Wage Laws in the United States," 3–4. Elizabeth Brandeis [Raushenbush], daughter of Louis Brandeis, worked as a professor of economics at the University of Wisconsin. She began her reform career as Beyer's assistant on the Washington, D.C., Minimum Wage Board, turning later to the study of public policy under the tutelage of John R. Commons. Her research focused on the need for labor legislation, especially social insurance laws.

80. Jesse C. Adkins, "Enforcement of a Minimum Wage Law as a Form of Collective Bargaining," *American Academy of the Political and Social Sciences* 90 (July 1920): 70–73. Also see Meg McGavran Murray, "The Work Got Done: An Interview with Clara Mortensen Beyer," in *Face to Face: Fathers, Mothers, Masters, Monsters-Essays for a Nonsexist Future*, ed. Meg McGavran Murray (Westport, Connecticut: Greenwood Press, 1983). For examples of studies conducted by the board, see Clara Beyer, "Minimum Wage for Women in Hotels and Restaurants in the District of Columbia," *Minimum Wage Board Report* 10: 3 (March 1920): 132–36; "Wages of Women Employed As Cleaners, Maids, and Elevator Operators in the District of Columbia," *Monthly Labor Review* 11: 5 (November 1920): 102–08; "The Minimum Wage at Work," 298.

81. Ethel M. Smith, "Raising the Pay of Washington's Women Workers," *Life and Labor Bulletin* (August 1919): 191–93.

82. Smith, "Raising the Pay of Washington's Women Workers," 191.

83. Frank Morrison to Ella M. Sherwin, n.p., August 3, 1920, Minimum Wage, 1913–1935, reel 16, WTUL.

84. Ethel M. Smith to Margaret Dreier Robins, Washington, D.C., June 30, 1919, reel 26, Margaret Dreier Robins Papers, hereafter cited as MDR.

85. Ethel M. Smith to Emma Steghagen, Washington, D.C., June 30, 1920, reel 26, MDR.

86. Ethel M. Smith to Margaret Dreier Robins, Washington, D.C., June 30, 1919, reel 26, MDR.

87. Ethel M. Smith to Margaret Dreier Robins, August 20, 1919, reel 25, MDR

88. Ethel M. Smith to Margaret Dreier Robins, June 30, 1920, MDR.

89. Ethel M. Smith to Margaret Dreier Robins, June 30, 1920, MDR; Ethel M. Smith to Margaret Dreier Robins, Washington, D.C., July 17, 1920, reel 26, MDR.

90. Ethel M. Smith to Margaret Dreier Robins, Washington, D.C., November 16, 1920, reel 26, MDR.

91 [Ethel M. Smith], "N.F.F.E. Publicity Bureau Now in Operation," *The Federal Employee* (December 4, 1920): 3.

92. Ethel M. Smith to Margaret Dreier Robins, November 16, 1920, MDR.

93. Emma Steghagen to Executive Board Members, Chicago, December 10, 1920, Headquarters Records, WTUL.

94. "Emerson Couldn't Sell Socks," *The Federal Employee* (December 1920): 3.

95. Ibid.

96. Ethel M. Smith to Margaret Dreier Robins, Washington, D.C., November 16, 1920, MDR.

97. Ibid.

98. Jane Tompkins, *West of Everything: The Inner Life of Westerns* (New York: Oxford University Press, 1992), 12, 56–57.

Chapter 2

1. See Amelia Fry, *Conversations with Alice Paul: Women Suffrage and the Equal Rights Amendment* (Berkeley: University of California Press, 1973), 7. Paul's papers do not provide extensive information about her father. We know that William Mickle Paul was vice-president of the Riverton and Palmyra Water Company. He also owned capital stock in the Valley View Company, the Squirrel Inn Company, and the Tacony Palmyra Ferry Company. When Paul looked back on her relationship with her father, she remembered that "he died early in her life," therefore, she did not think to ask him questions about his childhood or education.

2. Estate of William Mickle [1902], folder 202, box 13, Alice Paul Papers (hereafter cited as APP); "Bank President Is Dead," [1902], folder 214, box 14, APP; Fry, *Conversations with Alice Paul*, 5–7. I would like to thank Mary Ellen Chijioke, curator, Friends Historical Library of Swarthmore College, for information on Paul's parents. William and Tacie Paul married on September 21, 1881, Chester/Moorestown Records, 1818–1893, 38. They had three other children: Helen, Parry, and William. See *Friends Journal*, vol. 5 (1959): 92.

3. Fry, *Conversations with Alice Paul*, 17–18. According to the curator of the Friends Historical Library of Swarthmore College, Paul's maternal grandfather, William Parry, was a member of the committee that solicited funds for the founding of Swarthmore. There is no evidence, however, that he was a "particularly active member of the committee . . . nor did he serve on the Board of Managers" that governed the college. "The Parrys were . . . a prosperous and influential family . . . and his support (financial and otherwise) would have been very helpful for the project."

4. Author's conversation with Amelia Fry, August 1999.

5. Clarke A. Chambers, *Seedtime of Reform: American Social Service and Social Action, 1918–1933* (Minneapolis: University of Minnesota Press, 1963), 18–19; Ernest V. Hollis and Alice L. Taylor, *Social Work Education in the United States: Report of a Study Made for the National Council on Social Work Education* (New York: Columbia University Press, 1951), 4–11.

6. Frank Dekker Watson, *The Charity Organization Movement in the United States* (New York: Arno Press and New York Times, 1971), 173–75; Arthur Fink, *The Field of Social Work* (New York: Henry Holt and Company, 1942), 24; Lillian Brandt, *The Charity Organization Society of the City of New York, 1882–1907: Account of Present Activities*, Twenty-Fifth Annual Year End Report, September 13, 1907 (New York: B. H. Tyrrell Printers, 1907), 135–36.

7. Sklar, *Florence Kelley and the Nation's Work*, 182–90; Jane Addams, *Twenty Years at Hull House* (New York: Phillips, 1910), 98–100, 123, 156, 225–27.

8. Alice Paul, "Sketch of the New York College Settlement," unpublished thesis, New York School of Philanthropy, 1905–1906, 11–14, folder 20, box 2, APP.

9. Ibid., 22–23.

10. Ibid., 3–4, 15.

11. Stephen Steinberg, *The Ethnic Myth: Race, Ethnicity, and Class in America* (Boston: Beacon Press, 1981), 225–26.

12. Paul, "Sketch of the New York College Settlement," 20–23.

13. Alice to Mamma, New York City, June 30, 1906, folder 28, box 2, APP. Also see handwritten and typed resume drafts, folder 1, box 1, APP.

14. Addison Byron, "Work for the Returned Woodbrooker," *Friends Intelligencer* (August 13, 1919): 502–03.

15. For a history of Woodbrooke, see Robert Davis, ed., *Woodbrooke: 1903–1953: A Brief History of a Quaker Experiment in Religious Education* (London: Bannisdale Press, 1953). At Woodbrooke, Paul majored in sociology and minored in economics and politics. For descriptions of her courses and surroundings as a Woodbrooker, see Alice to Mamma, Woodbrooke, October 7, 1907, folder 27, box 2, APP; Alice to Mamma, Woodbrooke, October 10, 1907, folder 32, box 2, APP; Alice to Mamma, Woodbrooke, November 17, 1907, folder 27, box 2, APP; Alice to Mamma, Woodbrooke [1907], folder 33, box 2, APP.

16. James St. John Heath to Members of the Joshua Lippincott Scholarship Committee, Woodbrooke, March 3, 1909, folder 29, box 2, APP.

17. Alice to Mamma, Canningtown Settlement, London, December 23, 1907, folder 27, box 2, APP; Alice to Mamma, Woodbrooke, January 20, 1908, folder 28, box 2, APP.

18. Alice to Mamma, January 20, 1908, APP; "Miss Paul Puzzles Mother," *New York Times*, November 13, 1909, 6. Paul later used this experience to argue that

she understood the needs of factory workers. See "Alice Paul Biography," 1921, reel 7, NWPP.

19. Alice to Mamma, January 20, 1908, APP.

20. Alice to Mamma, Woodbrooke, February 9, 1908, folder 28, box 2, APP.

21. Alice to Mamma, Woodbrooke, March 15, 1908, folder 28, box 2, APP.

22. Alice to Mamma, Guernsey, April 5, 1908, folder 28, box 2, APP; Alice to Mamma, Woodbrooke, May 25, 1908, folder 28, box 2, APP.

23. Alice to Mamma, Hoxton Settlement, London [summer 1908], folder 31, box 2, APP; "Alice Paul Biography," 1921, NWPP.

24. Alice to Mamma, Peel Institute, Clerkenwell, August 21, 1908, folder 28, box 2, APP.

25. Alice to Parry [Paul], Woodbrooke, November 25, 1908, folder 182, box 12, APP; Alice to Mamma, London School of Economics, October 22, 1908, folder 28, box 2, APP; Alice to Mamma, December 8, 1908, APP; Alice to Parry, London School of Economics, November 25, 1908, folder 182, box 12, APP; Alice to Mamma, Peel Institute, Clerkenwell, December 12, 1908, folder 159, box 11, APP.

26. Ralf Dahrendorf, *LSE: A History of the London School of Economics and Political Science, 1895–1995* (New York: Oxford University Press, 1995); Lisanne Radice, *Beatrice and Sidney Webb: Fabian Socialists* (New York: Macmillan, 1984), 117–24.

27. Alice to Mamma, October 22, 1908, APP.

28. Alice to Mamma, Amsterdam, January 7, 1909, folder 29, box 2, APP.

29. Alice to Mamma, January 7, 1909, APP. Swarthmore faculty awarded the Joshua Lippincott scholarship yearly. Qualifications for applicants were determined by the faculty.

30. Alice to Mamma, December 12, 1908, APP; Alice to Mamma, Amsterdam, January 2, 1909, folder 28, box 2, APP.

31. Alice to Mamma, December 8, 1908, APP; Alice to Mamma, January 2, 1909, APP; James St. John Heath to Alice Paul, Woodbrooke, March 3, 1908, folder 28, box 2, APP; Alice to Mamma, January 7, 1909, APP.

32. Alice to Mamma, June 5, 1909, folder 31, box 2, APP.

33. Alice to Mamma, Woodbrooke, December 12, 1907, folder 27, box 2, APP. The WSPU began under the auspices of the International Labor Party (ILP) and originally sought the vote as a way to benefit working-class women. See Andrew Rosen, *Rise Up Women!: The Militant Campaign of the Women's Social and Political Union, 1903–1914* (Boston: Routledge and Kegan Paul, 1974); Emmeline Pankhurst, *The Importance of the Vote* (Charing Cross Road, W.C.: The Woman's Press, 1908).

34. Rosen, *Rise Up Women!*, 118–32; Ray Strachey, *The Cause: A Short History of the Women's Movement in Great Britain* (Port Washington, N. Y.: Kennikat Press, 1928), 310; David Mitchell, *The Fighting Pankhursts: A Study in Tenacity* (New York: Macmillan, 1967), 26–39.

35. Rosen, *Rise Up Women!*, 52–54, 79–85; Strachey, *The Cause*, 302; Emmeline Pankhurst, *My Own Story* (London: Eveleigh Nash, 1914), 81–87.

36. Alice to Mamma, January 22, 1909, folder 29, box 2, APP.

37. In addition to attending the women's suffrage debate in December, Paul also told her mother that she went to a suffrage meeting. In March 1908, she mentioned her amusement over the controversy of women's suffrage. Three months later, she walked in a suffrage procession. In December, she mailed picture postcards of suffragettes in prison clothing and told her mother, "One often sees them going through the streets dressed so to advertise one of their meetings." She attended a WSPU meeting in January 1909 that welcomed Emmeline and Christabel Pankhurst home from jail and in March explained the difference between a suffragist and suffragette to her mother. See Alice to Mamma, Woodbrooke, December 12, 1907, APP; Alice to Mamma, Woodbrooke, December 1907, folder 34, box 2, APP; Alice to Mamma, Woodbrooke, March 9, 1908, folder 28, box 2, APP; Alice to Mamma, London, June 27, 1908, folder 28, box 2, APP; Alice to Mamma, London, December 8, 1908, APP; Alice to Mamma, London School of Economics, January 14, 1909, folder 29, box 2, APP; Alice to Mamma, London School of Economics, January 22, 1909, APP; Alice to Mamma, London School of Economics, March 19, 1909, folder 29, box 2, APP.

38. "Miss Alice Paul Stirs London" [1909–1910], newspaper clipping fragment, folder 249, box 17, APP; "Miss Paul Puzzles Mother," 6.

39. Alice to Mamma, July 10, 1909, folder 29, box 2, APP. Also see Rosen, *Rise Up Women!*, 118–19; Mary Kinney, *Memories of a Militant* (London: Edwin Arnold and Company, 1924), 144–47; E. Sylvia Pankhurst, *The Suffragette Movement: Intimate Accounts of Persons and Ideals* (London: Longman's Green and Company, 1936), 316–17; E. Sylvia Pankhurst, *The Life of Emmeline Pankhurst: The Suffragette Struggle for Women's Citizenship* (London: T. Werner Laurie, 1935), 88–91; Pankhurst, *My Own Story*, 136–37, 142–48; Strachey, *The Cause*, 313–15; Margaret Wynne Nevinson, *Five Years' Struggle for Freedom: A History of the Suffragette Movement from 1908–1912* (London: Women's Freedom League, n.d.), 3, number 9556, reel 955, History of Women Collection.

40. Alice to Mamma, London, July 1909, folder 29, box 2, APP; Pankhurst, *My Own Story*, 136–37.

41. Alice to Mamma, July 1909, APP.

42. Ibid.

43. Ibid.

44. Alice to Mamma, July 1909, APP; Alice to Mamma, July 10, 1909, APP.

44. Alice to Mamma [August 1909], APP, Alice to Mamma, July 10, 1909, APP.

45. Alice to Mamma [July 1909], APP.

46. Alice to Mamma, Holloway Prison, London [August 1909], folder 29, box 2, APP.

47. Richard Byrne, *Prisons and Punishments of London* (London: Harrap, 1989), 149, 151–53.

48. Ibid.

49. Alice to Mamma [August 1909], APP.

50. Pankhurst, *The Suffragette Movement*, 312.

51. Alice to Mamma, August 5, 1909, folder 28, box 2, APP.

52. Alice to Mamma, August 5, 1909, APP.

53. Alice to Mamma, August 5, 1909, APP. Similarly, other WSPU members emphasized that "Signs of timidity on their part [the government] meant greater determination on ours."

54. Alice to Mamma, Edinburgh, August 13, 1909, folder 29, box 2, APP; Alice to Mamma, Edinburgh, August 18, 1909, folder 29, box 2, APP; Alice to Mamma, Edinburgh, August 21, 1909, folder 29, box 2, APP; Alice to Mamma, Kirkaldy, September 1, 1909, folder 31, box 2, APP; Alice to Mamma, Dundee, September 12, 1909, folder 29, box 2, APP; Alice to Mamma, Dundee, September 25, 1909, folder 29, box 2, APP; Alice to Mamma, Dundee, September 30, 1909, folder 29, box 2, APP; Alice to Mamma, London, October 27, 1909, folder 29, box 2, APP.

55. "Suffragist Activity: A Dangerous Enterprise," *Glascow Herald* [1909], folder 249, box 17, APP.

56. "Suffragist Interviewed," *Glasgow Bugle*, August 21, 1909, APP; "Campaign of Riot," *Daily Record*, August 21, 1909, folder 249, box 17, APP.

57. Alice to Mamma, September 25, 1909, APP; Alice to Mamma, September 30, 1909, APP.

58. Alice to Mamma, October 27, 1909, APP; Alice to Mamma, Clements Inn, London, October 31, 1909, folder 29, box 2, APP; Alice to Mamma, n.p., November 9, 1909, folder 29, box 2, APP.

59. "Alice Paul Returns Home," *New York Times*, January 21, 1910, 18; Alice to Captain C. M. Gonne, Liverpool, January, 5, 1910, folder 222, box 16, APP.

60. "W.S.P.U. Self-Denial Week: A Message from Mrs. Pankhurst" [1909], reel 49, NAWSA; Emmeline Pankhurst, "Verbatim Report of Mrs. Pankhurst's Speech," November 13, 1913, Parson's Theater, Hartford, Connecticut 1913, reel 845, number 6872, History of Women Collection.

61. "Lord Mayor's Feast Stoned By Women," *New York Times*, September 10, 1909, 1; "Two Americans in Guildhall Exploit," *New York Times*, November 12, 1909, 1; "Miss Paul's Friends Seek Her Release," *New York Times*, November 21, 1909, part 3, 4.

62. Tacie Paul, letter fragment [1909–1910] [Moorestown], folder 222, box 16, APP; Christabel Pankhurst to Tacie Paul, Clements Inn, London, November 30, 1909, folder 210, box 14, APP; American Ambassador Reid to Tacie Paul, n.p., November 30, 1909, folder 210, box 14, APP.

63. Marshall D. Swishing to Tacie Parry, Philadelphia, November 19, 1909,

folder 210, box 14, APP; Mickle Paul to Tacie Parry, Philadelphia, December 14, 1909, folder 210, box 14, APP.

64. Christabel Pankhurst to Tacie Paul, November 30, 1909, APP; Eleanor Brannan to Alice Paul, n.p., February 11, 1912, folder 159, box 11, APP.

65. Alice to Mamma, n.p., December 10, 1909, folder 29, box 2, APP.

66. Alice to Mamma, n.p., December 27, 1909, folder 31, box 2, APP.

67. Alice to Mamma, December 27, 1909, APP; Alice Paul to Captain C. M. Gonne, January 10, 1910, APP.

68. Elaine Scarry, *The Body in Pain: The Making and Unmaking of the World* (New York: Oxford University Press, 1985), 45–51.

69. Linda Ford, *Iron-Jawed Angels: The Suffrage Militancy of the National Woman's Party, 1912–1920* (Lanham: University Press of America, 1991), 18–19; Inez Haynes Irwin, *The Story of Alice Paul and the National Woman's Party* (Fairfax, Va.: Denlinger's, 1921), 6, 14–18.

70. Tacie Paul, letter fragment, n.d., APP; "Miss Paul to Make First Speech Here," *The Evening Bugle*, January 26, 1910, 1 (and folder 249, box 17, APP); Alice Paul, "Woman Suffrage at Moorestown," *Friends Intelligencer* 67: 8 (February 19, 1910): 121–22.

71. Alice Paul, "The Woman Suffrage Movement in Great Britain," *Annals of the American Academy of Political and Social Science* Supplement 27 (May 1910): 26–27.

72. Paul, "The Woman Suffrage Movement in Great Britain," 23.

73. Alice Paul, "The Legal Position of Women in Pennsylvania," Ph.D. dissertation, University of Pennsylvania, 1912, 86–89, 94–94, 254, 262–63.

74. Lucy Burns, "Report of the Work of the Congressional Union from May 1913," January 8, 1914 to November 1914, Suffrage Material Folder, NWPP.

75. Amelia Fry, "Along the Suffrage Trail," *American West* 6 (1969): 16–25.

76. Caroline Katzenstein, *Lifting the Curtain: The State and National Woman Suffrage Campaign in Pennsylvania As I Saw Them* (Philadelphia: Dorrance and Company, 1955), 185–99; Doris Stevens, *Jailed for Freedom: American Women Win the Vote* (New York: Boni and Leveright, 1920), 59–66; Fry, "Along the Suffrage Trail," 16–25; n.d. Two Contrasted Policies, reel 32, container 4, NAWSA.

77. 1913: Statement by the treasurer of NAWSA in Regard to Financial Affairs between the National Association and Congressional Committee during the Year 1913–1914, reel 32, NAWSA.

78. Anna Howard Shaw to Abby Scott Baker, n.p., December 24, 1913, reel 34, container 50, NAWSA.

79. Anna Howard Shaw to President and Executive Council, New York City, 1913, container 50, reel 34, NAWSA; Anna Howard Shaw to Abby Scott Baker, December 24, 1913, reel 34, container 50, NAWSA.

80. Anna Howard Shaw to Ruth McCormick, January 15, 1914, reel 34, container 50, NAWSA.

81. Anna Howard Shaw to Member of the Official Board, January 14, 1914, reel 34, container 50, NAWSA.

82. "McCormick Says AP Has Set Back the Vote Ten Years," January 31, 1914, reel 32, container 48, NAWSA.

83. "Mrs. McCormick Says Alice Paul Has Set Back the Vote Ten Years," Chicago, January 13, 1914, container 48, reel 32, NAWSA; unsigned letter to Helen Gardener, n.p., January 9, 1914, container 48, reel 32, NAWSA.

84. Ruth McCormick to Harriet Vittum, Washington, D.C., July 9, 1914, container 48, reel 32, NAWSA.

85. Mary Ware Dennett to Alice Paul, New York City, January 4, 1913, reel 1, National Woman's Party, Suffrage Years.

86. Mary Ware Dennett to Ruth McCormick, New York City, January 6, 1914, container 48, reel 32, NAWSA; Anna Howard Shaw to Ruth McCormick, New York City, February 5, 1914, container 50, reel 34, NAWSA.

87. Anna Howard Shaw to Ruth McCormick, New York City, February 15, 1914, container 50, reel 34, NAWSA.

88. Robert Boothe Fowler, *Carrie Catt: Feminist Politician* (Boston: Northeastern University Press, 1986), 25–27.

89. "Suffragists Will Picket White House," *New York American*, January 9, 1917, container 48, reel 32; "'Silent Pickets' of Suffragists at White House," *Evening Tel.*, January 10, 1917, container 48, reel 32, Records of the National American Woman Suffrage Association (hereafter NAWSA); Stevens, *Jailed for Freedom*, 59–66.

90. "Statement from Mrs. John Winter Brannan," Washington, D.C., November 28, 1917, folder 234, box 8, Doris Stevens Papers.

91. "Hunger Striker Is Forcibly Fed," *New York Times*, November 9, 1917, 13; Helen Paul to Tacie Paul, n.p., November 12, 1917, folder 210, box 14, APP.

92. "Hunger Striker Is Forcibly Fed," 13; "Miss Alice Paul on Hunger Strike," *New York Times*, November 17, 1917, 13; Helen to Tacie, November 12, 1917, APP.

93. Alice Paul to Elizabeth Marot, Washington, D.C., September 22, 1917, reel 49, NWPP.

94. Caroline Katzenstein, "Alice Paul, Pankhurst of the Potomac," *Philadelphia Record*, November 4, 1917, folder 252, box 17, APP; "Alice Paul, Chairman of the National Woman's Party Not A 'Mannish' Politician," n.d., folder 253, box 17, APP; Doris Stevens, "The Militant Campaign," *Omaha Daily News*, June 29, 1919, folder 230, box 8, Doris Stevens Papers; Alva Belmont, "Why Women Went to Jail," folder 235, box 8, Doris Stevens Papers.

95. Maud Wood Park (signed by EMS) to Mr. J. P. Yoder, United Press Association, July 13, 1917, reel 32, container 48, NAWSA.

96. Press release, Washington Branch Press Bureau, "National Suffrage Association Renews Federal Amendment Campaign at Washington," November 19, 1917, reel 32, container 48, NAWSA.

97. [Alice Paul] to H. O. Sarrels [Washington, D.C.], April 8, 1921, reel 9, NWPP; Elsie M. Hill to Mr. Richard Mayer, Washington, D.C., June 4, 1921, reel 8, NWPP; Elsie M. Hill to Mary Winsor, Washington, D.C., May 23, 1921, reel 14, NWPP; Elsie M. Hill to Gertrude Robey, Washington, D.C., June 2, 1922, folder 7, box 8, NWPP. Also see Anita L. Pollitzer to Mrs. Daniel O'Day (Washington, D.C.), April 22, 1921, reel 7, NWPP.

Chapter 3

1. Marjorie Taylor, "Defeat of Women Enrages Alice Paul," November 1922, reel 19, NWPP.

2. NAWSA first conceived of such a tribute but could not afford to pay the full cost of the statue. See Fowler, *Carrie Catt: Feminist Politician*, 25–27; Minutes of the Meeting of the Executive Committee of the Woman's Party, May 14, 1921, reel 114, NWPP; *Adelaide Johnson: Sculptress*, 1945, Series 5, Part A, Pamphlets, reel 149; Carol Rehfisch, "History of the Equal Rights Campaign," n.d., reel 24, NWPP.

3. [Dora Lewis] to Mrs. John K. Otley [Washington, D.C.], January 24, 1921, reel 6, NWPP. Also see unsigned letter to Maud Wood Park [Washington, D.C.], January 3, 1921, reel 5, NWPP; Mabel Vernon to Mrs. C. B. Pittman [Washington, D.C.], January 15, 1921, reel 5, NWPP; Alice Paul, Calling of the Convention to Order [Washington, D.C.], February 16, 1921, 11 A.M., Minutes of the National Woman's Party Convention, 6–7, Conference and Convention Proceedings, March 1917–June 1953, reel 115, NWPP.

4. For an excellent study of the NWP's role in shaping the meaning of American feminism, see Cott, *The Grounding of Modern Feminism*.

5. Alice Paul to Mrs. Michael Van Beuren, Washington, D.C., July 12, 1921, reel 9, NWPP; Alice Paul to Dr. Maitkin Friberg, Washington, D.C., September 16, 1921, reel 10, NWPP; Alice Paul to Mrs. O. H. Berryman, Washington, D.C., September 17, 1921, reel 10, NWPP.

6. Alice Paul to Rebecca Hourwich, Washington, D.C., June 10, 1922, reel 15, NWPP; Alice Paul, "Feminism a Hundred Years from Now," 1922, NWPP; Alice Paul to Rebecca Hourwhich, Washington, D.C., June 10, 1922, reel 15, NWPP.

7. Alice Paul to Dr. Maitkin Friberg, Washington, D.C., September 16, 1921, reel 10, NWPP.

8. Mary White Ovington to Harriot Stanton Blatch, n.p., December 3, 1920, NWPP; unsigned letter to Mabel Vernon, n.p., January 18, 1921, box 3, folder 1, NWPP.

9. Florence Kelley to Mrs. Lawrence Lewis [New York City], February 28, 1921, box 3, folder 12, NWPP.

10. Ella Rush Murray, "The Woman's Party and the Violation of the 19th Amendment," *The Crisis* 21: 6 (April 1921) 259–61.

11. Dorothy Sterling, *Black Foremothers: Three Lives* (Old Westbury, N. Y.: The Feminist Press, 1979), 147; Olympia Brown to Alice Paul, February 28, 1921, n.p., NWPP.

12. Freda Kirchwey, "Alice Paul Pulls the Strings," *The Nation* 112: 2904 (March 2, 1921): 333.

13. Alice Paul to Mrs. George H. Day, Washington, D.C., June 24, 1921, reel 8, NWPP.

14. Alice Paul to Mrs. John Rogers, Washington, D.C., March 24, 1921, box 3, folder 16, NWPP; Alice Paul to Mrs. George H. Day, Washington, D.C., June 24, 1921, reel 8, NWPP.

15. Alice Paul to Reverend Olympia Brown, Washington, D.C., March 8, 1921, folder 14, box 3, NWPP; Dora Lewis to Eunice Brannan, Washington, D.C., March 9, 1921, folder 14, box 3, NWPP; Alice Paul to Willystine Goodsell, Washington, D.C., April 1, 1921, folder 1, box 4, NWPP.

16. Ellen Crump to Alice Paul, n.p., October 10, 1922, folder 2, box 10, NWPP.

17. Ellen Crump to Burnita Shelton Mathews, October 10, 1922, n.p., reel 10, NWPP.

18. Amelia Fry, "Mabel Vernon: Organizer for Women's Rights, Petitioner for Peace" (Berkeley: University of California Press, 1978), 157–58. Vernon remembered that "Paul also possessed an antagonism for Jews . . . and if you say anything—now, for instance, if I say, 'Well, Anita is a Jew,' [Alice says], 'Yes, but she's different.'"

19. Alice Paul to Florence Sanville, Washington, D.C., April 2, 1921, folder 1, box 4, NWPP.

20. Ethel Smith to Elsie Hill, July 27, 1921, folder 11, box 4, NWPP.

21. Alice Paul to Elsie Hill, n.p., January 4, 1921, reel 5, NWPP; Susan Shelton White to Miss M. L. Roberts, n.d., n.p., folder 4, box 2, NWPP.

22. Alice Paul to Anita Pollitzer, Washington, D.C., September 18, 1921, reel 10, NWPP; Alice Paul to Mrs. John B. Waterman, Washington, D.C., May 25, 1922, reel 15, NWPP.

23. Alice Paul to Mrs. Keppele Hall, Washington, D.C., December 10, 1921, reel 11, NWPP; Ethel Smith to Alice Paul, Washington, D.C., December 10, 1921, reel 11, NWPP.

24. Alice Paul to Jane Norman Smith, November 29, 1921, folder 4, box 6, NWPP.

25. Alice Paul to Anita Pollitzer, Washington, D.C., September 18, 1921, reel 10, NWPP; Alice Paul to Jane Norman Smith, Washington, D.C., November 27, 1923, reel 24, NWPP.

26. [Alice Paul] to Anita Pollitzer, Washington, D.C., July 28, 1921, reel 9, NWPP.

27. Alice Paul to Mrs. William Kent, Washington, D.C., October 17, 1921, reel 10, NWPP.

28. Alice Paul to Mrs. John Winters Brannan, Washington, D.C., September 26, 1921, reel 10, NWPP.

29. The debate involved a lengthy correspondence that involved Paul, Smith, and their legal advisors. See: Shippen Lewis, August 1921, reel 8, NWPP; Alice Paul to Dora Lewis, Washington, D.C., September 17, 1921, reel 11, NWPP; Alice Paul to Shippen Lewis, Washington, D.C., September 19, 1921, reel 10, NWPP; Shippen Lewis to Alice Paul, n.p., September 23, 1921, reel 10, NWPP; Alice Paul to Shippen Lewis, Washington, D.C., September 27, 1921, reel 10, NWPP; Alice Paul to Shippen Lewis, Washington, D.C., November 10, 1921, reel 11, NWPP; Albert Levitt (citing Roscoe Pound) to Alice Paul [1921], n.p., reel 16, MDR; Roscoe Pound to Albert Levitt, Cambridge, May 27, 1921, reel 8, NWPP; Shippen Lewis to Elsie Hill, n.p., May 21, 1921, reel 8, NWPP; Elsie M. Hill to May Philbrook, Washington, D.C., May 24, 1921, box 4, folder 1, NWPP; Roscoe Pound to Ethel M. Smith, Cambridge, August 1, 1921, Legislation, Equal Rights General 1921, reel 14, WTUL.

30. Alice Paul to Katharine Fisher, Washington, D.C., March 9, 1922, folder 6, box 7, NWPP; Katharine Fisher to Elsie Hill [Denver, Colorado], March 6, 1921, reel 6, NWPP.

31. Ethel M. Smith to Maud Schwartz, Washington, D.C., February 17, 1921, reel 7, NYWTUL; Ethel Smith to Members and Friends, September 30, 1921, reel 51, NCL Correspondence, 1921, LC-WTUL.

32. Marjorie Taylor, "Defeat of Women Enrages Alice Paul," November 1922, reel 19, NWPP.

33. Ibid.

34. Alice Paul to Mrs. John B. Waterman, May 25, 1922, reel 15, NWPP.

35. Alice Paul to Elizabeth Christman, Washington, D.C., October 2, 1922, folder 1, box 10, NWPP.

36. Alice Paul to Mr. Sarka B. Hrbkova, Washington, D.C., February 4, 1922, folder 1, box 7, NWPP; Alice Paul to Dr. Maitkin Friberg, Washington, D.C., September 16, 1921, reel 10, NWPP.

37. Paul described the Washington College of Law, founded in 1896 by Mrs. Ellen Spencer Mussey, "as a labor of love," at a time in which women were excluded from law schools throughout the country. Assisted by Emma Gillette, who succeeded Mussey as dean, the school "has now grown to such a size and has interested such a large body of people in its progress that it is no longer necessary for Mrs. Mussey and Miss Gillette . . . to maintain it at a personal loss." See Alice Paul to Albert Levitt, August 11, 1921, Washington, D.C., reel 9, NWPP.

38. Members of the NWP sold outline copies of Alice Paul's dissertation to educate the public about the need for equal rights legislation. When Anita Pollitzer read Paul's work, she recalled, "I really saw this immediate fight of ours for the first time as the end of another struggle such as suffrage which we should attack and get through with." Anita Pollitzer to Izetta Jewell Brown [1922], reel 7, NWPP. See Paul, "The Legal Position of Women in Pennsylvania" Ph.D. dissertation, University of Pennsylvania, 1912, 86–89, 93–94, 262–63; Alice Paul, "Towards Equality: A Study of the Legal Position of Women in the United States," dissertation, American University, 1928; Paul completed an LL.B. at George Washington University Law School and received a certificate from the Washington College of Law in 1922. She received an LL.M in 1927 and a D.C.L. in 1928 from American University School of Law.

39. Alice Paul to Marion T. Burritt, Washington, D.C., March 14, 1921, reel 7, NWPP; Alice Paul to W. P. Vaughan, Washington, D.C., March 18, 1921, reel 7, NWPP; Elsie M. Hill to Member of the Woman's Party, Washington, D.C., October 24, 1921, reel 15, NWPP.

40. Elsie Hill to Mrs. Gertrude James Robey, Washington, D.C., June 2, 1922, folder 7, box 8, NWPP.

41. Minnie Kendall-Lowther, "A New Shrine for Womanhood," *The Fairmont Times*, reel 16, NWPP; "The New Woman's Party Fast Moving to the Fore," reel 119, NWPP; "A New Headquarters for the Woman's Party" [1922], reel 149, NWPP; Assistant Press Chairman to Mrs. William Brown Meloney, Washington, D.C., May 17, 1922, folder 4, box 8, NWPP; Elsie M. Hill to Mrs. Helen Glenn Tyson [Washington, D.C.], May 26, 1922, folder 6, box 8, NWPP. Also see Herman Gasch to Elsie M. Hill [Washington, D.C.], April 19, 1921, reel 7, NWPP; unsigned letter to Mrs. James Rector, n.p., May 3, 1921, reel 7, NWPP; Elsie M. Hill to Miss Carol A. Rehfisch [Washington, D.C.], June 13, 1921, reel 8, NWPP; Anita Pollitzer to Miss Sheldon Jackson, n.p., June 16, 1921, reel 8, NWPP; Alice Paul to Anita Pollitzer [Washington, D.C.], June 25, 1921, reel 8, NWPP; Alice Paul to John Gordon Battelle [Washington, D.C.], September 23, 1921, reel 10, NWPP; Alice Paul to Max Rotter [Washington, D.C.], November 17, 1921, reel 10, NWPP.

42. Elsie M. Hill to Mrs. Michael VanBeuren [Washington, D.C.], July 12, 1921, NWPP; Isabelle Kendig-Gill to Mrs. Nila F. Allen [Washington, D.C.], August 22, 1922, folder 9, box 9, NWPP; Minnie Kendall-Lowther, "A New Shrine for Womanhood," *The Fairmont Times*, reel 16, NWPP; "The New Woman's Party Fast Moving to the Fore," reel 119, NWPP.

43. Assistant Press Chairman to Mrs. William Brown Meloney, Washington, D.C., May 17, 1922, folder 4, box 8, NWPP; Elsie M. Hill to Mrs. Helen Glenn Tyson [Washington, D.C.], May 26, 1922, folder 6, box 8, NWPP.

44. Program of the Headquarters Dedication, May 21, 1922, reel 15, NWPP.

45. "The Magna Charta For Women," folder 8, box 5, NWPP, LC.

46. Program of the Headquarters Dedication, May 21, 1922, reel 15, NWPP.

47. Alice Paul to Elsie M. Hill, Washington, D.C., July 7, 1922, reel 16, NWPP; [Membership Secretary] to Miss Sallie Hovey [Washington, D.C.], July 11, 1922, reel 16, NWPP; Eleanor Brannan to Dr. Caroline E. Spencer [Washington, D.C.], July 13, 1922, reel 16, NWPP.

48. Anita Pollitzer to Mrs. Mattie Guild Squires, Washington, D.C., February 11, 1922, folder 2, box 7, NWPP.

49. Isabelle Kendig-Gill to Mrs. John B. Foley [Washington, D.C.], August 24, 1922, reel 17, NWPP. Also see Elsie M. Hill to Roberta D. Cornelius [Washington, D.C.], February 2, 1922, folder 1, box 7, NWPP.

50. Alice Paul to Elsie M. Hill, Washington, D.C., July 7, 1922, reel 16, NWPP; [Membership Secretary] to Miss Sallie Hovey [Washington, D.C.], July 11, 1922, reel 16, NWPP; Eleanor Brannan to Dr. Caroline E. Spencer [Washington, D.C.], July 13, 1922, reel 16, NWPP; Alice Paul to Mrs. Mary A. Nolan [Washington, D.C.], July 26, 1922, reel 16, NWPP.

51. Eleanor Brannan to Mrs. Helen I. Schermerhorn [n.p.], June 14, 1922, NWPP; Burnita Shelton Matthews to Katharine Fisher, Washington, D.C., June 16, 1922, reel 15, NWPP.

52. [Isabelle Kendig-Gill], Chair, Physician's Council to Miss Zona Gale, n.p., August 25, 1922, folder 9, box 9, NWPP; Isabelle Kendig-Gill to Reverend Olympia Brown [Washington, D.C.], August 25, 1922, reel 17, NWPP.

53. [Isabelle Kendig-Gill], Chair, Physician's Council to Alice Hamilton [Washington, D.C.], December 15, 1922, folder 3, box 11, NWPP.

54. Florence Kelley, "The New Woman's Party," *The Survey* 24 (March 3, 1921): 827.

55. Florence Kelley to Dora Lewis [New York City], March 3, 1921, folder 3, box 3, NWPP.

56. Kelley, "The New Woman's Party," 827.

57. Patricia Hummer, *The Decade of Elusive Promise: Professional Women in the United States, 1920–1930* (Ann Arbor: University of Michigan Research Press, 1976), 105.

58. Eleanor Brannan to Mrs. Delia Fletcher, n.p., November 2, 1922, folder 1, box 10, NWPP. Mabel Vernon to Doris Stevens, Washington, D.C., November 6, 1923, folder 7, box 15, NWPP; Hazel MacKaye to George Brokaw, Washington, D.C., October 26, 1923, folder 4, box 15, NWPP.

59. Hazel MacKaye, "Extracts from Letters of Hazel MacKaye [Washington, D.C.], May 1, 1921, folder 10, box 1, Elsie M. Hill Papers; Mabel Vernon to Mrs. Laura Sherry [Washington, D.C.], October 27, 1923, NWPP.

60. Hazel MacKaye, "Survey of Pageant Organization and Suggestions for a Plan to Conduct a Series of Pageants throughout the Country for the National

Woman's Party," reel 115, NWPP; Hazel MacKaye, "Campaigning with Pageantry," *Equal Rights* 1: 39 (November 10, 1923): 309. For an excellent analysis of NWP pageantry, see Ann Larabee, "Second Wave Feminist Theatre," (Ph.D. dissertation, State University of New York, Binghamton 1988), 56–84.

61. Hazel MacKaye, "Pageants Interpreting the Program of the National Woman's Party and Paying Tribute to the Progress of the Equal Rights Movement," n.p. [1923], reel 24, NWPP.

62. Lavinia Egan, "The Seneca Falls Conference," *Equal Rights* 1: 25 (August 4, 1923): 195–96.

63. Mabel Vernon to Mrs. M. Rollman, Washington, D.C., November 8, 1923, folder 7, box 15, NWPP.

64. Alice Paul to Lady Willie Forbus, November 14, 1922, reel 19, NWPP (and folder 3, box 11, NWPP); [EB] to Mrs. Edith Wing Hughes, November 22, 1922, reel 19, NWPP.

65. Alice Paul to Jane Norman Smith, March 22, 1923, Washington, D.C., NWPP.

66. Egan, "The Seneca Falls Conference," 195–96; Emma Bugbee, "Women Open Campaign for Equal Rights," *New York Tribune*, July 22, 1923 (reprinted in *Equal Rights* 1: 24 [July 28, 1923]: 189).

67. Alice Paul to Lady Willie Forbus, November 14, 1922, reel 19, NWPP (and folder 3, box 11, NWPP).

68. "Women in All States Have Representation in Tribute Given to Susan B. Anthony," *The Rochester Democrat*, July 23, 1923 (reprinted in *Equal Rights* 1: 24 [July 28, 1923]: 190).

69. Egan, "The Seneca Falls Conference," 195–96. The NWP transformed its newspaper, *The Suffragist*, into *Equal Rights* in the early months of 1921. The newspaper became the NWP's primary vehicle for conveying its agenda to the public and challenging the perspectives of its most vocal critics.

70. William Sweet, Governor of Colorado, "Program of the 75th Anniversary Western Memorial Celebration," September 22–23, 1923, reel 149, NWPP.

71. Ibid.

72. "Ceremonial Pageant in the Garden of the Gods," *Equal Rights* 1: 30 (September 8, 1923): 237–38.

73. Hazel MacKaye to Mrs. Frances Lane Glassell [Washington, D.C.], October 23, 1923, folder 4, box 15, NWPP; Mabel Vernon to Mrs. Frances Lane Glassell [Washington, D.C.], October 23, 1923, folder 4, box 15, NWPP; Mabel Vernon to Mrs. William J. Bartlett, Washington, D.C., October 28, 1923, folder 4, box 15, NWPP; Mabel Vernon to Mrs. M. Rollman, Washington, D.C., November 8, 1923, folder 7, box 15, NWPP.

74. Mabel Vernon to Mrs. Frances Lane Glassell, October 23, 1923, NWPP.

75. Mabel Vernon to Izetta Jewell Brown, Washington, D.C., March 30,

1921, reel 7, NWPP; Mabel Vernon to Mrs. J. D. Wilkinson, Washington, D.C., October 31, 1923, folder 5, box 15, NWPP.

76. Mabel Vernon to Mrs. J. D. Wilkinson [Washington, D.C.], October 23, 1923, folder 4, box 15, NWPP; Mabel Vernon to Mrs. Stephen Pell [Washington, D.C.], October 22, 1923, folder 4, box 15, NWPP; Mabel Vernon to Mrs. R.P. Barnes [Washington, D.C.], October 31, 1923, folder 5, box 15, NWPP; Mabel Vernon to Mrs. Robert LaFollette [Washington, D.C.], October 23, 1923, folder 4, box 15, NWPP.

77. [Hazel MacKaye], "The Anniversary Ceremony in the Crypt of the Capitol," November 17, 1923, reel 24, NWPP.

78. "Woman's Party Announces Final Plans for November Conference," November 1923, reel 24, NWPP.

79. [Hazel MacKaye], "The Anniversary Ceremony in the Crypt of the Capitol," November 17, 1923, reel 24, NWPP.

80. Alice Paul to Lady Willie Forbus, November 14, 1922, reel 19, NWPP (and folder 3, box 11, NWPP).

81. Hortense Russell, "The Amendment Is Introduced," *Equal Rights* 11: 44 (December 22, 1923): 355.

82. Hazel MacKaye to Mr. Frank McCarthy, Washington, D.C., October 24, 1923, folder 4, box 15, NWPP.

83. Elsie M. Hill to Mrs. Harriman Bushnell, n.d., n.p., folder 2, box 16, NWPP.

Chapter 4

1. Smith, "The Woman's Labor Movement," 217.

2. Ethel M. Smith to Maud Schwartz, Washington, D.C., February 17, 1921, reel 7, NYWTUL; Ethell M. Smith to Alice Paul, January 5, 1921, reel 5, NWPP; Smith, "Platform and Program of the National Women's Trade Union League," reel 8, MDR.

3. Ethel M. Smith, "The Labor Movement," Address Delivered at the Annual Banquet of the Industrial Department of the Y.W.C.A. of Richmond, Virginia, January 31, 1927, 1, folder 74, box 5, WTUL.

4. "Towards Better Working Conditions for Women," 5.

5. Margaret Dreier Robins, Extract from Address of Margaret Dreier Robins to the WTUL Fourth Biennial Convention, 1913, Women in Industry Service, box 77, Women's Bureau General Correspondence, 1919–1948, National Archives.

6. Margaret Dreier Robins, Address to the Seventh Biennial WTUL Convention, June 2, 1919, Speeches, reel 2, MDR.

7. Smith, "Labor's Position against the Woman's Party Amendment," *Life*

and Labor Bulletin 2: 9 (May 1923): 2. For a discussion of changing definitions of liberalism, see Charles Forcey, *The Crossroads of Liberalism: Croly, Weyl, Lippmann and the Progressive Era, 1900–1925* (New York: Oxford University Press, 1961), 10–31.

8. Smith, "The Woman's Labor Movement," 217.

9. Katharine Fisher (citing a letter from Ethel Smith) to Elsie M. Hill, n.p., May 1, 1921, Elsie Hill Papers; Elisabeth Christman to Mary [Anderson], March 29, 1924, reel 1, Mary Anderson Papers; Ethel M. Smith, Jo Coffin, and Elisabeth Christman to AFL, Executive Council [Washington, D.C.], August 8, 1921, reel 8, NYWTUL; Elisabeth Christman to House Committee on Labor, May 5, 1933, Minimum Wage, 1913–1935, reel 16, WTUL. Also see S. M. Franklin to Frank Duffy, June 15, 1915, reel 7, Headquarters Records, WTUL; Mollie Ray Carroll, *Labor and Politics: The Attitude of the American Federation of Labor toward Legislation and Politics* (New York: Houghton Mifflin, 1923), 86.

10. Melvyn Dubofsky, *Industrialism and the American Worker, 1865–1920* (Arlington Heights, Ill.: Harlan Davidson, 1975), 96–97.

11. Dana Frank, *Purchasing Power: Consumer Organizing, Gender, and the Seattle Labor Movement, 1919–1929* (Cambridge: Cambridge University Press, 1994), 32.

12. Samuel Gompers, "Trade Unionism and Women Suffrage," *Life and Labor Bulletin* 5: 7 (July 1915): 122–24.

13. Agnes Nestor, "American Federation of Labor Convention," *Life and Labor Bulletin* 5: 12 (December 1915): 183–85.

14. Mary T. Waggaman, "National Women's Trade Union League of America," *Monthly Labor Review* (April 1919): 1183.

15. Smith, "The Woman's Labor Movement," 217.

16. Katharine Fisher to Elsie M. Hill, n.p., May 1, 1921, folder 10, box 1, Elsie M. Hill Papers.

17. Ethel M. Smith, Jo Coffin, Elisabeth Christman to Executive Council, AFL [Washington, D.C.], 1921, WTUL.

18. Ethel M. Smith to Mrs. Alfred J. Brosseau, Washington, D.C., April 22, 1927, Attacks on the WTUL, 1925–1931, reel 16, WTUL.

19. For an excellent analysis of Rose Schneiderman's career, see Annelise Orleck, *Common Sense and a Little Fire: Women Working-Class Politics in the United States, 1900–1965* (Chapel Hill: University of North Carolina Press, 1995), 121–68.

20. Agnes Nestor's papers are contained in the Records of the WTUL, though historians have not yet studied her career. See her autobiography, *Woman's Labor Leader: An Autobiography* (Rockford, Ill.: Bellevue Books, 1954). For an early assessment of Mary Anderson's career, see Sister John Marie Daly, "Mary Anderson: Pioneer Labor Leader" Ph.D. dissertation, Georgetown University, 1968. Smith became lifelong friends with Mary Anderson and Rose Schneiderman, who both remember her "as an intelligent young woman" who made significant contributions to the work of the WTUL and Women's Bureau. See Mary Anderson,

Woman at Work (Minneapolis: University of Minnesota Press, 1951), 114; Rose Schneiderman, *All for One* (New York: Paul S. Eriksson, 1967), 174.

21. Ethel M. Smith, "Report in Washington News Service," Washington, D.C., 1921, reel 2, Headquarters Records, WTUL.

22. Ibid.

23. [Julia Hinaman], "Women's Joint Congressional Committee: Aims and Purposes," Washington, D.C., December 20, 1920, container 47, reel 32, NAWSA; Julia Hinaman, "Joint Congressional Committee Holds Second Meeting in Washington," Washington, D.C., December 20, 1920, container 47, reel 32, NAWSA.

24. Ethel M. Smith to Agnes Nestor, Washington, D.C., December 8, 1920, reel 26, Margaret Dreier Robins Papers.

25. Ibid.

26. Ibid.

27. Ibid.

28. Julia Hinaman, Publicity Director, "Joint Congressional Committee Holds Second Meeting in Washington," December 20, 1920, NAWSA.

29. "Women's Joint Congressional Committee," December 20, 1920, NAWSA.

30. Mary Anderson to Margaret Dreier Robins, Washington, D.C., February 27, 1920, reel 25, Margaret Dreier Robins Papers (hereafter cited as MDR); Ethel M. Smith to Margaret Dreier Robins, Washington, D.C., April 21, 1920, reel 25, MDR.

31. Wooddy, *The Growth of the Federal Government, 1915–1932,* 367–69.

32. Anderson, *Woman at Work,* 114. Also see Mary Anderson to Margaret Dreier Robins, Washington, D.C., January 26, 1920, reel 25, MDR; Mary Anderson to Margaret Dreier Robins, February 27, 1920, MDR.

33. Ethel M. Smith, "Women to the Front in the Government," *The Federal Employee* 3: 9 (September 1918): 847.

34. Ethel M. Smith to Friend, Washington, D.C., February 27, 1921, reel 7, NYWTUL. Also see Celia Rogers, "Discrimination against the Women's Bureau," *The Searchlight* 5 (March 1921): 13–15; Ethel M. Smith to Friend, Washington, D.C., February 17, 1922, reel 8, NYWTUL; Ethel M. Smith to Friend, Washington, D.C., March 3, 1922, reel 8, NYWTUL; Ethel M. Smith to Friend, Washington, D.C., March 6, 1922, reel 8, NYWTUL; Mary Anderson, Memorandum Regarding Appropriation Requested by the Women's Bureau . . . For the Fiscal Year Ending June 30, 1921, reel 13, MDR.

35. Matilda Lindsay (reporting for Ethel M. Smith), "Industrial Bills" [Washington, D.C.], May 18, 1921, reel 3, WJCC.

36. Ethel M. Smith to Friend, Washington, D.C., March 3, 1921, reel 7, NYWTUL.

37. Ethel M. Smith, "Our Legislative Activities at Washington," *Life and Labor Bulletin* 1: 5 (January 1923): 2–3.

38. Mary Anderson to Margaret Dreier Robins, Washington, D.C., November 22, 1922, reel 27, MDR.

39. Wooddy, *The Growth of the Federal Government*, 367–69.

40. For a history of the spoils system, see William Seal Carpenter, *The Unfinished Business of Civil Service Reform* (Princeton, N. J.: Princeton University Press, 1952), 3–23.

41. For a history of the commission, see Darrell Hevenor Smith, *The United States Civil Service Commission: Its History, Activities, and Organization* (Baltimore, Md.: The Johns Hopkins University Press, 1928).

42. Van Riper, *History of the United States Civil Service*, 278. Also see Florence Patteson Smith, "Equal Rights in the Service," *The Federal Employee* 2: 3 (March 1917): 111, 116.

43. "The Discrimination Against Women in the Government Service," 17.

44. Ibid.

45. Statement of Miss Ethel M. Smith, Secretary of the Legislative Committee of the National Women's Trade Union League, Senate Committee on Civil Service Reclassification of Salaries, 67th Congress, 1st session, May 17–June 16, 1921, 462–63.

46. Ibid., 463–66.

47. Senate, Report of the Reclassification of Civil Service Employees," 67th Congress, 2d session: 486, February 8, 1922.

48. Smith, "What Reclassification Means to Women," 12.

49. Ibid.; [Ethel M. Smith], Report of the Reclassification Committee, Washington, D.C., December 5, 1921, reel 3, WJCC; Ethel M. Smith, "Equal Pay for Equal Work, Press Release, Washington, D.C., February 23, 1924, reel 3, WJCC.

50. For a history of the Bureau of Efficiency, see Wooddy, *The Growth of the Federal Government*, 58.

51. [Ethel M. Smith], Report of the Reclassification Committee, May 18, 1921, WJCC.

52. Report of the Women's Committee for Reclassification of the Federal Civil Service, March 12, 1923, container 47, reel 32, NAWSA.

53. [Ethel M. Smith], "Women's Wages and Government Standards," *Life and Labor Bulletin* 7: 7 (March 1924, 1): NFFE, "The Reclassification Law," container 47, reel 32, NAWSA.

54. Ethel M. Smith, "Better Business for Uncle Sam: Personnel Board Is in Line with the Lehlbach Bill," *The Federal Employee* 7: 1 (January 1922): 13. For a history of the board, see Wooddy, *The Growth of the Federal Government*, 49–50.

55. Ethel M. Smith to Belle Sherwin, Washington, D.C., November 21, 1923, reel 67, Papers of the NLWV.

56. Ethel M. Smith, "Urge Merit System in Civil Service," Washington, D.C., February 23, 1924, reel 3, WJCC.

57. Ibid.

58. Ethel M. Smith to Belle Sherwin, November 21, 1923, NLWV.

59. Smith, "Urge Merit System in Civil Service."

60. Ethel M. Smith to Miss Belle Sherwin, March 19, 1924, NLWV.

61. Chapter 5 considers the alliance of people united in defense of the Washington, D.C., minimum wage law. The alliance included such noted individuals as: Edith Abbott, Chairperson, Committee on Women in Industry, LWV; John Andrews and Samuel McCune Lindsay, American Association of Labor Legislation; Samuel Gompers and Matthew Woll, AFL; Lida Hafford, General Federation of Women's Clubs; Mary Stewart, National Federation of Business and Professional Women; and Mrs. Ellis Yost, Women's Christian Temperance Union.

62. Margaret Dreier Robins, "The Minimum Wage," April 29, 1913, reel 2, MDR.

63. "League Secretary Is Appointed to Minimum Wage Board," *Life and Labor Bulletin* 7: 12 (December 1918): 275. Also see National Consumers' League, "Minimum Wage Legislation: Which States Have It?" no. 8644, reel 944, History of Women.

64. Adkins, "The Enforcement of a Minimum Wage Law," 70–73.

65. Ethel M. Smith to William Green, Washington, D.C., August 9, 1923, Minimum Wage, 1913–1935, reel 16, WTUL.

66. Samuel Gompers to Ethel Smith, Washington, D.C., July 6, 1922, Minimum Wage, 1913–1935, reel 16, WTUL.

67. Ethel M. Smith to Chairman, House Committee on Labor and Industries, Washington, D.C., March 22, 1921, Minimum Wage, 1913–1935, reel 16, WTUL.

68. Frank Morrison to Ella M. Sherwin, August 3, 1920, WTUL.

69. Ethel M. Smith to Chairman, House Committee on Labor and Industries, Washington, D.C., March 22, 1921, WTUL.

70. Ethel M. Smith to Members and Friends, Washington, D.C., December 16, 1921, reel 8, NYWTUL.

71. Ibid.

72. Ethel M. Smith, "A Plain Statement Concerning the Proposed Child Labor Amendment to the Federal Constitution," *Woman's Home Companion* (February 1925): 5.

73. Muncy, *Creating a Female Dominion in American Reform, 1890–1935*, 93–123.

74. Ethel M. Smith to Dear Sir, Washington, D.C., April 22, 1924, reel 1, WJCC.

75. Ethel M. Smith, "Report of the Legislative Secretary," June 1922 to June 1924, Minimum Wage, 1913–1935, reel 16, WTUL.

76. Ethel M. Smith to Mrs. A. C. Watkins, October 23, 1924, reel 1, WJCC.

77. Ethel M. Smith to Florence Thorne, Washington, D.C., October 9, 1924, Boston WTUL, reel 1, Records of the WTUL and Its Principal Leaders.

78. Report of the Children's Amendment Committee, December 8, 1924, reel 3, WJCC.

79. Mary Anderson to Margaret Dreier Robins, Washington, D.C., March 15, 1922, reel 27, MDR.

80. Mary Anderson to Margaret Dreier Robins, Washington, D.C., March 23, 1922, reel 27, MDR; Mary Anderson to Margaret Dreier Robins, Washington, D.C., October 17, 1922, reel 27, MDR; Ethel M. Smith to Mary Anderson, Washington, D.C., September 12, 1922, reel 27, MDR; Ethel M. Smith to Elisabeth [Christman], Washington, D.C., September 11, 1922, reel 6, WTUL; Ethel M. Smith, "A Trade Union Woman Afoot in Europe," *Life and Labor Bulletin* 1: 5 (January 1923): 1.

Chapter 5

1. Ethel M. Smith, "Equal Rights—Internationally!" *Life and Labor Bulletin* 4: 40 (March 1926): 2.

2. Ethel M. Smith to Maud Younger, Washington, D.C., October 11, 1921, reel 10, NWPP.

3. Horwitz, *The Transformation of American Law,* 169–92; Pound, "Mechanical Jurisprudence," 605–08.

4. Alice Paul to Jane Norman Smith, Washington, D.C., November 27, 1923, reel 24, NWPP. Also see Chapter 3.

5. To a great extent, Thomas M. Cooley and Christopher Tiedeman substantiated the late-nineteenth-century justifications of a negative state. Jurists frequently cited Cooley and Tiedeman in their arguments for judicial laissez-faire. See Thomas Cooley, *A Treatise on the Constitutional Limitations which Rest upon the Legislative Power of the States of the American Union* (Boston: Little, Brown, and Company, 1868); Christopher Tiedeman, *A Treatise on the Limitations of the Police Power in the United States* (St. Louis, Mo.: DaCapo Press, 1868).

6. Roscoe Pound to Albert Levitt, Cambridge, May 27, 1921, reel 8, NWPP; Albert Levitt to Alice Paul, n.p., May 1921, reel 8, NWPP; Roscoe Pound, "Liberty of Contract," *Yale Law Journal:* 18 (May 1909): 454–87; Pound, "Mechanical Jurisprudence," 605–23.

7. Sklar, *Florence Kelley and the Nation's Work,* 256–58; Kirkby, *Alice Henry: The Power of Pen and Voice,* 132–38.

8. With few exceptions, formalists tended to argue that state government could only exercise its police powers to protect the health, morals, and safety of

citizens. Laws that applied to men were usually overturned with the most noted exceptions of *Holden v Hardy*, 169 US 366 (1898), a decision upholding a Utah state eight hour law for miners; *Muller v Oregon*, 208 US 412 (1908), a case in which the Supreme Court upheld the constitutionality of a ten-hour law for women; and *Bunting v Oregon*, 243 US 426 (1917).

9. Alice Paul, "Feminism A Hundred Years From Now," NWPP; Alice Paul to Katharine Fisher, Washington, D.C., April 10, 1922, reel 14, NWPP.

10. Support for Paul's assertion can be found in Anita Pollitzer to Mabel Putnam, n.d., n.p., folder 1, box 4, NWPP; Alice Paul to Florence Sanville, April 2, 1921, NWPP.

11. Smith, "Equal Rights—Internationally!", 2.

12. Ethel M. Smith, "Statement Concerning the Operation of the Minimum Wage Law of the District of Columbia," May 27, 1933, Minimum Wage, 1913–1935, reel 16, WTUL.

13. "Why Do Working Women Oppose the So-Called 'Equal Rights' Blanket Amendment," 1922, box 75, WTUL Folder 1921, Women's Bureau Correspondence, National Archives (and 1922 Correspondence, reel 51, NCL); Ethel M. Smith, "Labor's Position against the Woman's Party Amendment," *Life and Labor Bulletin* 2: 6 February 1924, 1–2; Ethel M. Smith, "Professional Women, Business Women, Industrial Women," 2.

14. Ethel M. Smith, "Working Women's Case against Equal Rights," 12.

15. Ethel M. Smith to Maud Schwartz, Washington, D.C., February 17, 1921, reel 7, NYWTUL.

16. Alice Paul to Mrs. John Winters Brannan, Washington, D.C., September 26, 1921, reel 10, NWPP.

17. Alice Paul to Jane Norman Smith, Washington, D.C., November 29, 1921, NWPP; Anita Pollitzer to Elsie M. Hill, Washington, D.C., December 10, 1921, folder 155, box 15, Elsie M. Hill Papers.

18. Alice Paul to Lady Willie Forbus, Washington, D.C., November 30, 1921, reel 4, NWPP; Alice Paul to Della Mohr, Washington, D.C., December 13, 1921, reel 4, NWPP.

19. Alice Paul to Lady Willie Forbus, November 30, 1921, NWPP; Anita Pollitzer to Elsie Hill, December 10, 1921, Elsie M. Hill Papers.

20. Alice Paul to Mr. Walter B. Wilbur, Washington, D.C., December 11, 1921, reel 11, NWPP.

21. Statement of Shippen Lewis, August 1921, reel 8, NWPP; Alice Paul to Dora Lewis, Washington, D.C., September 17, 1921, reel 11, NWPP; Alice Paul to Shippen Lewis, Washington, D.C., September 19, 1921, reel 10, NWPP; Shippen Lewis to Alice Paul, n.p., September 23, 1921, reel 10, NWPP; Alice Paul to Shippen Lewis, Washington, D.C., September 27, 1921, reel 10, NWPP; Alice Paul to Shippen Lewis, Washington, D.C., November 10, 1921, reel 11, NWP. In August, the

ERA read: "Neither political nor civil disabilities on account of sex or marriage shall exist within the United States or any place subject to the jurisdiction thereof."

22. Albert Levitt married Elsie M. Hill in December 1921. Most of his personal papers are in the possession of their daughter, Leslie Latham. Also see the Albert Levitt Papers, Harvard Law School Library.

23. Albert Levitt (citing Roscoe Pound) to Alice Paul [1921], n.p., reel 16, MDR papers; Roscoe Pound to Albert Levitt, Cambridge, May 27, 1921, reel 8, NWPP; Shippen Lewis to Elsie Hill, n.p., May 21, 1921, reel 8, NWPP; Elsie M. Hill to Mary Philbrook, Washington, D.C., May 24, 1921, box 4, folder 1, NWPP; Roscoe Pound to Ethel M. Smith, Cambridge, August 1, 1921, Legislation, Equal Rights General 1921, reel 14, WTUL. Also see Zimmerman, "The Jurisprudence of Equality," 204–08.

24. Roscoe Pound to Ethel M. Smith, Cambridge [May 1921], Lawyers' Letters, Correspondence 1921, NCL; Albert Levitt to Alice Paul, May 1921, NWPP; Roscoe Pound to Albert Levitt, May 27, 1921, NWPP; Roscoe Pound to Ethel M. Smith, August 1, 1921, reel 11, NWPP; Elsie M. Hill to Alice Paul, Washington, D.C., August 2, 1921, reel 9, NW

25. Albert Levitt to Alice Paul, n.p., July 28, 1921, folder 11, box 4, NWPP. Also see Felix Frankfurter to Alice Paul, Cambridge, June 30, 1921, folder 10, box 1, Elsie M. Hill Papers (and folder 9, box 4, NWPP; reel 8, NWPP).

26. Felix Frankfurter to Alice Paul, June 30, 1921, NWPP.

27. Felix Frankfurter to Alice Paul, June 30, 1921, NWPP; Felix Frankfurter, "Memorandum on the Proposed Amendment to the United States Constitution," July 21, 1921, folder 11, box 4, NWPP; Albert Levitt to Alice Paul, July 28, 1921, NWPP.

28. Alice Paul to Walter Wilbur, December 11, 1921, NWPP.

29. Alice Paul to Agnes H. Morey, Washington, D.C., October 7, 1921, reel 10, NWPP.

30. Elsie M. Hill to Mrs. Sophie L.W. Clark, Washington, D.C., May 24, 1921, reel 8, NWPP.

31. Anita Pollitzer to Mrs. Rebecca R. Lee [Washington, D.C.], June 7, 1921, reel 8, NWPP.

32. Roscoe Pound to Felix Frankfurter, Cambridge, February 3, 1922, folder 1, box 7, NWPP.

33. Albert Levitt to Alice Paul, July 28, 1921, NWPP.

34. Albert Levitt to Alice Paul, n.p. [July 1921], reel 9, NWPP.

35. Author's interview with Leslie Latham, daughter of Elsie M. Hill and Albert Levitt, June 1997.

36. Albert Levitt to Mildred J. Gordon, n.p., November 28, 1921, folder 193, box 19, Elsie M. Hill Papers. Also see Albert Levitt, "Reflections upon the Bitter Consequences of Judicial Perversity," October 1921, folder 10, box 4, NWPP.

37. Albert Levitt to William Draper Lewis, n.p., December 5, 1921, folder 193, box 19, Elsie M. Hill Papers; Albert Levitt to Alice Paul, n.p., December 19, 1921, reel 11, NWPP.

38. Anita Pollitzer [citing Levitt] to Elsie M. Hill [Washington, D.C.], December 12, 1921, folder 156, box 15, Elsie M. Hill Papers.

39. Ethel M. Smith to Elsie M. Hill, Washington, D.C., July 27, 1921, folder 11, box 4, NWPP.

40. Ethel M. Smith to Mr. J. D. Wilkinson, Washington, D.C., December 21, 1921, 1921 Correspondence, reel 11, NWPP.

41. Felix Frankfurter to Ethel M. Smith, Cambridge, September 8, 1921, reel 8, NYWTUL (and reel 11, NWPP; Legislation, Equal Rights, General 1921, WTUL); Alice Paul to Mrs. Agnes Morey, Washington, D.C., November 16, 1921, reel 11, NWPP.

42. Felix Frankfurter to Ethel M. Smith, September 8, 1921, NYWTUL.

43. Ethel M. Smith to Members and Friends, September 30, 1921, NCL.

44. Ethel M. Smith, "Why Do Working Women Oppose Blanket Legislation?," 1922, NCL.

45. Alice Paul [citing Ethel M. Smith] to Shippen Lewis, Washington, D.C., October 12, 1921, reel 10, NWPP.

46. Ethel M. Smith to Florence Kelley, Washington, D.C., October 10, 1921, reel 51, 1921 Correspondence, NCL; Ethel M. Smith to Florence Kelley, Washington, D.C., October 26, 1921, 1921 Correspondence, reel 51, NCL.

47. Alice Paul to Mrs. John Winters Brannan, September 26, 1921, NWPP.

48. Alice Paul to Lady Willie Forbus, Washington, D.C., November 30, 1921, reel 11, NWPP.

49. Alice Paul to Mrs. John Winters Brannan, Washington, D.C., September 10, 1921, reel 10, NWPP.

50. Alice Paul to Chester C. Platt, September 15, 1921, NWPP.

51. Charles G. Curtis to Ethel M. Smith, Washington, D.C., December 17, 1921, reel 51, NCL; Ethel M. Smith [citing Simeon Fess] to Florence Kelley, Washington, D.C., December 15, 1921, 1921 Correspondence, reel 51, NCL.

52. Katharine Ludington to Maud Wood Park, n.p., November 30, 1921, reel 66, NLWV; Florence Kelley to Maud Wood Park, New York City, November 30, 1921, reel 66, NLWV.

53. Ethel M. Smith, "Conference on the So-Called Equal Rights Amendment Proposed by the National Woman's Party," December 4, 1921, reel 8, MDR. For other versions of the conference, see Florence Kelley, "Conference with the Representatives of the Woman's Party," December 4, 1921, reel 51, NCL; "Conference Held," December 4, 1921, reel 11, NWPP.

54. Maud Younger to Ethel M. Smith, Washington, D.C., December 19, 1921, reel 11, NWPP (and 1921 Correspondence, reel 51, NCL).

55. Smith, "Conference on the So-Called Equal Rights Amendment," n.d. MDR.

56. Ethel M. Smith to George Gordon Battle, Washington, D.C., December 15, 1921, reel 11, NWPP.

57. Conference Summary, December 4, 1921, NWPP.

58. Ethel Smith to Alice Paul, Washington, D.C., December 10, 1921, reel 27, MDR (and reel 11, NWPP).

59. Ethel M. Smith to Alice Paul, December 10, 1921, MDR; Maud Younger to Ethel Smith, December 19, 1921, Washington, D.C., December 19, 1921, reel 11, NWPP (and 1921 Correspondence, reel 51, NCL).

60. Ethel Smith to Alice Paul, December 10, 1921, MDR.

61. Ibid.

62. Ethel M. Smith to Maud Younger, Washington, D.C., December 28, 1921, reel 11, NWPP.

63. Ethel M. Smith to Rose Schneiderman, Washington, D.C., December 2, 1921, reel 8, NYWTUL.

64. Ethel M. Smith to Alice Paul, December 10, 1921, MDR.

65. Anita Pollitzer to Elsie M. Hill, December 10, 1921, Elsie M. Hill Papers; Elsie M. Hill to Mrs. Lillian M. Ascough [Washington, D.C.], February 1, 1922, folder 1, box 7, NWPP; Elsie M. Hill to Miss Lydia M. Gooding [Washington, D.C.], February 2, 1922, folder 1, box 7, NWPP; Alice Paul to Katharine Fisher, Washington, D.C., March 9, 1922, folder 6, box 7, NWPP; Alice Standish Buell, Director, YWCA National Board, "Equal Rights Amendment to the Federal Constitution and Equal Rights Bills in State Legislatures—Discussion" [1921–1922], folder 5, box 7, NWPP.

67. Ethel M. Smith, "Working Women Want Equality, but Oppose Blanket Laws," March 10, 1922, 1922 Correspondence, reel 51, NCL.

68. Ethel M. Smith, "Equal Rights and 'Equal Rights': What Is Wrong with the Woman's Party Amendment?," 12.

69. Ethel M. Smith, "Protective Legislation in Danger" [1922], reel 10, NWPP.

70. Ethel M. Smith, "Working Women Want Equality, but Oppose Blanket Laws," February 26, 1922, NCL.

71. Ibid.

72. Agnes Nestor to Executive Board, n.p., January 4, 1922, 1922 Correspondence, reel 2, WTUL.

73. Organizations opposed to the ERA by February 1922 included: the Women's Trade Union League, National Consumers' League, League of Women Voters, American Association of University Women, Girls Friendly Society, Young Women's Christian Society, Women's Christian Temperance Society, American Home Economics Association, National Council of Jewish Women, General Federation of Women's Clubs, and the American Federation of Labor.

74. Alice Paul to Katharine Fisher, March 9, 1922, NWPP.

75. Massachusetts passed the first women's minimum-wage law in 1912. Other states followed suit, including: California and Wisconsin (1913); Colorado, Minnesota, Arkansas, Kentucky, Nebraska, Oregon, Utah, and Washington (1915) and Arizona (1917).

76. *Adkins v Children's Hospital*, 261 US 67 L. ed., 791.

77. See *Munn v Illinois* 94 US 113 (1877); *Holden v Hardy*, 169 US 366 (1898); *Muller v Oregon* 208 US (1908); *Bunting v Oregon* 243 US (1917); *Adkins v Children's Hospital*, 261 US 67, pp.792–93.

78. *Adkins v Children's Hospital*, 796.

79. See *In Re Lockwood*, 154 US 116 (1894).

80. Ethel M. Smith, "Labor's Position Against the Woman's Party Amendment," 2.

81. Ethel M. Smith, "Minimum Wage Legislation Declared Unconstitutional," *Life and Labor Bulletin* 1: 9 (May 1923): 1–2 (and Minimum Wage, 1913–1935, reel 16, WTUL).

82. Ethel M. Smith to Mrs. Green, Washington, D.C., August 9, 1923, "Minimum Wage, 1913–1935," reel 16, WTUL; Ethel M. Smith to [Potential Conference Participants], April 18, 1923, reel 8, MDR (and Minimum Wage, 1913–1935, reel 16, WTUL).

83. Ethel M. Smith, "New Wage Decision Stirs Women to Act," *New York Times*, Wednesday, April 11, 1923, 12; Minimum Wage Conference, May 1923, Legislation, Minimum Wage, 1917–1923, 1945, WTUL.

84. Agnes Nestor to [Conference Participants], April 18, 1923, reel 8, MDR; Ethel M. Smith to [Potential Conference Participants], April 18, 1923, MDR; Ethel M. Smith, "Women's Wages and Supreme Court Decision To Be Discussed by National Conference," May 13, 1923, "Minimum Wage, 1913–1935," reel 16, WTUL; "Parley to Discuss Wage Law's Death," *Washington Post*, May 13, 1923, 2 (and reel 2, WTUL).

85. Smith, "Women's Wages and Supreme Court Decision To Be Discussed by National Conference." Though participants worked for mutual aims, some tension originated before the conference, because Smith did not ask Samuel Gompers to assist in organizing the event. "Ethel took full blame herself, and I think the old man felt all right," said one WTUL member. "The reason Ethel was so anxious that the League should call the meeting was the very fact that the old man does not work well with women's organizations, and we knew the organizations would not respond to a meeting called by Gompers" in light of past experiences with him. [Mary Dreier] to Margaret Dreier Robins [New York City] [May 1, 1923] reel 27, MDR.

86. Ethel M. Smith, "Conference on Minimum Wage Legislation and the Supreme Court Decision," *Life and Labor Bulletin* 1: 9 (June 1923): 2 (and folder 52, box 4, WTUL).

87. [Smith] "Conference on Minimum Wage Legislation and the Supreme Court Decision," 2. For a detailed discussion of conference proceedings, see "Adopted Unanimously by Conference of National Organizations," May 15–16, 1923, Minimum Wage, 1912–1935, reel 16, WTUL.

88. "Parley to Discuss Wage Law's Death," 2; [Smith] "Conference on Minimum Wage Legislation and the Supreme Court Decision"; [Ethel M. Smith] to Members of the Executive Board, "Report on Convention Proceedings," June 18, 1923, Minimum Wage, 1913–1935, reel 3, WTUL.

89. Ethel M. Smith to Delegates to the Conference, Washington, D.C., November 7, 1923, Minimum Wage, 1913–1935, reel 16, WTUL; Ethel M. Smith, Matthew Woll, and John Ryan to Maud Wood Park, Washington, D.C., June 28, 1923, reel 66, NLWV.

90. Smith, "New Wage Decision Stirs Women to Act," 12.

91. Women of color, who tended to be employed in domestic service, were frequently exempted from the provisions of women's labor laws. See Vivien Hart, "Feminism and Bureaucracy: The Minimum Wage Experience in Washington, D.C.," *Journal of American Studies* 26: 1 (April 1992): 13.

92. "The Woman's Party and the Minimum Wage for Women," *Equal Rights* 1: 44 (April 22, 1923): 356.

93. Alice Paul to Mrs. Clarence Smith [Jane Norman], March 22, 1923, NWPP; unsigned letter to Mrs. Robert B. Stearns, November 10, 1923, NWPP.

94. "The Woman's Party and the Minimum Wage for Women," 356.

95. Ethel M. Smith, "The Supreme Court v. Itself," *Life and Labor* 2: 8 (April 1924): 2; Smith, "Labor's Position against the Woman's Party Amendment," 1–2.

96. "Special Feature: The Equal Rights Amendment," *Congressional Digest* 3: 6 (March 1924): 199, 206.

Conclusion

1. Emma M. Gillette to Miss Mary Ritter Toole, Washington, D.C., October 2, 1922, folder 1, box 10, NWPP; Agenda for the Meeting of the Lawyers' Council of the NWP, Washington, D.C., November 11, 1922, reel 10, NWPP; Isabelle Kendig-Gill to Mrs. Alice Park [Washington, D.C.], August 10, 1922, reel 17, NWPP; Anita Pollitzer to Miss Sheldon, n.p., August 10, 1922, reel 17, NWPP.

2. Smith, "Professional Women, Business Women, Industrial Women," 1–3; "The Test of Equality," *Life and Labor* 7: 1 (December 1928): 1.

3. Patricia Cain, "Feminism and the Limits of Equality," *Georgia Law Review* 24 (1990): 805–06.

4. In *Muller v Oregon*, 208 US 412 (1908), the Supreme Court upheld the

constitutionality of a ten-hour law for women. Also see *Bunting v Oregon,* 243 US 426 (1917).

5. Carole Pateman, *The Sexual Contract* (Stanford, Calif.: Stanford University Press, 1988).

6. See "Are Women's Clubs 'Used' by Bolshevists?: Interlocking Directorates Used Effectively to Disseminate Propaganda," *The Dearborn Independent,* March 15, 1924, 2, 12; an American citizen, "Why Don't Women Investigate Propaganda?: Vigorous House-Cleaning to Prevent Further Duping of Organizations," March 22, 1924, *The Dearborn Independent,* 10, 13; Ethel M. Smith to Florence Kelley, Washington, D.C., May 24, 1924, reel 68, NLWV. Ethel M. Smith, "Super Patriots Continue Attack on Women," Press Release, Washington, D.C., May 13, 1925, reel 17, History Data, 1920–1927, WTUL; Special Committee of the WJCC, April 2, 1924, reel 4, Mary Anderson Papers.

7. Ethel M. Smith, "Super Patriots Continue Attacks on Women," May 13, 1925, reel 17, WTUL.

8. Smith, "An Informal History," 27.

9. Nancy Fraser, ed., "Beyond the Master/Subject Model: On Carole Pateman's *The Sexual Contract,*" in *Justice Interruptus: Critical Reflections on the "Postsocialist" Condition* (New York: Routledge, 1997), 225–35.

10. Mary Jo Frug, *Postmodern Legal Feminism* (New York: Routledge, 1992), 148–49.

Bibliography

I. Primary Sources:

A. Archival Collections:

Boston:
Papers of the National Women's Trade Union League and Its Principal Leaders, Schlesinger Library
Alice Paul Papers, Schlesinger Library
Doris Stevens Papers, Schlesinger Library

Washington, D.C.:
Equal Rights, Library of Congress
The Federal Employee, Library of Congress
Felix Frankfurter Papers, Library of Congress
History of Women Collection
Life and Labor Bulletin, Library of Congress
National Woman's Party Papers, 1913–1974, Library of Congress
National Woman's Party Papers, Suffrage Years, Library of Congress
National Women's Trade Union League Papers, National Archives
New York Women's Trade Union League Papers, Library of Congress
Papers of the National League of Women Voters, Library of Congress
Proceedings of the American Federation of Labor, Library of Congress
Records of the National American Woman Suffrage Association, Library of Congress
Records of the National Consumers' League, Library of Congress
Records of the National Federation of Federal Employees Union, NFFE Headquarters
Records of the National Women's Trade Union League, Library of Congress
Records of the Women's Joint Congressional Committee, National Archives
The Suffragist, Library of Congress
Women's Bureau General Correspondence, National Archives

B. Oral Histories and Family History:

Butler, Amy. Interview with Leslie Latham, March 1997.
Ethel M. Smith. "An Internal History of the Virginia-Kentucky Pattesons in Illinois, their Forebears and their Kin. Including the Lewises of Llangollen," 1948, Schlesinger Library.
Fry, Amelia R. *Conversations with Alice Paul: Woman Suffrage and the Equal Rights Amendment.* Berkeley: University of California Press, 1973.
——. *Mabel Vernon: Organizer for Women's Rights, Petitioner for Peace.* Berkeley: University of California Press, 1978.

C. Congressional Testimony:

Senate. Report of the Reclassification of Civil Service Employees." Senate Report, 67th Congress, 2d session, no. 486, February 8, 1922.
Smith, Ethel M. Testimony on Reclassification of Salaries. Senate Committee on Civil Service, 67th Congress, 1st session, May 17–June 16, 1921.
——. Testimony, Senate Hearing before the Committee on Public Health and National Quarantines, 66th Congress, 2, S3529.

D. Government Documents:

Beyer, Clara. "Minimum Wage for Women in Hotels and Restaurants in the District of Columbia." *Minimum Wage Board Report*, vol. 10, no. 3 (March 1920).
——. "History of Labor Legislation for Women in Three States." *Bulletin of the Women's Bureau*, no. 66. Washington, D.C.: U.S. Government Printing Office, 1929.
Minimum Wage Board. *Third Annual Report of the Minimum Wage Board of the District of Columbia for the Year Ending December 31, 1920.* Washington, D.C.: U.S. Government Printing Office, 1921.
"Towards Better Working Conditions for Women: Methods and Policies of the National Women's Trade Union League of America." *Bulletin of the Women's Bureau*, no. 252. Washington, D.C.: U.S. Government Printing Office, 1953.

E. Articles:

"To Serve Suffragists as Executive Secretary," *The Woman Citizen.* 48: 15 (April 1917).
"National a Reality: President Gompers Issues Call for Convention of Federal Employees Unions at Washington, September 24, 1917." *The Federal Employee* 2: 5 (May 1917).

"League Secretary is appointed to Minimum Wage Board." *Life and Labor Bulletin* 4: 12 (December 1918).

"Women in All States Have Representation in Tribute to Susan B. Anthony." *Equal Rights* 1: 24 (July 28, 1923): 190.

"Ceremonial Pageant in the Garden of the Gods." *Equal Rights* 1: 30 (September 8, 1923).

"The Development of Minimum Wage Laws in the United States, 1912–1927." Bulletin of the Women's Bureau 61 (Washington, D.C.: U.S. Government Printing Office, 1928).

"The Test of Equality." *Life and Labor* 7: 1 (December 1928).

Adkins, Jesse. "The Enforcement of a Minimum Wage Law As a Form of Collective Bargaining." *The American Academy of Political and Social Science* 90 (July 1920): 70–73.

Anderson, Mary. "Organizing the Bureau of Engraving and Printing." *Life and Labor Bulletin* 8: 1 (January 1918): 11.

Beyer, Clara. "Wages of Women Employed as Cleaners, Maids, and Elevator Operators in the District of Columbia." *Monthly Labor Review* 11: 5 (November 1920): 102–08.

———. "The Minimum Wage at Work in the District of Columbia." *Proceedings of the National Conference of Social Work, Chicago, 1917–1939* 47 (1920): 298–305.

———. "Minimum Wage Laws in the United States." *Life and Labor Bulletin* 7: 6 (May 1929).

Brandt, Lillian. *The Charity Organization Society of the City of New York, 1882–1907: Account of Present Activities.* Twenty-Fifth Annual Year End Report, September 13, 1907. New York: B. H. Tyrrell Printers, 1907.

Bugbee, Emma. "Women Open Campaign for Equal Rights." 1: 24 (July 28, 1923): 189.

Byron, Addison. "Work for the Returned Woodbrooker." *Friends Intelligencer* (August 13, 1919): 502–03.

"Civil Service Rules Permit Discrimination." *The Woman's Journal* 48: 3 (January 20, 1917): 1.

Eastman, Crystal. "Alice Paul's Convention." *The Liberator* (April 1921): 10.

"Government Not Fair to Women: Discrimination Found in All Branches of Service—Civil Service Examinations Closed." *The Woman's Journal* 48: 6 (February 10, 1917): 32.

Egan, Lavinia. "The Seneca Falls Conference." *Equal Rights* 1: 25 (August 4, 1923).

Etheridge, Florence. "Government Employees Unite in Live Organization." *Life and Labor Bulletin* 7: 12 (September 1917).

———. "Political Activity and the Federal Employee." *Life and Labor Bulletin* 7: 10 (October 1918).

Hubbard, Charles Meredith. "Relation of Charity Organization Societies to Relief So-
cieties and Relief-Giving." *American Journal of Sociology* 6: 1 (May 1901): 787–89.

Hunter, Robert. "The Difference between Social Settlements and Charity Orga-
nization." *Journal of Political Economy* 11 (1902): 75–88.

Keating, Edward. "The Reclassification Problem." *The Federal Employee* 4:4 (April
1919).

Kelley, Florence. "The New Woman's Party." *The Survey* 24 (March 3, 1921): 827.

MacKaye, Hazel. "Campaigning with Pageantry." *Equal Rights* 1: 39 (November
10, 1923): 309.

———. "One of the Great Champions of Women's Rights: Alice Paul." *Women's
Viewpoint* (August 1925): 10, 49.

Murray, Ella Rush. "The Woman's Party and the Violation of the 19th Amend-
ment." *The Crisis* 21: 6 (April 1921): 259–61.

Nastor, Agnes. "American Federation of Labor Convention." *Life and Labor Bul-
letin* 5: 12 (December 1915).

Paul, Alice. "Is a Blanket Amendment the Best Method in the Equal Rights Cam-
paign." *Congressional Digest III* (March 1926): 198.

———. "Woman Suffrage at Moorestown." *Friends Intelligencer* 67: 8 (February
19, 1910): 121–22.

———. "The Woman Suffrage Movement in Great Britain." *Annals of the Ameri-
can Academy of Political and Social Science*, supplement 27 (May 1910): 26–27.

Pound, Roscoe. "Liberty of Contract." *Yale Law Journal* 18 (May 1909): 454–87.

———. "Mechanical Jurisprudence." *Columbia Law Review* 8 (December 1908):
605–23.

Rogers, Cecilia. "Discrimination against the Women's Bureau." *The Searchlight* 5
(March 1921): 13–15.

Russell, Hortense. "The Amendment Is Introduced." *Equal Rights* 11: 44 (Decem-
ber 22, 1923).

Smith, Ethel M. "Safeguarding Industrial Standards." The Woman Citizen 1: 2
(June 9, 1917).

———. "A Liberty Sandwich." *The Woman Citizen* 2 (May 4, 1918): 453.

———. "Girl Cigar Makers on Strike." *The Federal Employee* 3: 5 (May 1918).

———. "Low Wages Send Cigar Makers on Strike." *Life and Labor Bulletin* 7: 5
(May 1918).

———. "Washington Committee Holds Organization Campaign." *Life and Labor
Bulletin* 7: 6 (June 1910).

———. "N.F.F.E. Publicity Bureau Now in Operation," *The Federal Employee*
(December 4, 1920).

———. "In the Dooryard of the World's Largest Employer." *Life and Labor Bulle-
tin* (June 1921).

———. "Woman's Organization Week: An Account of the Active Campaign Just

Conducted by the Women's Trade Union League in the Interest of the Better Organization of the Working Women of Washington." *The Federal Employee* 3: 6 (June 1918).

———. "Justice in Sight for 4,000 Women." *Life and Labor Bulletin* 7: 7 (July 1918).

———. "Senatorial Folly and the Suffrage Amendment." *Life and Labor Bulletin* 8: 3 (March 1919).

———. "The Woman's Labor Movement." *The Federal Employee* 4: 4 (April 1919).

———. "Raising the Pay of Washington Women Workers." *Life and Labor Bulletin* (August 1919).

[Smith, Ethel M.]. "Minimum Wage Bill for Women in the District of Columbia." *Life and Labor Bulletin* 4: 5 (May 1918).

———. "Congress Grants Inadequate Raise to Women Workers." *The Woman Citizen* 3 (August 10, 1918): 215.

Smith, Ethel M. "Take Politics out of the Civil Service." *The Federal Employee* (September 17, 1921).

———. "We Ask No Favors." *The Federal Employee* (September 24, 1921).

———. "Women to the Front of Government." *The Federal Employee* 3:9 (September 1918).

Smith, Ethel M. "What Reclassification Means to Women." Cited in George A. Warren, "Women Urge Square Deal for Women in Federal Service." *The Federal Employee* 7: 4 (April 1922).

———. "A Trade Union Woman Afoot in Europe." *Life and Labor Bulletin* 1: 5 (January 1923).

[Smith, Ethel M.]. "Conference on Minimum Wage Legislation and the Supreme Court Decision." *Life and Labor Bulletin* 1: 9 (June 1923).

———. "The Supreme Court v. Itself." *Life and Labor Bulletin* 2: 8 (April 1924).

———. "Women's Wages and Government Standards." *Life and Labor Bulletin* 7: 7 (March 1924).

———. "A Plain Statement Concerning the Proposed Child Labor Amendment to the Federal Constitution." *Woman's Home Companion* (Feb. 1925).

———. "Equal Rights—Internationally!" *Life and Labor Bulletin* 4: 40 (March 1926).

———. "Professional Women, Business Women, Industrial Women." *Life and Labor Bulletin* 7: 1 (December 1928).

———. "The Test of Equality." *Life and Labor Bulletin* 7: 1 (December 1928).

———. "To Standardize Women's Wages." *The Medical Women's Journal* 27 (February 1920): 61.

———. "Our Legislative Activities at Washington." *Life and Labor Bulletin* 1: 5 (January 1923).

———. "What A Congresswoman Has Done for Working Women." *The Woman Citizen* 1: 8 (July 1917): 136.

————. "Toward Equal Rights For Men and Women. Washington, D.C.: Committee on the Legal Status of Women, *National League of Women Voters* (May 1929).

Smith, Florence Patterson. "Equal Rights in the Service: Discrimination against Women in the Federal Service on Account of Sex, and the Remedy Sought." *The Federal Employee* (March 1917).

————. "How Federal Employees Have Become Articulate." *Life and Labor Bulletin* 10: 4 (April 1928).

————. "Facts about Working Women." *Bulletin of the Women's Bureau* (Washington, D. C.: U.S. Government Printing Office, 1925).

Steward, Luther. "President [Luther] Steward's Report: A Clear and Concise Summary of the Work and Progress of Our National Federation for the Year Ended June 30." *The Federal Employee* (September 4, 1920).

Voss, C. J. "Women's Union at Bureau of Engraving Observed Twentieth Anniversary." *The Federal Employee* 14: 3 (March 1929).

Waggaman, Mary T. "National Women's Trade Union League of America." *Monthly Labor Review* (April 1919): 1183–85.

F. Books:

Addams, Jane. *Twenty Years at Hull House*. New York: Phillips, 1910.

Anderson, Mary. *Woman at Work*. Minneapolis: University of Minnesota Press, 1951.

Carroll, Mollie Ray. *Labor and Politics: The Attitude of the American Federation of Labor Toward Legislation and Politics*. New York: Houghton Mifflin, 1923.

Cooley, Thomas. *A Treatise on the Constitutional Limitations which Rest upon the Legislative Power of the States of the American Union*. Boston: Little, Brown, and Company, 1868.

Irwin, Inez Haynes. *Alice Paul and the Story of the National Woman's Party*. Fairfax, Va.: Denlinger's, 1921.

Katzenstein, Caroline. *Lifting the Curtain: The State and National Woman Suffrage Campaigns in Pennsylvania As I Saw Them*. Philadelphia: Dorrance and Company, 1955.

Kinney, Mary. *Memories of a Militant*. London: Edwin Arnold and Company, 1924.

Nestor, Agnes. *Woman's Labor Leader: An Autobiography*. Rockford, Ill.: Bellevue Books, 1954.

Pankhurst, E. Sylvia. *The Life of Emmeline Pankhurst: The Suffragette Struggle for Women's Citizenship*. London: T. Werner Laurie, 1935.

————. *The Suffragette Movement: Intimate Accounts of Persons and Ideals*. London: Longman's Green and Company, 1931.

Pankhurst, Emmeline. *The Importance of the Vote*. Charing Cross Road, W.C.: The Woman's Press, 1908.

————. *My Own Story.* London: Eveleigh Nash, 1914.

Schneiderman, Rose. *All for One.* New York: Paul S. Eriksson, 1967.

Strachey, Ray. *The Cause: A Short History of the Women's Movement in Great Britain.* Port Washington, N. Y.: Kennikat Press, 1928.

Tiedeman, Christopher. *A Treatise on the Limitations of the Police Power in the United States.* St. Louis, Mo.: Da Capo Press, 1868.

II. Secondary Sources:

A. Dissertations:

Becker, Susan. "An Intellectual History of the National Woman's Party." Ph.D. dissertation, Case Western Reserve University, 1975.

Daly, Sister John Murie. "Mary Anderson: Pioneer Labor Leader." Ph.D. dissertation, Georgetown University, 1968.

Larabee, Ann E. "First Wave Feminist Theater, 1890–1930." Ph.D. dissertation, State University of New York, Binghamton, 1988.

O'Leary-Archer, Lynne M. "The Contentious Community: The Impact of Internecine Conflict on the National Woman's Party, 1920–1947." Ph.D. dissertation, University of Sourthern California, 1988.

Patterson, Cynthia. "The Beginnings of Modern Feminism: The National Woman's Party's Campaign for the Equal Rights Amendment in the 1920s." PhD. dissertation, Northwest University, 1987.

Paul, Alice. "The Legal Position of Women in Pennsylvania." Ph.D. dissertation, University of Pennsylvania, 1912.

————. "Towards Equality: A Study of the Legal Position of Women in the United States." Doctor of Common Law dissertation, American University, 1928.

B. Articles:

Cain, Patricia. "Feminism and the Limits of Equality." *Georgia Law Review* 24 (1990): 803–47.

Cohen, Miriam, and Michael Hanagan. "The Politics of Gender and the Making of the Welfare State, 1900–1940: A Comparative Perspective." *Journal of Social History* 24: 3 (Spring 1991): 469–84.

Cott, Nancy. "What's in a Name? The Limits of 'Social Feminism': or Expanding the Vocabulary of Women's History." *Journal of American History* 76: 3 (December 1989): 809–29.

Fry, Amelia. "Alice Paul." In *The Influence of Quaker Women on American History:*

Biographical Studies, edited by Carol and John Stoneburner, 232–34. Lewiston: The Edwin Mellon Press, 1986.

———. "Alice Paul and the ERA." In *Rights of Passage: The Past and Future of ERA,* edited by Joan Hoff-Wilson, 8–24. Bloomington: Indiana University Press, 1986.

———. "Along the Suffrage Trail." *American West* 6 (1969): 16–25.

Gamson, William A. "Social Psychology of Collective Action." In *Frontiers in Social Movement Theory,* edited by Aldon D. Morris and Carol McClurg Mueller, 53–76. New Haven, Conn.: Yale University Press, 1992.

Hart, Vivien. "Feminism and Bureaucracy: The Minimum Wage Experience in the District of Columbia." *Journal of American Studies* 26: 1 (April 1992): 1–22.

Johnson, Barbara. "The Postmodern Feminism." *Harvard Law Review* 105 (1992): 1076–83.

Johnson, Eldon. "General Unions in the Federal Service." *Journal of Political Economy* 2: 1 (February 1940): 24–27.

Kirchwey, Freda. "Alice Paul Pulls the Strings," *The Nation* 112: 2904 (March 2, 1921): 332–33.

Lipschultz, Sybil. "Social Feminism and Legal Discourse, 1908–1923." *Yale Journal of Law and Feminism* 2: 1 (Fall 1989): 131–60.

Murray, Meg McGavran. "The Work Got Done: An Interview with Clara Mortensen Beyer." In *Face to Face: Fathers, Mothers, Masters, Monsters—Essays for a Nonsexist Future,* edited by Meg McGavran, 203–32. Westport, Conn.: Greenwood Press, 1983.

Sklar, Kathryn Kish. "The Greater Part of the Petitioners Are Female: The Reduction of Women's Working Hours in the Paid Labor Force, 1840–1917." In *Worktime and Industrialization: An International History,* edited by Gary Cross, 103–33. Philadelphia: Temple University Press, 1988.

———. "Why Were Most Politically Active Women Opposed to the ERA in the 1920s?" In *Right of Passage: The Past and Future of ERA,* edited by Joan Hoff-Wilson, 25–35. Bloomington: Indiana University Press, 1986.

Walker, Harvey. "Employee Organizations in the National Government Service: The Formation of the National Federation of Federal Employees." *Public Personnel Studies* 10: 5 (October 1941): 130–35.

———. "Employee Organizations in the National Government Service: The Period Prior to World War I." *Public Personnel Studies* 10: 3 (August 1941): 67–73.

Zimmerman, Joan G. "The Jurisprudence of Equality: The Women's Minimum Wage, the First Equal Rights Amendment, and *Adkins v. Children's Hospital,* 1905–1923." *Journal of American History* (June 1991): 188–225.

C. Books:

Aron, Cindy. *Ladies and Gentlemen of the Civil Service: Middle-Class Workers in Victorian America.* New York: Columbia University Press, 1987.

Betters, Paul V. *The Personnel Classification Board: Its History, Activities, and Organization*. Washington, D.C.: The Brookings Institution, 1931.

Byrne, Richard. *Prisons and Punishments of London*. London: Harrap, 1989.

Cain, Sir Sidney. *The History of the Founding of the London School of Economics and Political Science*. London: G. Bell and Sons, 1963.

Carpenter, William Seal. *The Unfinished Business of Civil Service Reform*. Princeton, N. J.: Princeton University Press, 1952.

Chambers, Clarke A. *Seedtime of Reform: American Social Service and Social Action, 1918–1933*. Minneapolis: University of Minnesota Press, 1963.

Cott, Nancy. *The Grounding of Modern Feminism*. New Haven, Conn.: Yale University Press, 1987.

Dahrendorf, Ralf. *L.S.E.: A History of the London School of Economics and Political Science, 1895–1995*. New York: Oxford University Press, 1995.

Davis, Robert, ed. *Woodbrooke: 1903–1953: A Brief History of a Quaker Experiment in Religious Education*. London: Bannisdale Press, 1953.

Dreier, Mary. *Margaret Dreier Robins: Her Life, Letters, and Work*. New York: Island Press Cooperative, 1950.

Dubofsky, Melvyn. *Industrialism and the American Worker, 1865–1920*. Arlington Heights, Ill., Harlan Davidson, 1975.

Dye, Nancy Schrom. *As Equals and As Sisters: Feminism, the Labor Movement and Women's Trade Union League of New York*. Columbia: University of Missouri Press, 1980.

Eisenstein, Zillah. *The Female Body and the Law*. Los Angeles: University of California Press, 1988.

Ferguson, Elizabeth A. *Social Work: An Introduction*. Philadelphia: J. B. Lippincott, 1969.

Fine, Sidney. *Laissez-Faire and the General Welfare State*. Ann Arbor: University of Michigan Press, 1956.

Fink, Arthur. *The Field of Social Work*. New York: Henry Holt and Company, 1942.

Flexner, Eleanor. *Century of Struggle: The Women's Rights Movement in the United States*. London: Belknap Press of Harvard University Press, 1959.

Forcey, Charles. *The Crossroads of Liberalism: Croly, Weyl, Lippmann, and the Progressive Era, 1900–1925*. New York: Oxford University Press, 1961.

Ford, Linda. *Iron-Jawed Angels: The Suffrage Militancy of the National Woman's Party, 1912–1920*. Lanham: University Press of America, 1991.

Fowler, Robert Boothe. *Carrie Catt: Feminist Politician*. Boston: Northeastern University Press, 1986.

Frank, Dana. *Purchasing Power: Consumer Organizing, Gender, and the Seattle Labor Movement 1919–1929*. Cambridge: Cambridge University Press, 1994.

Fraser, Nancy, ed. *Justice Interruptus: Critical Reflections on the "Postsocialist" Condition*. New York: Routledge, 1997.

Frug, Mary Jo. *Postmodern Legal Feminism*. New York: Routledge, 1992.

Godine, Robert Morton. *The Labor Problem in the Public Service: A Study of Political Pluralism.* Cambridge: Harvard University Press, 1951.

Hart, Vivien. *Bound By Our Constitution: Women, Workers, and the Minimum Wage.* Princeton, N. J.: Princeton University Press, 1994.

Hillman, Arthur. *Sociology and Social Work.* Washington, D.C., Public Affairs Press: 1956.

Hollis, Ernest V., and Alice L. Taylor. *Social Work Education in the United States: Report of a Study Made for the National Council on Social Work Education.* New York: Columbia University Press, 1951.

Horwitz, Morton. *The Transformation of American Law: The Crisis of Legal Orthodoxy, 1870–1960.* Boston: Harvard University Press, 1987.

Hummer, Patricia. *The Decade of Elusive Promise: Professional Women in the United States, 1920–1930.* Ann Arbor: University of Michigan Research Press, 1976.

Ingle, Larry H. *Quakers in Conflict: The Hicksite Reformation.* Knoxville: University of Tennessee Press, 1986.

Kenneally, James. *Women and American Trade Unions.* St. Albans, VT: Eden Press Women's Publications, 1978.

Kessler-Harris, Alice. *Out to Work: A History of Wage-Earning Women in the United States.* New York: Oxford University Press, 1982.

Kessler-Harris, Alice, Jane Lewis, and Ulla Wikander, eds. *Protecting Women: Labor Legislation in Europe, the United States, and Australia, 1880–1920.* Chicago: University of Chicago Press, 1995.

Kirkby, Diane. *Alice Henry: The Power of Pen and Voice.* New York: Cambridge University Press, 1991.

Lehrer, Susan. *Origins of Protective Labor Legislation for Women, 1905–1925.* Albany: State University of New York Press, 1987.

Lemons, James Stanley. *The Woman Citizen: Social Feminism in the 1920s.* Urbana: University of Illinois Press, 1973.

Marshall, T. H., and Tom Bottomore. *Citizenship and Social Class.* Cambridge: Cambridge University Press, 1950.

Mitchell, David. *The Fighting Pankhursts: A Study in Tenacity.* New York: Macmillan, 1967.

Muncy, Robyn. *Creating a Female Dominion in American Reform, 1890–1935.* New York: Oxford University Press, 1991.

Orleck, Annelise. *Common Sense and a Little Fire: Woman Working-Class Politics in the United States, 1900–1965.* Chapel Hill: University of North Carolina Press, 1995.

Pateman, Carole. *The Sexual Contract.* Stanford, Calif.: Stanford University Press, 1988.

Payne, Elizabeth. *Reform, Labor, and Feminism: Margaret Dreier Robins and the Women's Trade Union League.* Chicago: University of Chicago Press, 1988.

Pumphrey, Ralph E., and Muriel W. *The Heritage of American Social Work.* New York: Columbia University Press, 1961.

Radice, Lisanne. *Beatrice and Sidney Webb: Fabian Socialists.* New York: Macmillan, 1984.

Rosen, Andrew. *Rise Up Women!: The Militant Campaign of the Women's Social and Political Union, 1903–1914.* Boston: Routledge and Kegan Paul, 1974.

Rupp, Leila, and Verta Taylor. *Survival in the Doldrums: The American Women's Right Movement, 1945 to the 1960s.* Columbus: Ohio State University Press, 1990.

Russell, Elbert. *The History of Quakerism.* New York: Macmillan, 1942.

Scarry, Elaine. *The Body in Pain: The Making and Unmaking of the World.* New York: Oxford University Press, 1985.

Scott, Joan. *Gender and the Politics of History.* New York: Columbia University Press, 1988.

Sibeon, Roger. *Towards a New Sociology of Social Work.* Aldershot: Averbury, 1991.

Sklar, Katheryn Kish. *Florence Kelley and the Nation's Work: The Rise of Women's Political Culture, 1830–1900.* New Haven, Conn.: Yale University Press, 1995.

Smith, Daoreth Hevenor. *The United States Civil Service Commission: Its History, Activities, and Organization.* Baltimore, Md.: The Johns Hopkins University Press, 1928.

Spero, Sterling. *Government as Employer.* New York: Remsen Press, 1948.

Steinberg, Stephen. *The Ethnic Myth: Race, Ethnicity, and Class in America.* Boston: Beacon Press, 1981.

Sterling, Dorothy. *Black Foremothers: Three Lives.* Old Westbury, N. Y.: The Feminist Press, 1979.

Tompkins, Jane. *West of Everything: The Inner Life of Westerns.* New York: Oxford University Press, 1992.

Twiss, Benjamin. *Lawyers and the Constitution: How Laissez-Faire Came to the Supreme Court.* Princeton, N. J.: Princeton University Press, 1942.

Van Riper, Paul. *History of the United States Civil Service.* White Plains, N. Y.: Row, Peterson, and Company, 1958.

Watson, Frank Dekker. *The Charity Organization Movement in the United States.* N. Y.: Arno Press and New York Times, 1971.

Wigdor, David. *Roscoe Pound: Philosopher of Law.* Westport, Conn.: Greenwood Press, 1974.

Wooddy, Carroll. *The Growth of the Federal Government, 1915–1932.* New York: McGraw-Hill, 1934.

INDEX